A Bountiful Decade

A
Bountiful
Decade

Selected Acquisitions 1977-1987
The Nelson-Atkins Museum of Art

Catalogue compiled and edited by Roger Ward with the assistance of Eliot W. Rowlands

This catalogue is published on the occasion of an exhibition
at The Nelson-Atkins Museum of Art, Kansas City, Missouri
October 14 – December 6, 1987

COVER
Jean Baptiste Pater: *Le Goûter* (cat. 52)

Table of Contents

Dedicated to Laurence Sickman and Ross Taggart

Preface

This exhibition of selected acquisitions from the years 1977-1987 is something of a summary report on the most important activity of The Nelson-Atkins Museum of Art during one of the most dynamic decades in its history. Undoubtedly it reflects the initiatives, interests, good fortune, and tastes of the Museum's talented staff of curators, led by the two directors who served during the period, Ralph T. Coe and Marc F. Wilson. Simultaneously, the exhibition pays tribute to the community's involvement in the Museum by acknowledging the outstanding generosity of its patrons and friends. From any perspective it is easy to recognize that since 1977 the Museum has enjoyed considerable success in its effort to achieve the stated goal of its founder, William Rockhill Nelson, to "purchase . . . works of the fine arts which will contribute to the delectation and enjoyment of the public generally."

As a glance through Roger Ward's handsome catalogue reveals, *A Bountiful Decade: Selected Acquisitions 1977-1987* is quite literally the consequence of a remarkable record of munificence — of that special favor the Museum has enjoyed in the philanthropic history of Kansas City. Several works of art testify to Nelson's on-going legacy, for they were purchased with income from the Trust bearing his name that came into being in 1926. Of more recent memory, and a highlight of the previous ten years, was the 50th Anniversary Fund of 1982-83 which celebrated the Museum's first half century by raising some $58 million. While this impressive sum comprised numerous works of art, a significant proportion of the total consisted of contributions to be used for acquisitions; whether given or purchased, many of those artworks are included in the present exhibition. Since 1982-83 many more gifts in kind have been made by an array of donors, and a substantial number of contemporary paintings and sculptures have come to the Museum thanks to the liberality of the Friends of Art. Likewise, a profound debt of gratitude is owed to the members of the Society of Fellows and the Business Council for their continuous support of the Museum's programs and acquisitions.

It is the hope of each of us who has served as Trustee during the past decade that the present exhibition, along with its catalogue, will assist in the celebration of that enlightened and exceptionally active patronage which has so profoundly enriched the collections of The Nelson-Atkins Museum of Art and, by extension, the cultural life of our great city.

Foreword

This catalogue was prepared in conjunction with an exhibition of some 116 works of art selected from the more than 2200 acquisitions made by The Nelson-Atkins Museum of Art between January 1, 1977 and the early months of 1987. In the years to come I hope it also will serve to remind us that the preeminent goal of this institution is the development of a permanent collection of superior works of art for the enjoyment and benefit of all.

In the past decade much has happened in the world of art museums to obscure the pivotal importance of the permanent collection. This is true because the museum's role within the context of modern American society has been radically altered by a number of unforeseen and far-reaching changes. The most significant have to do with the "socialization" of the art museum, meaning its integration into a society recognized for a plurality of social, ethnic, and economic communities whose individual claims to influence society's institutions are recognized as legitimate. Museums therefore have striven to become organizations that both serve the needs of ever growing constituencies while reflecting their diversity.

In order to reconcile traditional commitments to professional excellence with new claims on their finite resources, museums have had to introduce a variety of new modes of operation. For while museums are supposed to be devoted to the collecting, preservation, and study of great works of art, in the future their welfare almost surely will depend on the development of aesthetic and learning experiences for a very broad spectrum of the public. So it is essential to remember that the museum's traditional activities and its more innovatory ones are not mutually exclusive; rather they are interdependent, for it is the quality of a collection and the depth of our knowledge of it that determine the type, extent, and vitality of all other programs originated by the museum. The essential and irreducible nucleus of a great art museum is constituted, therefore, of its permanent collections. They form the critical mass that generates the energy that drives the museum forward in whatever direction it might choose to go. The obvious corollary is that the greatness of the entire collection is only a function of the quality and importance of the individual objects which it comprises.

During the past decade it has become increasingly difficult to make acquisitions of the highest caliber for the Nelson due to the ever greater amounts of money chasing the dwindling number of superior works of art, meaning that in some areas the dizzying rapidity of the upward spiral of prices has outstripped this Museum's ability to pay. That is why the purchase of Degas's *L'Atelier de la modiste* (cat. 48), made near the beginning of the decade under examination, very well may be the last of its kind: the international market for Impressionist paintings is now so overheated in comparison with those for other schools or periods of European painting that it is not the place to attempt to compete with limited resources. Viewing this exhibition or reviewing its catalogue nevertheless will reveal that the trustees, directors, and curators of the past ten years have enjoyed conspicuous success in their search for works of special distinction over a remarkably wide field. Discipline and patience have resulted in the concentration of funds in fewer objects of masterful quality according to a scheme of priorities that reflects the strengths (not just the needs) of the collection and a realistic assessment of both present opportunity and potential availability. On a few occasions during the past decade such an assessment has convinced the Trustees that it was appropriate to pay what was at the time a record price for a certain kind of object or for the work of some particular artist. In each case the decision to do so was taken only after the most deliberate process of evaluating all the relevant aesthetic, financial, and ethical arguments pertaining to the work of art and the expenditure of a mighty sum in order to obtain it.

As persons familiar with the Nelson's history read through this catalogue, they will recognize that during the previous decade the manner in which acquisitions have been funded has undergone a substantive change. In the first forty years of the Museum's history, its trustees relied almost entirely on investment income for the purchase of works of art. By the 1970s the role of the individual benefactor had begun to take on new prominence, and the Museum's present reliance on donors and patrons for further additions to the collection is made unmistakably clear by the length of the list that appears at the beginning of each section of the catalogue. The excellent record of the past ten years was made possible by the extraordinary generosity of all these individuals, and to every one of them a profound debt of gratitude is owed. The means by which the Museum will continue to add outstanding works of art to its collections, thereby reinforcing its uniquely important position in the cultural life of Kansas City, are not entirely apparent. What is obvious to those of us entrusted with the daily welfare of the Museum is that we have an urgent responsibility to continue to broaden our horizons in search of the support which will guarantee that the coming ten years will be as bountiful as the remarkable decade we are now celebrating.

Marc F. Wilson
Director and Chief Curator of Oriental Art

Introduction

This catalogue is dedicated to Laurence Sickman, Director Emeritus, who retired in 1977, and to Ross Taggart, whose retirement from the position of Senior Curator coincided with the celebration of the Museum's Fiftieth Anniversary at the end of 1983. It is against the background provided by their achievements as connoisseurs and scholars that the collecting activities of the past decade should be seen. Both men were educated at Harvard University, where in the second quarter of this century museology as a formal discipline attained the level of sophistication previously encountered only in a handful of German universities. Their subsequent paths to Kansas City were indirect ones, but later both men demonstrated exceptional devotion to the Nelson and passed the entirety of their respective museum careers in its service. Mr. Sickman's association with the Trustees of the museum-to-be in Kansas City began in 1931. As advisor, curator, director, and emeritus, his success in the formation and development of the Oriental collections of the Nelson-Atkins is recognized as one of the outstanding curatorial achievements of the modern age. Though Mr. Taggart's long tenure began with his appointment as Registrar in 1947, within a few years he had taken on an awesome range of curatorial responsibilities. Whether in Old Master Drawings, Antiquities, American Art, or the Decorative Arts, one often finds evidence of that rare combination of good taste, good sense, and sensitivity which characterized Mr. Taggart's curatorial decisions and the innumerable acquisitions resulting from his recommendations.

A Bountiful Decade: Selected Acquisitions 1977-1987 was conceived to meet a variety of needs. Most obviously, it is intended to review and assess the Museum's collecting activities during a short but exceptionally dynamic period in its history by highlighting some of the more noteworthy recent additions to the collection. The Director personally considered more than two thousand acquisitions made during the years of interest; from that large number he selected the "best of the best" as representatives of a decade of growth and abundance. A few of the exhibited objects were acquired by private foundations on behalf of the Museum, a number were given directly by previous owners, while others came by bequest; some acquisitions have been made by the curatorial staff with restricted or designated purchase funds provided by individuals for specific objects or types of objects. Such acquisitions necessarily carry a credit line that contains the name of the associated person(s) or organization. Numerous other purchases have been feasible because of investment income from The William Rockhill Nelson Trust and/or The Nelson Gallery Foundation. The latter is the Museum's operating body and receives unrestricted contributions such as those made to the Fiftieth Anniversary Fund and through the Society of Fellows. Whether as donors of artworks or contributors to finances, literally thousands of people thereby have participated in the vital process of augmenting the Museum's permanent collections — far and away its most important and abiding resource. It is hoped, therefore, that the exhibition will be perceived as a glowing tribute and expression of thanks to those who have made possible the accomplishments of the last years. Further, the catalogue will remain as a testament to their generosity while serving as a stopgap until a series of publications documenting various departmental collections begins to appear two years hence.

The catalogue is organized according to the scheme of the exhibition. Sweeping changes, introduced since 1977, in the administrative structure of the Museum have meant that each of the eight major sections of its collection is recognized as a separate curatorial department. Like the exhibition, whose arrangement was governed by the desire to achieve an orderly presentation of many dissimilar objects, the catalogue is divided into individual sections for the different departments. Anomalous is the intermingling of objects from the Department of Decorative Arts with European paintings, while the Department of Antiquities — recently defined as an area of independent curatorial jurisdiction — unfortunately is not represented in the exhibition. Divided by department, the works of art in each section of the catalogue appear in the chronological order of acquisition, not according to date of execution. This unorthodox approach was meant not to confuse but to illustrate patterns of collecting. Depending on the individual(s) responsible for making acquisitions in a given area, such an arrangement of the entries permits the emergence of lines of continuity over the ten-year period, or makes it obvious when there has been a change in terms of interest, emphasis, expertise, and opportunity.

Every department has been favored by both the generosity of patrons and the service of talented curators. Remarkable gifts of African and Native American art, especially those from the Sosland family, have been supplemented by a series of purchases of distinguished masterworks. The Oriental department has enjoyed enviable philanthropy in the form of gifts and bequests, like that of the late Mrs. George H. Bunting, Jr.; the munificence of the Hall Family, in particular, permits it to continue to acquire by purchase works of only the highest caliber, as befits the excellence of the collections. The collection of the Department of European Art at the Nelson has been splendidly enhanced by individuals like the late Helen Foresman Spencer, whose gifts in the earlier 1970s had included landmarks of French Impressionism such as Monet's *Boulevard des Capucines* and Degas's *Ballet Rehearsal*. The Anonymous Donors made possible a series of brilliant acquisitions in the late 1970s (cat. 43-48, 69), while more recent purchases have been made thanks to other benefactors and the Trustees' liberality with funds from the Foundation. A number of the Museum's finest American paintings have come to it only during the last decade, even though prices have risen sharply and relentlessly. The department's enlightened patrons have been led by the conspicuous example of the Enid and Crosby Kemper Foundation, donor of major canvases by (among others) Church, Eakins, and Sargent. Twentieth-Century Art has achieved unprecedented prominence in the Museum as a result of the continued support of the Friends of Art and the innovative scheme of collecting on behalf of the Museum by Fixtures Furniture. It was also during this period that Foundation funds were first expended on a work of contemporary art (cat. 86). The collection of the Department of Prints, Drawings, and Photographs was greatly strengthened by the magnificent gift of several hundred drawings, the great majority by European old masters, in the McGreevy Bequest; three sheets from this truly unique Kansas City collection are included in the exhibition (cat. 94-96). Various restricted funds, loyal benefactors, and the support of the Foundation have made possible the acquisition of many other works of art on paper whose diversity is equalled only by their first-rate quality.

Without prejudice it can be said that few museums, especially in this country, could rival the offerings of *A Bountiful Decade*. The record speaks for itself with some authority; it is one from which not only the Museum's Trustees and its staff can take satisfaction, but likewise should be a source of considerable pride for all Kansas Citians. The joy we take from our recent past inspires an optimistic anticipation of the future.

Roger Ward
Associate Curator of European Art

Acknowledgments

Only some ten months ago the decision was taken that there ought to be, in the autumn of 1987, an exhibition of selected acquisitions from the decade which began on January 1, 1977. The idea was Marc Wilson's, and I was pleased to be entrusted with both the project and the preparation of a worthy catalogue. It was obvious from the beginning, however, that the effort would require an exceptional amount of cooperation and collaboration if the task were to be accomplished successfully and on time. The Trustees are to be congratulated for the swift and unequivocal commitment they made to support the exhibition. My sincere thanks go to the curatorial staff, who responded to the unanticipated call for catalogue entries with both good cheer and alacrity. Ann Erbacher, Registrar, and her staff are to be applauded for the efficiency with which they provided technical data, and for their continued assistance throughout the long process of verifying our facts and figures. Particularly deserving of recognition are the efforts of Elsie Sakuma, formerly the Registrar's Assistant, who organized a great deal of new photography on behalf of the catalogue, and E. G. Schempf, who produced some of the most beautiful transparencies and photographs in the Museum's files. I am much indebted to Michael Churchman and Mary Ellen Young, who labored tirelessly to assemble the lists of donors to the various departments and shared their enthusiasm for *A Bountiful Decade* when my own energies flagged. Given the eclectic nature of the exhibition, Michael Hagler's sympathetic installation again demonstrates his sensitive and creative response to the problems of design; I am indeed grateful to Bobby Hornaday and his staff for their swift but meticulous implementation of Mr. Hagler's plans. Most of all I should like to thank Dr. Eliot Rowlands, my colleague in the Department of European Art and collaborator on this project, and Jean Drotts, Curatorial Secretary, whose organizational skills are everywhere evident throughout the handsome catalogue. Their devotion to the project from its inception was unqualified, and it is no exaggeration to state that without their diligent and good-natured support, neither the exhibition nor publication could have materialized.

Roger Ward
Project Director and Editor

Contributors to the Catalogue

H.A.	Henry Adams, Samuel Sosland Curator of American Art
M.J.A.	Mary Jo Arnoldi, formerly Associate Curator of the Arts of Africa, Oceania, and The Americas (1983-1985)
D.B.	David Binkley, Associate Curator of the Arts of Africa, Oceania, and The Americas
E.P.B.	Edgar Peters Bowron, formerly Curator of Renaissance and Baroque Art (1978-1981)
D.H.F.	Dorothy H. Fickle, Associate Curator of South Asian Art
J.G.	Jay Gates, formerly Curator of American Art (1981-1983)
P.J.G.	Patricia J. Graham, formerly Research Fellow, Department of Oriental Art (1984-1986)
J.H.	Jennifer Hardin, Research Assistant, Department of American Art
W.-K.H.	Wai-Kam Ho, Laurence Sickman Curator of Oriental Art
J.K.	Joseph Kuntz, formerly Associate Curator of European Decorative Arts (1983-1985)
G.L.McK.	George L. McKenna, Curator of Prints, Drawings, and Photographs
E.R.	Eliot Rowlands, Assistant Curator of European Art
D.E.S.	Deborah Emont Scott, Sanders Sosland Curator of 20th-Century Art
R.W.	Roger Ward, Associate Curator of European Art
E.W.	Elizabeth Wilson
M.F.W.	Marc F. Wilson, Director and Curator of Oriental Art
K.S.W.	Kwan S. Wong, formerly Research Fellow, Department of Oriental Art (1975-1979)

Notes on the Entries

Catalogue entries are grouped according to areas of curatorial jurisdiction. Within each division the entries are arranged in the chronological order in which the objects were acquired.

Dimensions are given in metric form only, height preceding width for two-dimensional objects. Free-standing sculptures usually are described in terms of height only, while circular objects are described by diameter only or height and diameter depending on shape and size.

Because of their extraordinary size and/or weight, a few objects could not be installed in the exhibition and remain on view in their usual venues. These are: the Kushana *Nagini* (cat. 17), James Rosenquist's *Venturi and Blue Pinion* (cat. 85), and Frank Stella's *Birkirkara* (cat. 88). Robert Rauschenberg's *Tracer* (cat. 86) is absent due to its inclusion in the travelling exhibition *Made in U.S.A.* All four works are represented in the current exhibition by photograph murals.

Department of the Arts of Africa, Oceania, and the Americas

Donors to the
Department
1977-1987

Anonymous
Association of American Indian Affairs
Mr. and Mrs. William W. Baker Fund
Mr. and Mrs. Jerry D. Berger
Mrs. Peter T. Bohan Bequest
Bunting Sound System
Mrs. Wayne R. Carlson (in memory of Wayne R. Carlson)
Bessie Lurine Christiansen
Carl C. Clark Bequest
Mrs. Peter I. Cloonan
Ralph T. Coe (in honor of Mr. and Mrs. Morton I. Sosland)
Dr. and Mrs. George A. Colom
The William M. Craig Family
John M. Crawford, Jr.
Peter W. Davidson
George H. and Elizabeth O. Davis Fund
Mrs. Ilus W. Davis
Mrs. Lewis B. Dougherty (in honor of Dr. William Hamilton Moore, Jr.)
Mr. and Mrs. William L. Evans, Jr.
Marc Leo Felix
Dr. and Mrs. W. David Francisco
John A. Friede (in honor of the Fiftieth Anniversary of The Nelson-Atkins Museum of Art)
Mr. and Mrs. Dean Graves
Evelyn A.J. Hall (in honor of the Fiftieth Anniversary of The Nelson-Atkins Museum of Art)
Miss Eleanor Halley
Nell B. Hayden
Mr. and Mrs. Frank Bernard Henderson, Jr.
Dr. and Mrs. Thomas M. Holder
Airy Smeltzer Jones Fund
Donald D. Jones (in memory of LaRue C. Jones)
Donald D. Jones (in memory of Sylvan and LaRue C. Jones)
LaRue C. Jones Memorial Fund
Mr. and Mrs. Norman B. Kahn
Marcus Kaplan
Mr. and Mrs. Keith Kassel
Dr. Harry G. Kroll
Mark and Robin Kyle
Leawood Women's Club
Mr. and Mrs. Robert Ridenour Lester
Mr. and Mrs. E.M. Lieberman
Jean S. Lighton
Mr. and Mrs. Lee R. Lyon
Mrs. Edward G. McLean
Mr. and Mrs. Robert H. Mann, Jr.
Mr. and Mrs. Morton D. May
Mrs. C. Mehornay

Mr. and Mrs. Roy A. Miller (in memory of De Aun Lorts)
Mary Howard Moore (in honor of Brigadier-General Harold Palmer Howard)
Kate Mulhearn
J. Wilson and Martha T. Nance (in honor of Mr. and Mrs. Reginald G. Thompson)
Native Sons of Kansas City
Eleanor Nelson (in memory of Alvin B. Brown)
Mrs. Richard R. Nelson
Mrs. A.L. O'Brien
Mr. and Mrs. James W. Powell (in memory of David Humphreys Powell)
Jack Ralston
Mrs. Jack Rieger (in memory of Hortense P. Lorie)
Mrs. Emmett Scanlan, Jr.
Edgar O. Smith
The Sosland Family
Sosland Magic Theater
Mr. and Mrs. Morton I. Sosland
Mr. and Mrs. Morton I. Sosland (in honor of the Fiftieth Anniversary of The Nelson-Atkins Museum of Art)
Robert L. Stolper
Mrs. Eugene M. Strauss
Mr. and Mrs. Herman R. Sutherland
John L. Swarts
Mr. and Mrs. Donald H. Tranin
Van Keppel Primitive Fund
William Van Keppel
Mrs. Paul Ward
Mr. and Mrs. William P. Ward
Dr. Larry Welling
Donald and Fifi White

1

WESTERN GREAT LAKES

Bandolier Bag, c. 1850

Woolen trade cloth, beads, and silk, 31.8 x 17.8 cm.

Gift of J. Wilson Nance and Martha T. Nance in honor of Mr. and Mrs. Reginald G. Thomson. 77-26/1.

One of the most important objects in the Native American collection of the Museum is this spectacular beaded bandolier bag. The small, rectangular buckskin bag attached to a strap — used by hunters and travelers — is of an earlier type and is known from the third quarter of the 18th century. The decorative bandolier bag established in the late 18th and early 19th centuries featured the division of the face of the bag into two panels, each featuring colored quills worked into intricate geometric patterns. Further ornamentation often was added in the form of a cut leather fringe or loops embellished with quill, hair, or beads. These appear to have become fashionable in the Great Lakes region in the 19th century, by which time the original, utilitarian purpose of the bag had been overshadowed by its use in ceremonial dress. One or more bags would be carried to complete an elaborate costume.

The Nelson-Atkins piece is important not only because of its extremely beautiful loom-beaded panels and bandolier strap, but because the name and the date *Joseph Lan/tre Nov 11 1850* have been incorporated into the design of the front panel. Another example, very similiar in style, is in the Chandler-Pohrt Collection, Detroit Historical Department, Historic Fort Wayne, Michigan.

D.B.

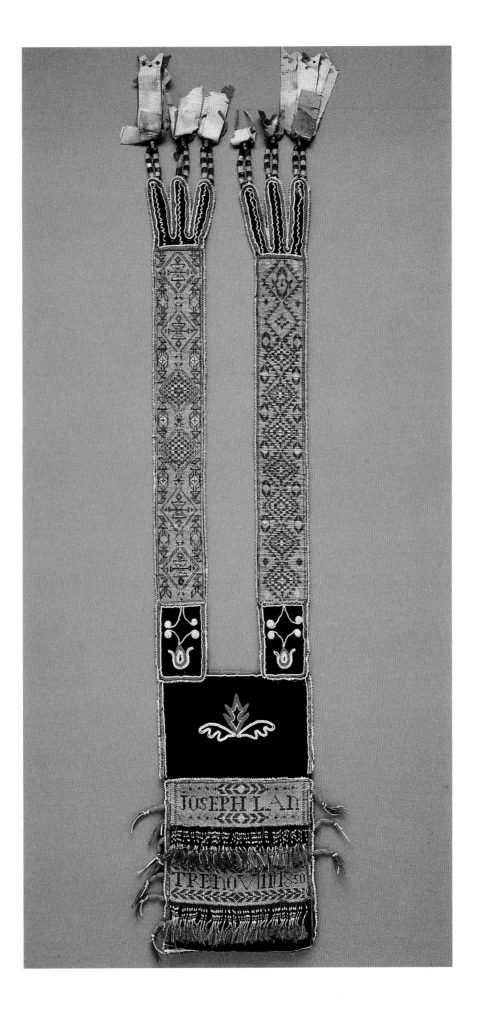

2

MANINKA/BAMANA (Mali)
Female Puppet Figure, 19th century
Wood, 78.7 cm. (h.)
Male Puppet Figure, 19th century
Wood, 64.8 cm. (h.)
Gift of Mr. and Mrs. Morton I. Sosland. 78-42/1,2.

Puppet theatre performances occur at least twice annually in connection with the agricultural and fishing cycles of south central Mali. Puppets appear in the forms of spirits and animals as well as human beings, those included in the present exhibition being busts of male and female figures. They are all that remain of a pair of elaborately dressed puppets that once entertained crowds of people during theatrical events. The busts would have been worn on the heads of dancers hidden by coverings of brightly colored cloth. Originally the puppets would have had moveable arms manipulated by the hidden dancer. The male puppet represents a member of another ethnic group who would have been a stranger to the region, and therefore his actions would have satirized the differences between the viewers of the performance and their neighbors. The female puppet represents a woman considered both physically beautiful and morally sound.

D.B.

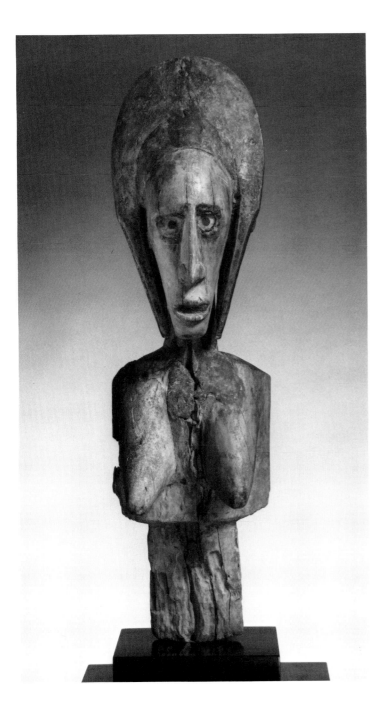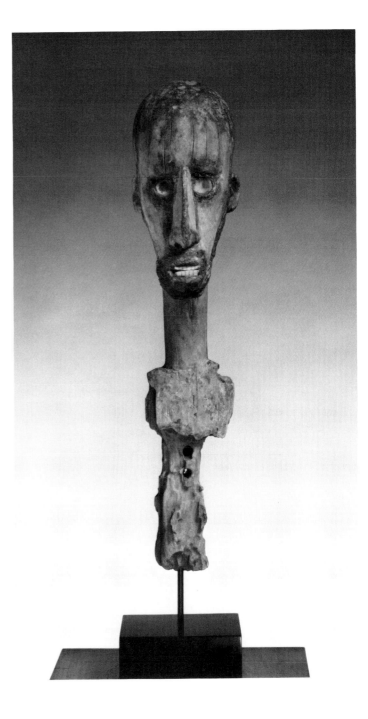

3

DELAWARE

Spirit Doll, late 19th century

Wood, cloth, metal, leather, beads, and hair, 27.3 cm. (h.)

Gift of Mr. and Mrs. Lee R. Lyon. 79-8/1.

The Delaware people flourished in the 18th and 19th centuries in parts of Pennsylvania, New York, and New Jersey as well as Delaware, but later they were dispersed in locations such as southern Ontario, Wisconsin, and Oklahoma. Although the forced movements fundamentally altered the structure of their society, many ritual practices were tenaciously maintained. Among the Delaware of Oklahoma, some families prepared annual feasts to honor spirit dolls which were believed to insure physical health and material well-being. New clothing was made for the doll, it was given a gift of jewelry, and attached to a pole in order that family members might dance with it. At the conclusion of the dancing the feast was eaten. This doll is dressed in a finely made blouse and skirt with elaborate ribbon appliqué; it is adorned with a silver brooch, pins, and bracelets. The doll was acquired along with a trunk of equally well-made miniature clothing, evidence that it figured prominently on several such occasions.

D.B.

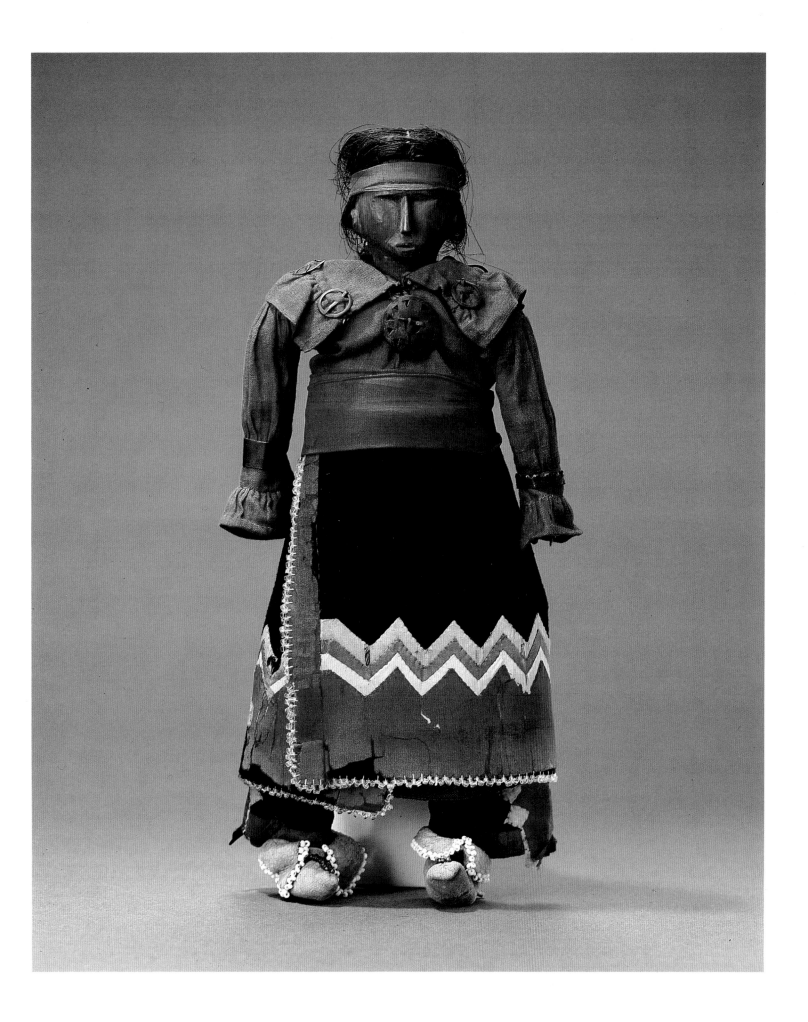

4

BAULE (Ivory Coast)

Goli Mask: Kpan, 19th century

Wood, 40 x 21 cm.

Gift of Mr. and Mrs. Morton I. Sosland. 79-56.

One of the most popular masquerades among the Baule people is the *goli* series held in connection with a funeral, following the harvest, or to commemorate the visit of a dignitary. Four pairs of masks dance during the *goli* performance. This particular mask, called *kpan,* is among the most important of all and appears near the end of the dance sequence. The powerfully stylized face and high cresting hairstyle epitomize the Baule concept of female beauty as well as the attainment of both high status and spiritual power.

D.B.

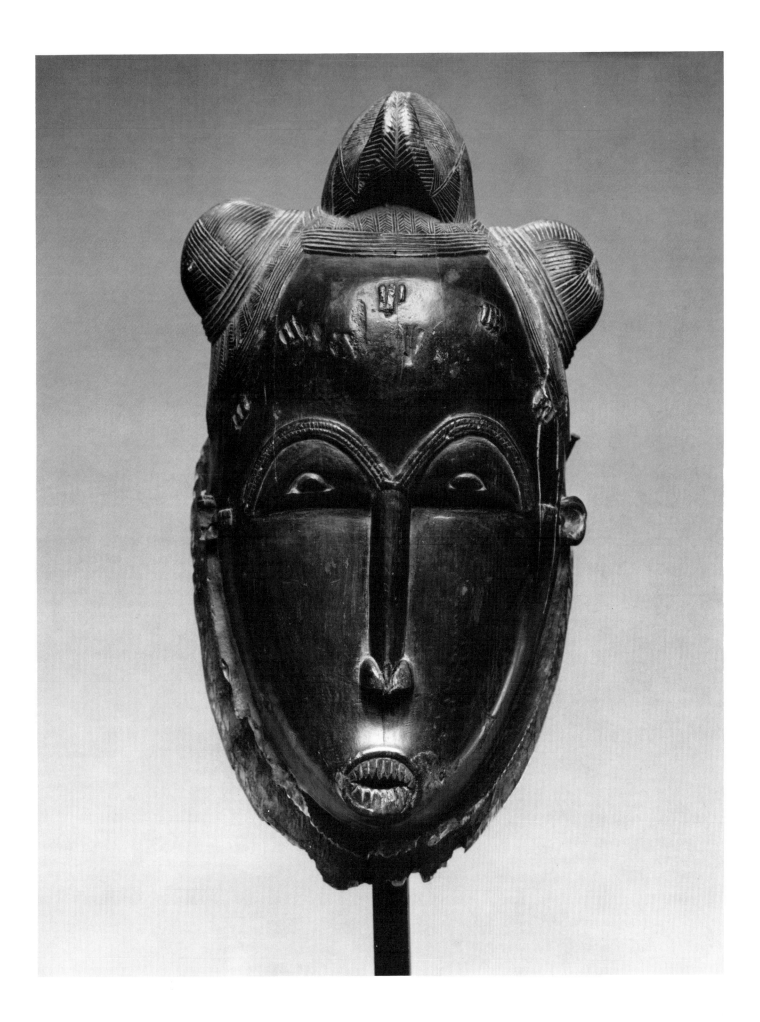

5

HAIDA (British Columbia)
Chair, c. 1860-70
Painted wood, 83.5 x 42.5 x 44 cm.
Gift of Ralph T. Coe. 80-42/2.

Although animals appear as mythological characters in Northwest Coast art, or as crests on totem poles, for example, it is most unusual to find one used in connection with a functional object like this chair. The flat tail of a beaver forms a vertical splat in the back of the chair while the animal's body serves as its seat. The maker has modeled his chair after a European prototype, for indigenous examples take the form of three-sided backrests.

D.B.

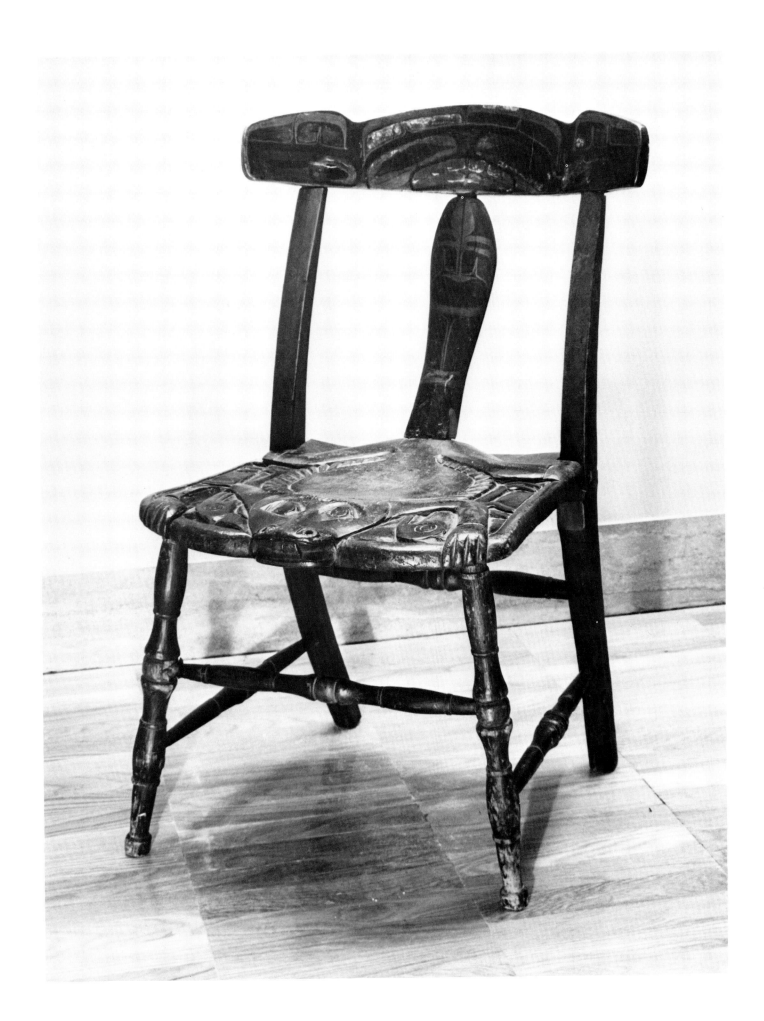

6

KWAKIUTL (British Columbia)

Hamatsa Mask depicting Hokhokw,
c. 1920

Wood, cedar bark, and paint,
172 cm. (l.)

Gift of Ralph T. Coe in honor of
Mr. and Mrs. Morton I. Sosland.
81-51.

One of the more important occasions for the Kwakiutl people of the Northwest Coast was the Hamatsa dance of the Winter Ceremonial for which a bewildering variety of mask forms were made. Perhaps the most important mask in the Hamatsa dance sequence was the mask Hokhokw; it represents a long beaked wild bird who eats men.

The dramatic sculptural power of this mask would best be seen in the semi-darkness of the house where the dance took place. The mask would clack its articulated beak and move erratically in a murderous frenzy from a standing to a crouching position seeking its victims. The appearance would be accompanied by the sound of rattles and whistles. Other masks and figures would also perform in turn. These included 'transformation' masks which would change from one form into another before the astonished viewers or figures. They would then fly through the air or move mysteriously across the floor on invisible strings. These and other theatrical feats were integral components of the Winter Ceremonial and were created to make visible powerful spirit forces or to dramatize mythological beings.

D.B.

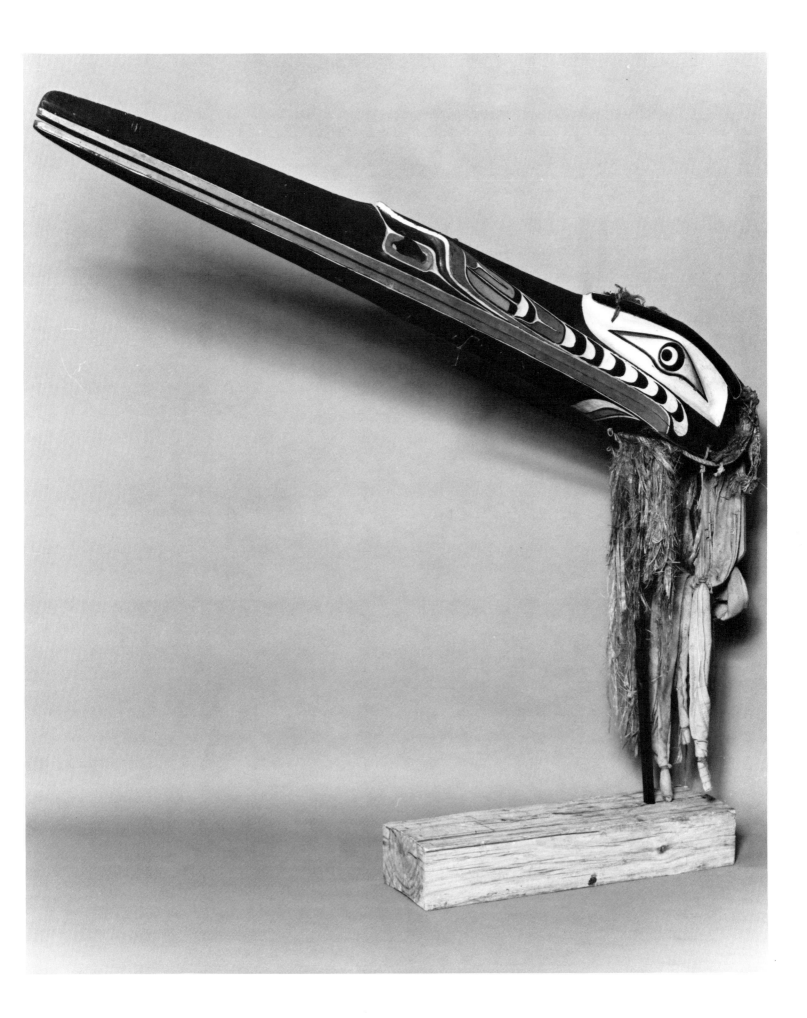

7

HEMBA (Zaire)

Standing Figure, 19th century

Wood, 80.6 cm. (h.)

Gift of Mr. and Mrs. Morton I. Sosland in honor of the Fiftieth Anniversary of The Nelson-Atkins Museum of Art. 81-53.

This standing male figure was created by a master Hemba carver to honor a recently deceased member of a ruling family. The figure then was placed with other, similar ones in the possession of the family, each of them named for an illustrious ancestor, and arranged according to seniority. Grouped together in this way, the wooden figures constituted a record of the family's lineage and provided visual substantiation of its claim to rightful authority.

While the importance of the sculptural traditions of Central Africa has been recognized for decades, only in recent years has the figural carving of the Hemba been distinguished from that generally attributed to the Luba people of eastern Zaire. Recent scholarship has differentiated between regional and local styles and thereby has stimulated a greater appreciation for the magnificent accomplishments of Hemba master carvers. This particular figure displays all the salient features of Central African style: a monumental frontality, with emphasis placed on the head (note the elaborate coiffure) and a symmetrical arrangement of the features, including the arms held tightly at the sides of the body with the hands framing the abdomen. The subtle treatment of details by the master carver completes the figure — in every respect a major sculptural statement.

M.J.A. and D.B.

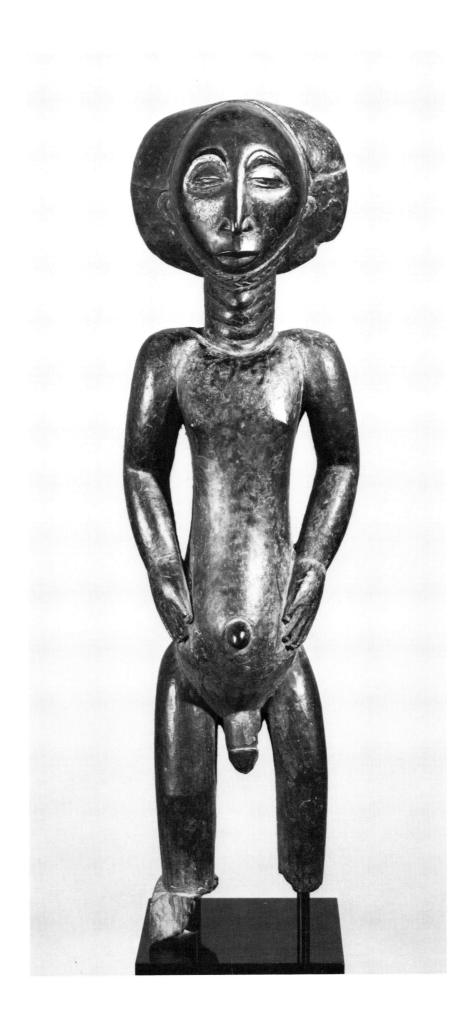

8

SIOUX

Medicine Bundle Wrapper, c. 1870

Buckskin (elk?), quill, and
horse hair, 109 x 76 cm.

Gift of Donald D. Jones in memory
of his mother, LaRue C. Jones.
81-66.

The concept that the world and everything in it
emanated power was a fundamental tenet of
the religious beliefs of the Plains Indians. A
novice learned to communicate with the forces
immanent in nature through some visionary
experience that was given tangible expression
by making a bundle containing specifically
selected items like bird feathers, animal skins,
pieces of cloth, or grasses. The contents of the
bundle served as a mnemonic device to recall
the novice's vision and thus as a channel of
spiritual communication. Such wrappers often
were called "medicine bundles" because the
combination of materials inside them was
thought to be efficacious in battle and other
pursuits.

The Nelson-Atkins medicine bundle
formerly was owned by the Elk Dreamers
Society of the Sioux tribe, whose last recorded
meeting was held in 1885. Depicted on it is a
bull elk's head with greatly enlarged horns,
evocative of strong and aggressive forces.

D.B.

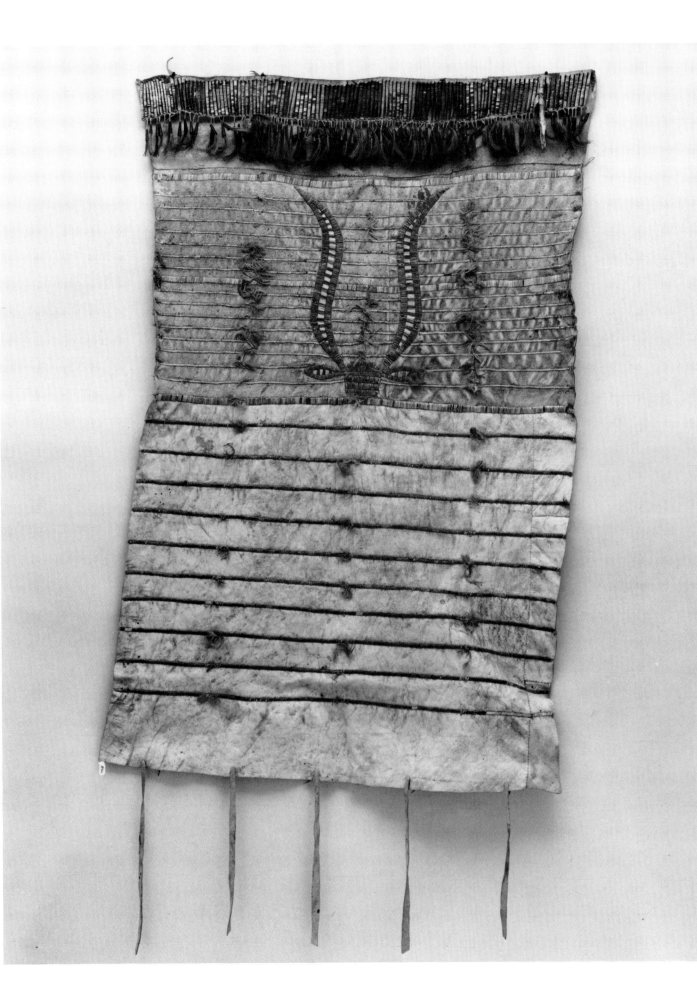

9

ANASAZI (Arizona)

Bowl, c. 1350-1400

Clay and mineral pigments,
24.1 cm. (diam.)

Gift of Donald D. Jones in memory
of his parents, Sylvan and LaRue
C. Jones. F82-53/1.

Before contact with Spanish explorers in the 16th century, several important traditions of polychrome ceramics had developed in the American Southwest. These were created by Anasazi- and Mogollon-related peoples, and are designated by names such as Pinedale, Homolovi, Showlow, and Saint Johns. One of the most famous of these styles, called "Four-Mile," flourished from c. 1350-1400 A.D. As exemplified by the bowl in this exhibition, Four-Mile artisans used a palette restricted to red, white, and black, as well as scroll and stepped motifs in imaginative asymmetrical compositions.

D.B.

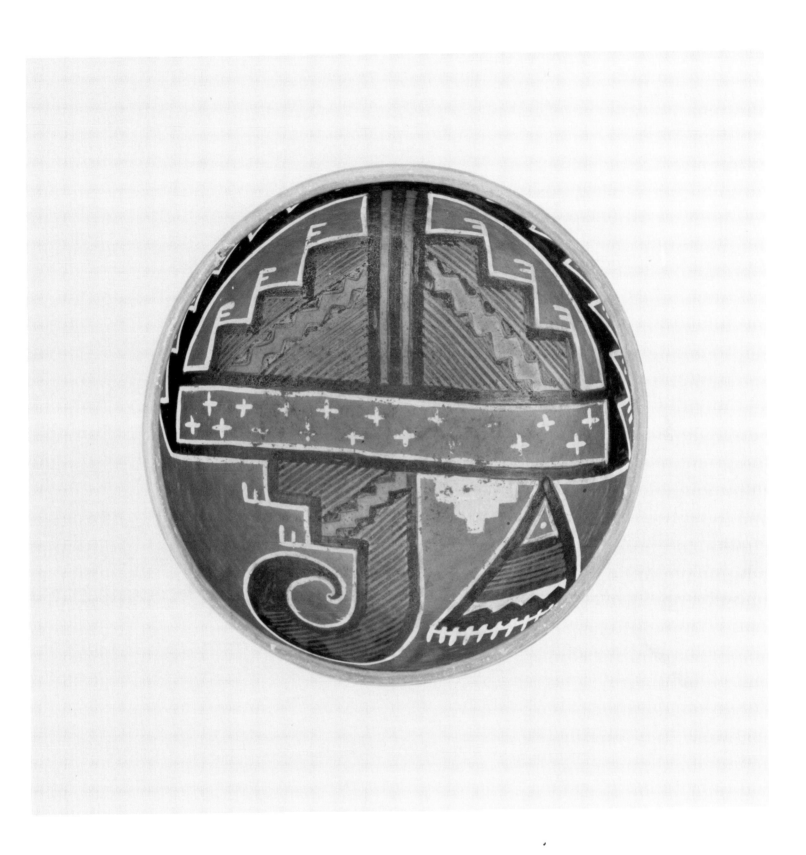

BENA LULUA (Zaire)
Standing Figure, 19th century
Wood, 47.5 cm. (h.)
Purchase, The Nelson Gallery Foundation. F84-50.

This superb figure of a pregnant woman was created by a master sculptor of the Bena Lulua (Luluwa) people, the most populous group living in the Kasai River region of Zaire. Various names are given to figures of this type, including *lupingu lua luimpe* which means "statuette of beauty and of good fortune." Among the purposes attributed to them is their use against infections of the eyes and skin; primarily, however, they are used as charms to assure the safe delivery and good health of newborn infants. According to Bena Lulua beliefs, ancestral spirits inhabiting such figures protect both pregnant mothers and newborn children. Shortly after the birth of a child both it and the mother, along with the wooden statuette, are cleansed with rain water and then covered with red powder, palm oil, and lime. These ablutions are thought to honor the ancestors and thereby to insure their continuing protection of the child. In the case of a sculpture of some age, like the present example, frequent applications of these materials have left a rich, deep patina on the surface of the sculpture that enhances it by accentuating its topography.

The figure is carved of hardwood and stands only 19-1/2 inches high. This suggests that it was made in the mid 19th century, for during the early 1880s an internal political struggle led to the suppression of sculptural images among the Bena Lulua; afterwards such figures seem not to have been made more than twelve inches in height. Despite its modest size the sculptural presence of the Nelson-Atkins figure is monumental. The skillful interpretation of the swelling organic forms is balanced by delicate surface carving which defines the eleborate scarification of the body and details of the loincloth which the figure wears. The symmetry and balance which the sculptor achieves, the sensitivity of execution, and the serenity of expression place it firmly within the classical traditions of African art.

M.J.A. and D.B.

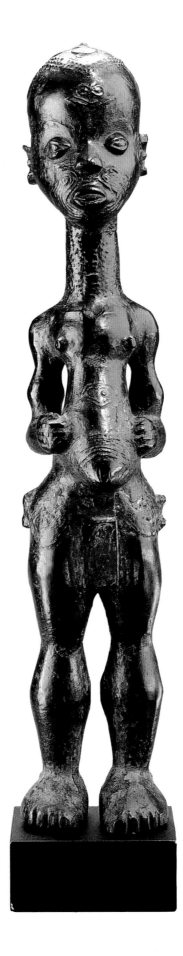

11

URHOBO (Nigeria)

Seated Figure, early 20th century

Wood, 124.6 cm.(h.)

Acquired through the generosity of George H. and Elizabeth O. Davis. F86-7.

The seated male figure is of a particular type of sculpture created by the Urhobo people of southwestern Nigeria to honor collective spirit forces. These forces, called *edjo*, are believed to inhabit natural phenomena such as lakes, rivers, trees, and even the air itself. Depending on the size of an Urhobo village, two, three, or more *edjo* are thought to coexist in the surrounding area. (More often, however, a particular spirit is identified with the community.) To honor them, figural sculpture is commissioned and placed in shrines. These may contain as many as a dozen figures representing a cross-section of the community, including chiefs, warriors, priests and priestesses, supplicants, and retainers. Associated with a shrine and its accumulated sculptures are several spiritual leaders whose responsibilities include the maintenance of the shrine: performing daily and weekly rites of consecration, as well as organizing the annual festivals that feature dances, feasts, and masquerades — all intended to honor the *edjo* and to insure its continued protection of the village.

While *edjo*-related sculptures may be made of materials including metal and clay, the most fully realized examples are the large wood carvings of seated or standing figures representing the founders of Urhobo communities. The most dramatic are depictions of the victorious warriors who are believed to have secured the territory on which a community later flourished. The figure recently acquired by the Nelson-Atkins Museum comes out of this particular tradition and was intended to glorify martial success. The monumental torso with thrusting chest and emphatically designed shoulders, fixed gaze, firmly set teeth and jutting jaw convey the restrained power and confidence of a mythical founder-hero of the Urhobo people. On the figure's chest is a packet containing medicinal ingredients believed to provide Urhobo warriors with the supernatural powers required for success in battle. The single bead worn at the neck indicates that the wearer is an *ovie,* or high ranking priest of the *edjo* cult, while the two strands of beads across the chest indicate membership in the association of *ohonvworen:* prosperous and influential community leaders.

Other figures by the same hand are known, including one in the Epcot Center Collection and several more in the National Museum of Nigeria. The sculpture now in Kansas City is superior to all published examples by virtue of its boldly conceived sculptural unity and careful attention to detail.

D.B.

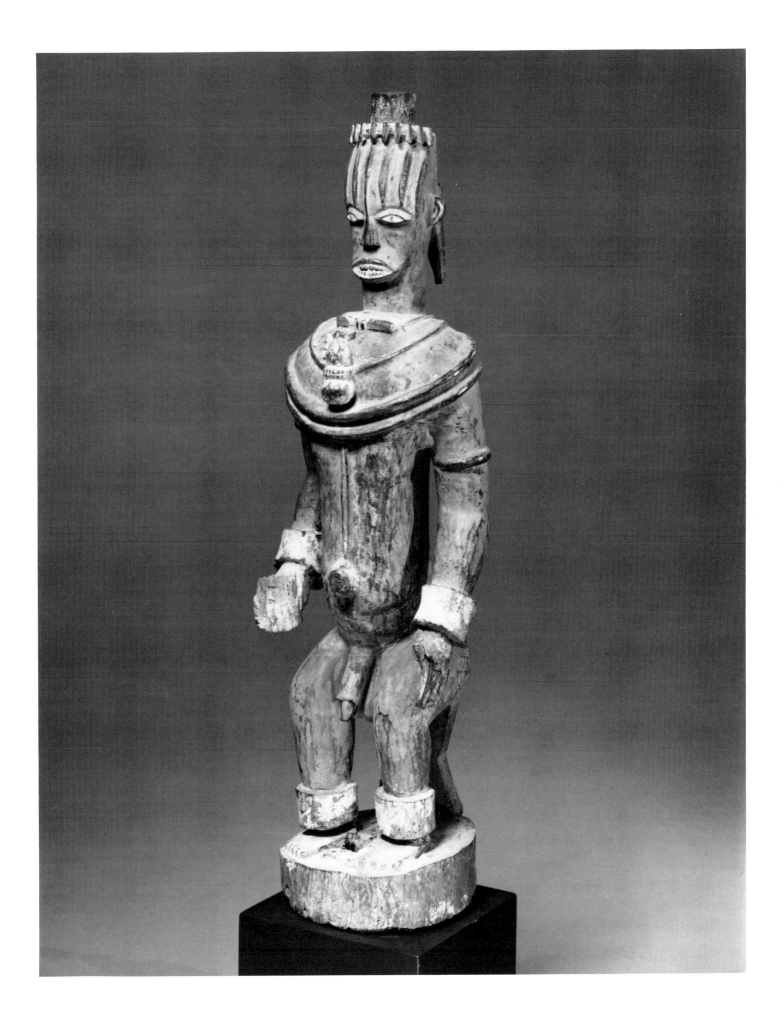

Department of Oriental Art: China, Japan, and South Asia

Donors to the Department 1977-1987

Sir Harold Acton, Kt., C.B.E.
Mrs. B.C. Altman (in memory of B.C. Altman)
Anonymous
David T. Beals III Fund
Mrs. David T. Beals Fund
Ralph A. Beebee
Mrs. E.B. Berkowitz
Mr. and Mrs. William A. Bernoudy (in honor of Laurence Sickman)
Mrs. Peter T. Bohan Bequest
Mrs. George H. Bunting, Jr.
Mrs. George H. Bunting, Jr. (in honor of Laurence Sickman)
Mrs. George H. Bunting, Jr. Bequest
Mrs. George H. Bunting, Jr. Fund
Karen Ann Bunting
Mr. and Mrs. O.G. Bunting
Mr. and Mrs. Morris Cohen
George A. Colom, M.D.
Dr. and Mrs. George A. Colom
Griffith Coombs
John M. Crawford, Jr.
John M. Crawford, Jr. (in honor of the Fiftieth Anniversary of The Nelson-Atkins Museum of Art)
George H. and Elizabeth O. Davis Fund
Mrs. DeVere Dierks (in memory of Ruth Dierks Konstantinou)
Mr. and Mrs. Richard L. Dunlap
Edith Ehrman Memorial Fund
Robert H. Ellsworth (in honor of Laurence Sickman)
Mrs. William Leon Evans
William L. Evans, Jr.
Robert and Paulina Everitt Fund
Robert and Paulina Everitt Fund (in memory of Mrs. George H. Bunting, Jr.)
Robert and Paulina Everitt Fund (in memory of Alice Mary Coleman)
Robert and Paulina Everitt Fund (in honor of Laurence Sickman)
Mr. and Mrs. Myron S. Falk, Jr. (in honor of Laurence Sickman)
The Friends of Art

Dr. and Mrs. Stanley Friesen
Mrs. Edward B. Garnett
Mr. and Mrs. O. Rundle Gilbert
Jerry L. Griggs
John W. Gruber
John W. Gruber (in honor of Laurence Sickman)
Donald J. Hall
Hall Family Foundations
Joyce C. Hall Estate
Hallmark Educational Foundation
Hallmark Oriental Endowment
Nathan Vadim Hammer
Dr. and Mrs. Peter Heinbecker
Roger Horchow
Nellie Hussey Estate
Mrs. A.W. Jank
Marion Jessup
Frederick W. and Grace R. Kaler
Frederick W. and Grace R. Kaler (in honor of Laurence Sickman)
Julianne Kemper (in memory of Mrs. M.R. Sickman)
Ginpoh Y. King
Lincoln Kirstein
Lincoln Kirstein (in honor of Laurence Sickman)
Sarah and Charles Koester
Dr. Mathias Komor (in honor of Laurence Sickman)
Dr. Robert F. Lamar Bequest
William H. McCluskey
Milton McGreevy
Milton McGreevy Bequest
Barbara Hall Marshall
Sylvia E. Matson
Mr. and Mrs. Jack May
Mrs. Irving Spencer Meinrath
Mrs. J.D. Miller, Jr.
The Morgan Gallery
The Jim Morgan Memorial Clay Collection
Frances H. O'Brien
Mr. and Mrs. Charles D. Pierce
Frederick Nelson Pugsley Estate
Barbara Forrester Rahm Bequest

Elizabeth Ann Reid
Mrs. George Reuland
A.R. Robinson
Mrs. Keller Rockey
Mr. and Mrs. J. Woodson Rollins
Joseph L. and Ann L. Sanders
Mrs. Samuel Sawyer
Laurence Sickman
Laurence Sickman (in memory of Martha Richards Fletcher)
Laurence Sickman (in memory of Mme. Paul Mallon)
Miriam Babbitt Simpson Bequest
Helen F. Spencer Bequest
Mrs. Kenneth A. Spencer
Tenkei Tachibana
John S. Thacher
John S. Thacher (in honor of Laurence Sickman)
John S. Thacher Bequest
The Uhlmann Family Fund
Charles van Ravenswaay (in honor of Mr. and Mrs. Ross E. Taggart)
Mr. and Mrs. Lloyd E. Wagner, Jr.
Mr. and Mrs. Earl D. Wilberg Fund
Mr. and Mrs. George D. Woods
Shoji Yamanaka
Wu Tso-jen and Hsiao Shu-fang (in honor of the Fiftieth Anniversary of The Nelson-Atkins Museum of Art)

12

JAPANESE

Kamakura Period (1185-1333)

Striding Lion: Mount for the Buddhist Deity, Monju, mid 13th century

Wood with extensive traces of paint, 67 cm. (h.)

Purchase, The William Rockhill Nelson Trust. 77-51

With the passage of time, Buddhism not only spread to the remotest corners of China and Japan but also changed radically as it grew in complexity and appeal. Sects, schools, and doctrines burgeoned. Some promoted salvation through simple and sincere faith, thus appealing broadly to illiterate peasants and laborers who sought refuge from lives of unrelenting misery. At the opposite end of the spectrum, Buddhism developed rarified systems of abstruse thought that sought understanding of the universe, the forces that governed it and, indeed, the very constitution of existence and knowing.

Just as Buddhist doctrine became ever more complex, so too did its pantheon. A few deities became the centers of special cults. The deity Monju had long been depicted as attendant to the historical Buddha Shakyamuni (Shaka in Japanese) in iconic representations of a triad with the Buddha in the center flanked by Fugen and Monju on either side. Following the lead of the Chinese, a cult centering on Monju grew up and flourished in Japan from the 12th through the 15th centuries. Monju was shown alone as the principal and exclusive image, and for the most part, he was depicted seated on the back of his identifying vehicle, a ferocious striding lion. Monju was the deity of youth and wisdom, and it is this latter symbolic attribute that was the key to the worship of Monju in Japan.

The magnificent Nelson-Atkins lion once served as a mount for an image of Monju seated on a carved wooden lotus blossom that in turn rested upon a shaft rising from the middle of the lion's back. The broken stub of the shaft may be seen in the center of the circle of lotus leaves that decorate the top of the saddle cloth. It is not known how long the image of Monju has been separated from its lion mount, but there is no trace of the image in the storerooms of the Miidera, a prominent temple near Kyoto, where the lion was found. Although it is not inconceivable that the Museum's *Lion* and its lost image of Monju were once attendants in a Shaka triad, the preponderance of circumstantial evidence suggests that they would have been placed in a small subsidiary shrine in one corner of a large temple hall.

Comparison with other surviving examples of the period leaves no doubt that a master hand was responsible for the lion in the Museum's collection. While most other examples are stiff and cartoon-like, often tending to decorative excess, the master of the Kansas City sculpture has imbued his work with a naturalism that is persuasive in all ways. The supple movement of the surfaces and sensitive articulation of anatomical details are remarkable. Limbs, haunches, and shoulders have been rhythmically coordinated to produce a sense of muscular power and motion. The massive neck and growl are convincing and lend the piece a presence that is not usually found in Japanese images of lions. Naturalism and dramatic expressiveness are hallmarks of the Kamakura Period, typified in this instance by the use of glass to make the eyes of the animal.

Also typical is the construction of the sculpture from multiple blocks of wood around a central cavity. Major seams appear beneath layers of cracked and missing paint: studying these will allow the interested viewer to retrace the artist's steps.

M.F.W.

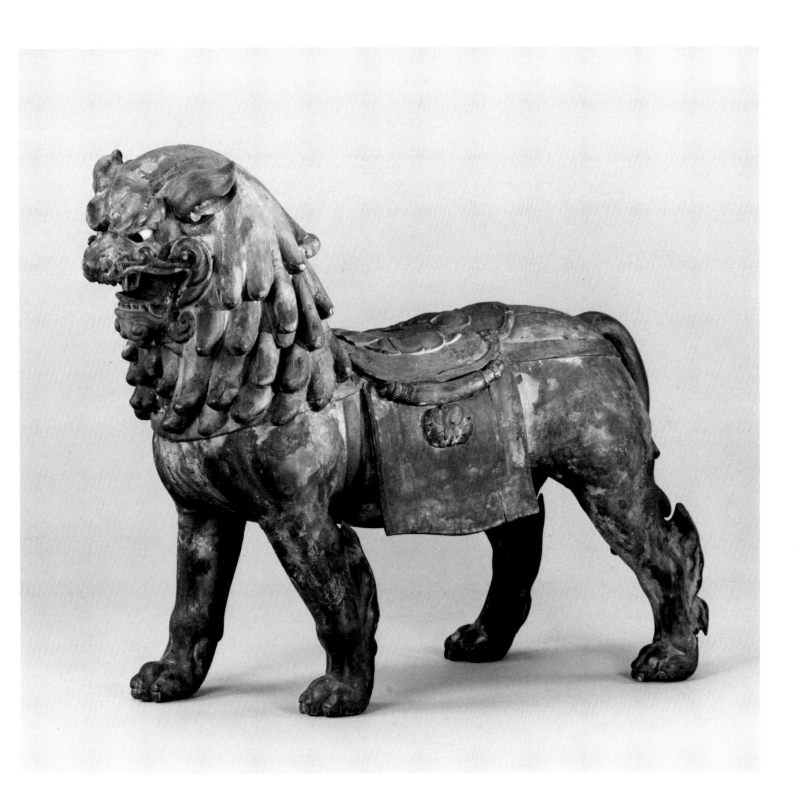

13

IZUKA TŌYŌ

Japanese, active 1760-80

Tiered Writing Box (Suzuribako)

Various lacquer techniques on wood, 21.5 x 35 x 21 cm.

Acquired through the generosity of David T. Beals III. F78-23.

Izuka Tōyō has signed his masterpiece with a three-word studio name, *Kanshosai*, in the lower right corner of one of the narrow ends of the box. Below the three gold characters appears his flourish mark in red lacquer.

Very little is known about Tōyō except for a brief mention indicating that he was active from about 1760 to 1780. Although his works are relatively rare, enough has survived to indicate a consummate craftsman who directed his skills to the production of presentation pieces that were meant to impress as technical showpieces that were not really meant to be used in a practical, everyday way.

This example falls into that category. There are no traces of actual use as a writing box. The lower two tiers are reserved for storage of paper and perhaps brushes as well. Removing the lid reveals writing equipment set into the floor of the top tier—a rectangular inkstone on which solid tablets of ink are ground with water, applied drop by drop from the spout of a small silver water container that rests in a depression next to the inkstone. Thin, ivory-handled brushes that are really more decorative than useful complete the ensemble of utensils.

Originally made for the Sō family, this writing box is noteworthy for its artistic inventiveness and technical perfection. A variety of techniques has been employed, most depending upon a suspension of gold and occasionally silver flakes and powder in the layers of lacquer, while a layer of finely powdered metal lies close to the surface, either under a transparent surface coating or within an upper layer of semi-opaque colored lacquer.

Perhaps more extraordinary than the technical perfection is the inventive use of irregular geometric zones which have been boldly disposed in striking ornamental compositions. The assertive interjection of lozenges of bold color is remarkable even for Japanese sensibilities, which have for centuries shown preference for asymmetrical ornamental design.

The motives employed by Tōyō form something of a catalogue of decorative devices. Some have sources in armor patterns. Others are borrowed from textile and paper dyers. Traditional motives drawn from the natural world, such as chrysanthemums and flying plovers, contend with clouds, snowflakes and oil slick trails. Natural motives, although recognizable as what they are, have been reduced to decorative abstractions.

M.F.W.

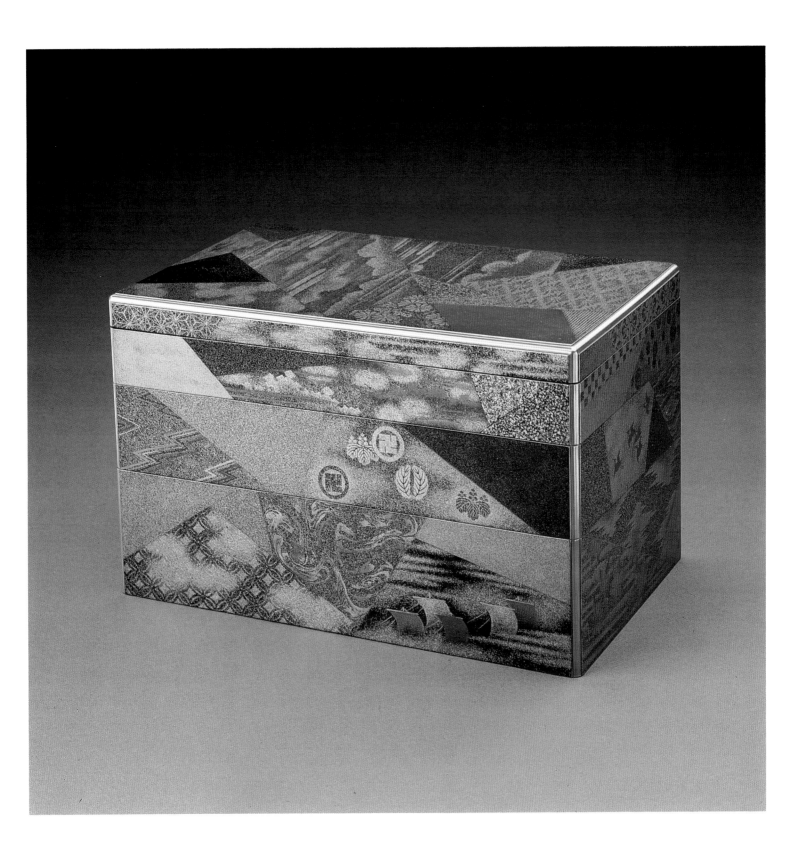

14

CHINESE LAMAISTIC
Ch'ing Dynasty (1644-1911)
The White Mahakala and Attendants,
18th century
Colors on cotton, mounted on brocade, 78.5 x 51.5 cm.
Gift of Mr. Laurence Sickman.
78-29.

This painting is an example of a painted *thanka,* the Tibetan term for a religious banner, usually on cloth, that can be rolled up. These were traditionally used as an aid for worship or meditation. The principal figure, Mahakala, is one of the great Dharmapalas or guardians of the law, demonic beings who have been incorporated into Buddhism as protectors of the teachings. His name, Mahakala, means The Great Black One, but here he has been depicted in a rare white form.

Mahakala stands within a fiery mandorla on a lotus pedestal, stepping upon two elephant-headed gods who represent the Hindu Ganesha, symbolizing for Buddhists the obstacles to be overcome by the worshipper. He wears royal garments and jewelry, but has a demonic face with a third eye and wildly upward-flying hair. His six hands hold a trident, elephant goad, skull cup containing a bottle and gems, a jewel, drum and chopper.

The Dharmapala is surrounded by many other beings, both benign and terrific. Immediately above his head is a blue Buddha, Akshobhya, one of the five great transcendental Buddhas revered in Tibetan Lamaism. In the center of the top row is Vajradhara, the Adi- or Primordial-Buddha. He is flanked by two yellow-capped monks, suggesting that this *thanka* was created within the Gelukpa or Yellow-Hat sect, a reformist group founded in the 15th century, the most important sect in recent Tibetan history.

In the upper two corners are a type of being called *yi-dam,* special protective deities who assist individual worshippers in their religious practices. These are usually depicted in *yabyum,* that is, in union with a partner, a combination frequently encountered in Tibetan art. The male is a symbol for ritual, while the female stands for knowledge. The union of the two represents the attainment of the religious goal, the blending of one's being with the underlying Reality of the universe.

A red Amitabha, the transcendent Buddha of the West, sits next to the *yi-dam* at the upper left, and a benign white figure in *yabyum* sits in the corresponding position at the right. In the second row are the goddess, White Tara, the dharmapala Kubera, and the Green Tara. At the two o'clock position is the great bodhisattva Manjushri, holding a book and a sword.

On both sides of the principal figure are five goddesses who stand or dance. Four hold choppers and skull-cups filled with gems, while the fifth holds a drum and an elephant goad. These are flanked by tiny animal-faced figures offering gifts. Below the central Mahakala are two more Dharmapalas, a corpulent seated Kubera holding a lemon and a mongoose on the left, and on the right, a standing form of Kubera called Kalajambhala, holding a mongoose spitting out jewels.

Offerings, animals, Buddhist symbols and dancers are depicted across the bottom of the *thanka.* Near the altar are two Chinese figures. They probably are the patrons of this painting.

This *thanka* may have been produced in one of the Lamaistic temples of Peking in China. Chinese-style clouds and flowers fill the background and tiny pavilions at lower right and left are notably Chinese in style.

D.H.F.

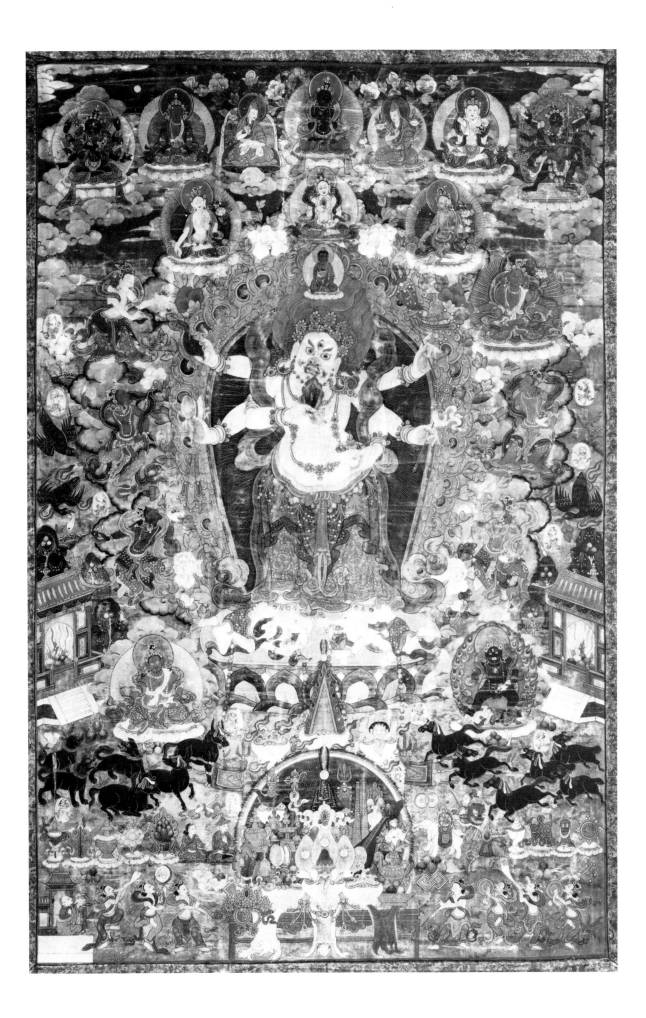

15

JAPANESE

Edo Period (1615-1867)

Apothecary's Bottle, c. 1670-80.

Arita ware. White porcelain with underglaze blue decoration, 38.4 cm. (h.)

Gift of Mrs. George H. Bunting, Jr. 78-39.

Despite Japan's proximity to the major porcelain producing centers of China and Korea, both of which had produced porcelain for centuries, the manufacture of porcelain appeared surprisingly late in Japan. The exact date of the first sustained production of porcelain remains uncertain and clouded in legend that associates its appearance with an immigrant from Korea named Ri Sempei, who reportedly found suitable porcelain clay near the town of Arita on Kyushu, the southernmost of Japan's five large islands.

What is important here is not so much who and precisely when, but the character of the manufacture. The earliest wares produced in the vicinity of Arita relied heavily upon Korean and Chinese prototypes. In a very short time, however, Japanese potters had succeeded in mastering a rich repertory of shapes and decorative motives that included European designs as well as a fairly full range of patterns based on Chinese types. Though native Japanese designs appeared in ever greater numbers, these did not supplant the forms and patterns borrowed from the Chinese (with whose changing fashions the Japanese remained up-to-date). The decor of the Kansas City bottle is a version of a Chinese original, but the spread of the flowers and leaves and the rapid, almost cursory, brushing of the drawing and color are distinctly Japanese.

Although the bottle shape with high slender neck and swelling belly had been common to many cultures around the globe by the 17th century, the pronounced fullness of the belly, the rapid taper of the neck and the broad foot are Japanese characteristics typical of the second half of the 17th century.

From the mid 17th century onwards, the production of porcelain on Kyushu was a matter of burgeoning international trade between the Japanese and the Dutch. During a relatively short period of 1660 to 1680, the Japanese manufactured about two and one-half million pieces of porcelain for the Dutch East India Company.

The Museum's bottle was created for this trade and found its way to Europe by way of the enterprises of Johannes Campuys (1634-95), who served as head of the Japanese post of the Dutch East India Company from 1671 to 1684. He took advantage of a practice that permitted privateering and commissioned the production of large orders for his personal trade. Our apothecary's jar bears his initials, written I.C., in underglaze blue on the foot. It is likely that the shape and decoration were specified by Campuys. The double, superimposed mouth rim, for example, bespeaks non-Japanese preferences.

M.F.W.

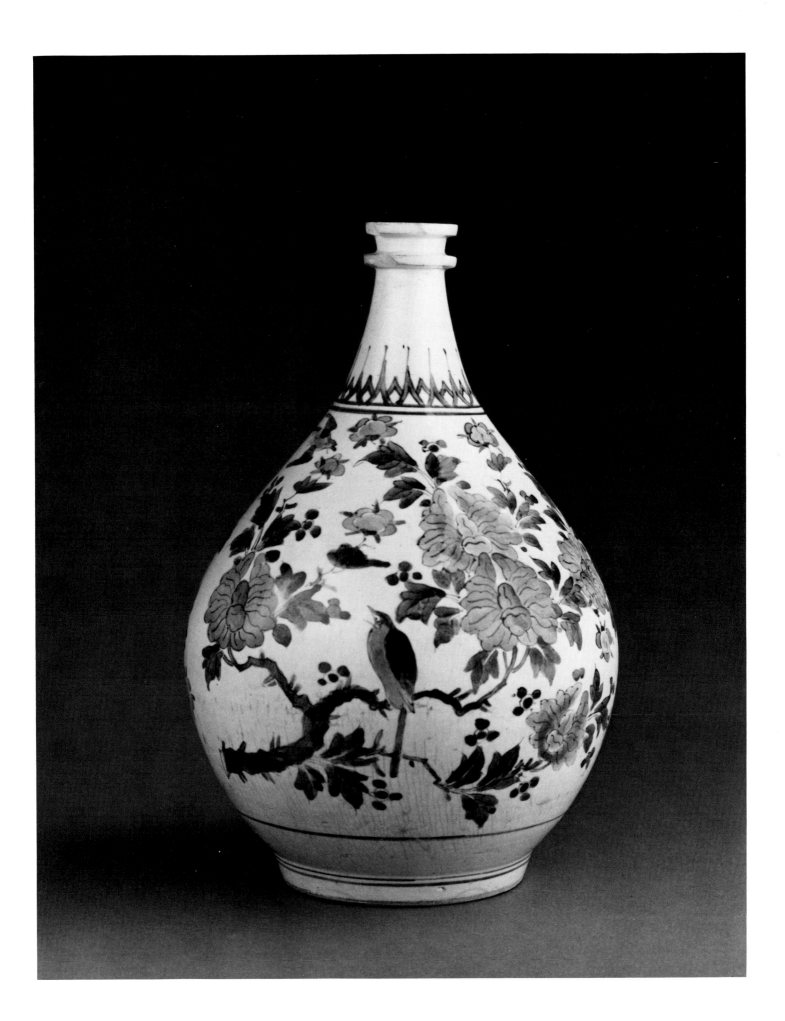

16

YAMAMOTO BAIITSU
Japanese, 1783-1856
The Plum Blossom Studio, 1846
Ink and light color on satin,
133 x 51.4 cm.
Acquired through the generosity of the Edith Ehrman Memorial Fund. F79-13.

Baiitsu, the Nanga (Southern school) painter from Nagoya whose name denotes an independent spirit as symbolized by the noble solitude of the plum blossom, was justly famous for his paintings of prunus. Born in the last phase of Japanese feudal culture, Baiitsu's lifetime came during a period of great social and political change. It was the age of Rai Sanyo (1780-1832), the prominent Confucian scholar, whose eager adaptation of Chinese literati ideals can be read as a last-ditch attempt to uphold the floundering values of feudal Japan. But it was also the age of scientific pioneers like Sugita Genpaku (1773-1817) and Ino Tadataka (1745-1818), the founders of modern Japanese medicine and geography, whose outlook on nature was grounded in objectivity and empiricism.

Baiitsu's paintings of flowers and birds mirror this age of transition. Coolly rational with a keen sense of design, while being both descriptive as well as decorative, Baiitsu's vision is unmistakably Japanese; yet his was a Japanese vision cultivated and refined by the taste and sensibility of the Chinese literati. This latter influence did not come from personal instruction by living teachers, but from Baiitsu's direct copying and emulation of Chinese models—either originals available in local collections, or reproductions found in printed manuals of painting such as the widely imitated *Mustard Seed Garden*. Since some of his models were questionable originals owned by Nagoya patrons, Baiitsu's concept of Chinese *bunjinga* (literati painting) apparently included Shen Nan-pin, the flower and bird painter of the Ch'ien-lun Period whose influence in Japan far exceeded his reputation in his own homeland. Baiitsu's great accomplishment was to transform the sleek realism of Shen Nan-pin into an art which is decorative without being showy, symbolically suggestive without being whimsical or obscure.

The Plum Blossom Studio is one of Baiitsu's finest landscape paintings. Painted on satin in pinkish shades and extremely pale tones of ink, the scene depicts the silent desolation of winter with a few warm touches of spring. Its composition was apparently inspired by a Chinese painting of the same title which was reproduced in the manual *Mustard Seed Garden*. In this image of noble seclusion, Baiitsu conveys poetic feeling with unusual plastic clarity. *The Plum Blossom Studio* is a masterpiece by one of the last 19th-century Japanese painters who maintained the fragile balance between "realism" and the good taste of the literati.

W.-K.H.

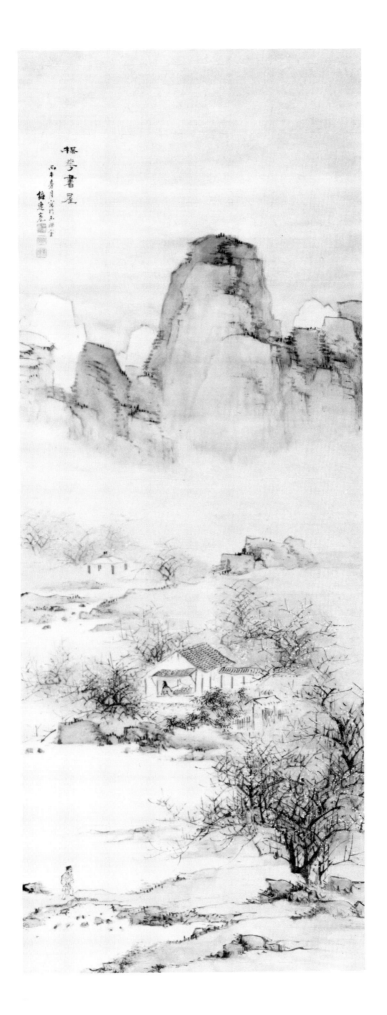

17

INDIAN (Mathura)
Kushana Dynasty (late 1st to late 3rd century)
Nagini, 2nd century
Red mottled sandstone, 159.5 cm. (h.)
Purchase, The William Rockhill Nelson Trust. 79-21.

Before the advent of Buddhism and Hinduism, the people of India worshipped a number of nature deities. Among these were the snake deities, the *naga* and *nagini*. A cult of the *naga* is attested in Indian literature, ancient shrines have been located by archaeologists, and images of *naga* and *nagini* have survived. An important center of this cult was Mathura, a site whose remains date from the 3rd century B.C. until about the 10th century A.D. An especially prolific period occurred during the first two centuries after Christ, when Mathura served as the southern capital of the powerful Central Asian Kushana Dynasty. Many Buddhist remains exist from that period, but images of *naga* continued as well.

This life-size figure of a *nagini* is a fine example of the art of Mathura. The images of that vicinity were produced from a red mottled sandstone acquired from quarries located nearby at Sikri. The goddess is depicted as an ideal woman in accordance with Indian aesthetic ideals. She has round, full breasts, a narrow waistline, and broad hips and thighs. Originally she wore a circlet of serpent heads about her own head, representing the multi-headed crown of a cobra, the usual method of depicting a snake deity in Indian art. Only a vestige of this snake hood now remains. Her legs seem to dissolve into the coils of a serpent at the base, and on the back of the image, incised lines suggest the serpent coils at the bottom and the serpent heads at the top. This *nagini* stands with her weight evenly distributed on her two legs in a rigid frontal pose. The pose and the stalwartness and heaviness of the image are derived from the earlier nature deity images of the last two centuries before Christ. Her wide-open eyes and slight smile, the type of hairdo, and the jewelry, beaded girdle and flowing scarf are all typical of the Mathura images of the Kushana Period.

D.H.F.

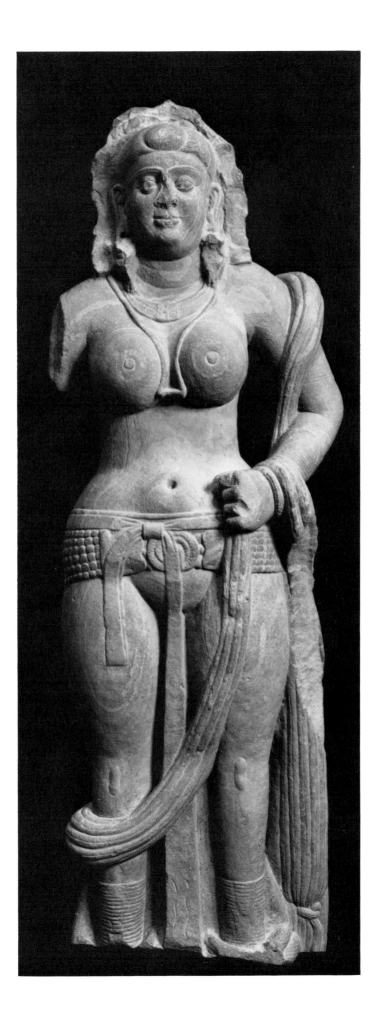

KAO CH'I-P'EI

Chinese, 1672-1734

Dancing Crane and *Bamboo Stream*, from the album *Finger Paintings of Assorted Subjects*, before 1712

Ink or ink and light color on paper, 36 x 57.5 cm. (each)

Acquired through the generosity of Mrs. George H. Bunting, Jr. F79-48/12,3.

"Individualist" painters of the 17th and early 18th century cultivated styles that were so personal and often so removed from past traditions that their works seem strange and even bizarre. While their primary interest may have been seeking new frontiers of creativity, some deliberately cultivated eccentricity in their art. Then, as now, value was accorded to the shocking and the odd. By the end of the K'ang-hsi reign (1662-1722), eccentric styles had not only been accepted but were in danger of becoming fashionable and so, in turn, facile and glib.

In much of his work Kao Ch'i-p'ei strained to affect a certain recklessness. When it failed, it fell into the crude and messy. When successful, he achieved breathtaking kinesthetic effects. Energy and form merge perfectly in his best works. In modern parlance he was something of a promoter, and he contrived a technique of finger painting whose quirkiness was doubtless the root of much of the tremendous popularity his works enjoyed. Kao used his fingers, the balls of his hands and even a fingernail which he grew long and split like a pen.

Kao was a prodigy who had begun painting as a child and achieved a considerable reputation early in life. For whatever reason, Kao was never quite satisfied with his art and life. Throughout his inscriptions and writings rings a melancholy note. Mention of depression and sadness appears over and over again.

The album of twelve *Finger Paintings of Assorted Subjects* is typical of the man and is one of his most successful creations. It was special to him, and he treasured it, as indicated in his inscription on the exhibited leaf entitled *Dancing Crane*, where he has written:

I have no way of alleviating sadness, for the only thing I can do is daub ink with my fingers. This album was set aside for a long time after it was finished. Occasionally I read the poems of the Four Ling recluses from Yung-chia. They refresh my spirit and gladden my eye. Taking out this album, I picked some lines of poetry to inscribe on the leaves. Basically, these lines do not fit with the things in the paintings. I just did it for a laugh, and it may be a help in dispelling sadness.

Early summer of the *jen-ch'en year* (1712) of the K'ung-hsi era.

In this album, Kao obviously has striven for dramatic technical and compositional effects. He has, however, restrained them so that in the end we view them as ingenious extremes of energy and elegance. The placement of the bird in *White Egret* or the spire in *A Striking Peak* are examples of extreme imbalance in asymmetrical compositions. Dash and verve inform much of his brushwork, and with notable success, as in the *Leaping Fish* and especially in *A Branch of Pine*. The painting of the bamboo foliage in *Bamboo Stream* (also included in the exhibition) provides a good impression of the staccato effects that his long, split fingernail could achieve. Most, if not all, the inscriptions were, however, written with an ordinary pointed calligraphy brush.

The album format can be exploited by the artist to produce progression or surprise through contrast and change. Kao has shown himself to be a master of the unexpected in orchestrating the viewer's experience.

M.F.W.

19

Attributed to
CH'IAO CHUNG-CH'ANG
Chinese, active late 11th/early 12th century

Second Prose Poem on the Red Cliff, after 1082

Ink on paper, 29.5 x 560.4 cm.

Purchase, The Nelson Gallery Foundation. F80-5.

A long handscroll brushed only in ink on paper, Ch'iao Chung-ch'ang's masterpiece epitomizes better than any other surviving painting the revolutionary aesthetic goals espoused by a group of late Northern Sung Dynasty scholar-painters, ones which set the underlying tone for much of Chinese criticism for the next several hundred years. This powerful new elite forged a new definition of art based on the humanistic knowledge that was the cornerstone of the new sociopolitical order. To be taken seriously as art, a painting should appeal to man's cerebral side, rather than to the superficial appeal of naturalism. Meticulous technique was avoided in favor of the primitive graphic energy which informed earlier, archaic art. According to the viewpoint of these literati, true painting did not address the general public, but was made by a chosen few for their own delectation. Chinese painting theory had thus arrived at the concept of "art for art's sake."

There were many giants among this extraordinary group of late Northern Sung scholar-official painters. History has accorded primacy to Su Shih (1037-1101) and Li King-lin (c. 1040-d. 1106). Of the two, Su was the greater genius, and one of China's foremost poets and calligraphers. His influence on the new literati painting was exercised largely through his critical writings, and it was he who composed, in 1082, the text entitled *Second Prose Poem on the Red Cliff*. Li Kung-lin's influence was felt more through his paintings than through critical pronouncements, but few genuine paintings of his survive.

No painting reveals the essentials of Li's style and epitomizes the literati movement as well as Ch'iao Chung-ch'ang's *Red Cliff*. Moving from right to left, the opening episode shows Su and his friends talking about revisiting the Red Cliff. One friend notes that he has an especially delicious fish that they could prepare. All lament the lack of wine, whereupon Su decides to pass by his home to see if his wife can remedy the situation. In the next scene, Su is at home, receiving a jar of wine which his wife had set aside for just such an occasion. Next, Su and his friends are seen seated at the foot of the Red Cliff, where waters swirl. (An archaic touch is the figure of Su, shown here on a larger scale than his friends.) Then Su ascends a twisted gorge lined with jagged boulders. As one proceeds horizontally along the scroll, the viewer travels vertically up the cliff with Su. At mid level is a dense thicket of gnarled trees through which Su must pass. (Ch'iao endows this scene with a bravura show of brushwork.) Su then rejoins his friends, and together they drift leisurely along the river. The final scene shows Su in his house asleep at the back of the room. His dream is depicted at the front of the room. In it two Taoist immortals dressed in feather capes passed by his house and asked whether Su had enjoyed his outing at the Red Cliff. Astonished, and receiving only a knowing glance to his inquiries about their identities, Su recognized that it was they who had flown over his boat.

The insistence upon plain drawing in ink derives from Li King-lin. The fluctuating brushwork suggesting cliffs illustrates the literati love of abstraction and of calligraphic brushwork. The awkwardness of Ch'iao's architectural subjects was deliberate; it stressed instead abstract graphic effects.

M.F.W.

(details)

20

JAPANESE

Muromachi Period (1392-1568)

Ewer, 15th century

Wood and Negoro lacquer,
36.2 cm. (h.)

Acquired through the generosity of the Edith Ehrman Memorial Fund. F80-25.

The term Negoro is used generically today to refer to wares having a wooden core covered with red lacquer or more rarely with a surface layer of red and black lacquer. Technically, the wooden core of the object is first covered with a thin layer of finely ground clay mixed with lacquer. Over this primer is brushed an intermediate coat of black lacquer, followed by one or more coats of red lacquer. This surface is left unpolished, and often attains decorative interest from the pattern of visible brushstrokes.

The name Negoro comes from the name of a Buddhist temple, the Negoro-dera, which was active at the town of the same name from the late 13th through the late 15th centuries. Vessels and paraphernalia for the altar as well as utensils and bowls for ordinary food service are known to have been produced there. The production of Negoro wares became widespread as their utility made them suitable for domestic use as well.

Negoro wares survive in good number from the Muromachi (1392-1568), Momoyama (1568-1614), and Edo Periods (1615-1867). This ewer is among the most pleasing of Negoro shapes. It is exceptional in the massiveness of its proportions. The high spring of the handle, the large, almost clumsy spout, and the heavy and low swelling of the body verify an early date. Smaller examples, often with crisper profiles and more refined proportions, should be assigned to the Momoyama and Edo Periods. They fail to achieve the monumentality of this masterpiece.

Slightly uneven wear that reveals the dark ground through the red surface layers is considered desirable and must be taken into account when judging a piece.

M.F.W.

21

HUNG-JEN

Chinese, 1610-1664

Pine Trees and *Mountain Crest*, from the album *Landscape Studies*, 1664

Ink on paper, 24.6 x 17.1 cm. (each)

Gift of Mrs. George H. Bunting, Jr. 80-33/1,8.

Art historians often divide painters of the second half of the 17th century and early 18th century into two camps: "Individualist" and "Orthodox." Hung-jen is classified in the former group. It would be a mistake to think that stylistic affinities abounded among those termed "Individualist." The "Individualist" can be identified by an intensely personal style that separated him, in fact, from his contemporaries and distinguished him from tradition. If stylistic links were tenuous from one "Individualist" to another, then alliance can be seen in shared concerns. All were interested in the very definition of art, in the constitution of painting as an art of creativity that mirrored creative processes of nature, in the tension between the authority of the past and the need for personal creativity in one's own time, and in the conflict they found in issues such as whether personal purity could be maintained while accepting money for the products of their art. Some owed allegiance to the fallen Ming Dynasty (1368-1644) and agonized over their culpability.

Hung-jen is usually also identified as the most prominent painter in a group called the Hsin-an School. The name refers to a major city in Anhui. There is good reason to speak of an Anhui School and the "Four Masters of Hsin-an" because common stylistic characteristics may be identified. All are indebted to the Yüan Dynasty (1279-1368) Master Ni Ts'an (1301-1374). All showed a preference for dry brush strokes, angular rock formations and certain tree types and architectural renderings.

The album of eight leaves now in the Nelson-Atkins Museum typifies the artist and also confirms the report that he died unexpectedly, only ten days after painting this album for a friend. In the leaf that depicts a pair of old pines, included in the present exhibition, the outlines of the trunks signal Hung-jen's interest in dry, grey drawing. There is a crystalline quality about much of his brushwork that leaves pine needles sharp and brittle. Applied to cliffs and other rock formations, it leaves an impression of flintiness and fracture. Trees and grains may appear delicate yet tensile. No better combination of tensile rhythms and angular dry texture can be found than in his study entitled *Rock*. Throughout his career, the expressive content of his paintings changed very little, showing always a cool detachment.

Each of the leaves has been supplied with a one-word caption by the artist; exceptionally, in the case of the *Mountain Crest* (also exhibited), he has impressed one of his seals in red cinnabar immediately below.

M.F.W.

松

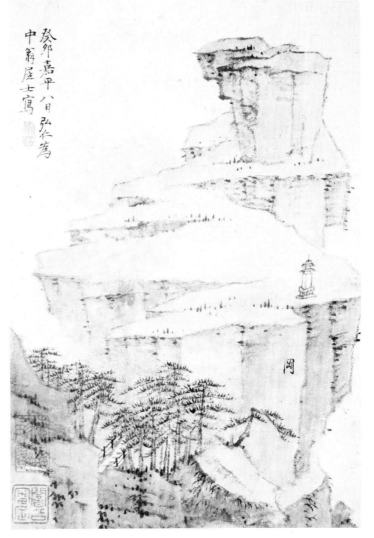

癸卯嘉平八日弘仁篤
中翁居士寫

岡

CHINESE

T'ang Dynasty (618-906)

Covered Jar, 9th century

Stoneware decorated with suffused black and grey-blue glaze, 59.2 (h.) x 24 cm. (diam.)

Acquired through the generosity of Mrs. DeVere Dierks in memory of Ruth Dierks Konstantinou. F80-34.

Universally admired for the splendor of its low-fired lead glazed funerary ceramics known as *T'ang san-ts'ai* (see cat. 30), the T'ang Dynasty was distinguished by other types of polychrome glazed pottery which are equally brilliant and were produced in the same metropolitan area around the eastern capital Lo-yang. Unlike the "three-color" lead glazed tomb figurines however, another type was made primarily for daily use; this category includes handsome jars, deep bowls, some elegantly shaped vases, and even musical instruments. The covered jar in the Museum's collection is characterized by its pale grey stoneware body of almost porcelaneous quality. The thick lustrous black glaze, which was suffused with splashes of greyish blue glaze and high-fired over a thin layer of slip to prevent excessive running and dripping, produced a strikingly decorative effect which is most pleasing to modern eyes.

Until the recent discovery of three major kiln sites in central Honan Province, little had been known about this type of polychrome glazed black ware. In the antique trade it was often labeled as T'ang Chün, suggesting its close relationship with the Chün wares of the Sung and Yüan periods. Archaeological findings have demonstrated that this designation is in fact correct, for some of the excavated pieces were actually found in kiln sites at Yü-hsien, the center of production for Chün ware in the Sung and Yüan periods. The Huang-tao yao wares therefore occupy a significant position in the history of Chinese ceramics, for they not only expanded and further refined the polychrome glaze tradition of the T'ang Dynasty; concurrently they established the crucial connection between earlier achievements and the later development of classical Chün ware, which in the 12th and 13th centuries attained one of the highest pinnacles in the long and illustrious history of the production of ceramics in China.

W.-K.H.

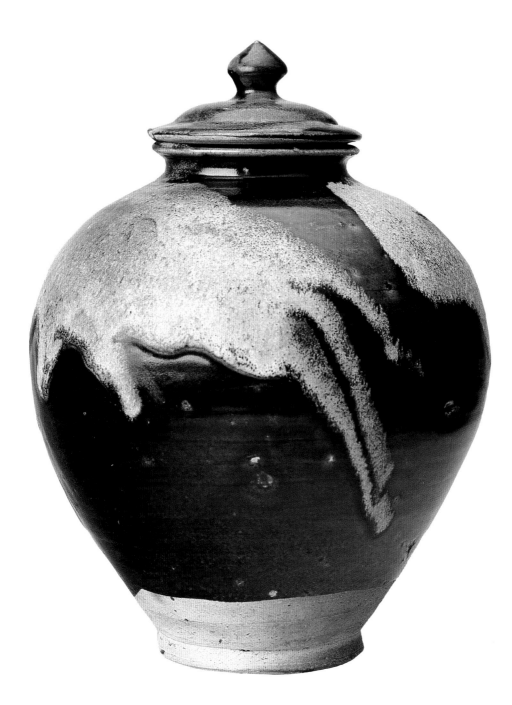

JAPANESE

Late Heian Period (794-1185) or early Kamakura Period. (1185-1333)

Half of Frame for a Temple Drum, 12th century

Wood with lacquer, paint, and gilding, 330 cm. (h.)

Acquired through the generosity of the Edith Ehrman Memorial Fund. F81-16.

Among all the creatures and characters that make up the cast of Far Eastern art, none is more distinctive than the dragon. Set amidst curling clouds, which is where dragons may be found, the dragon is the preeminent symbol of all that is positive—life, growth, air and light. The report of a dragon sighting was cause for a national celebration, for it meant that the realm was wisely ruled according to the principles of the ancient sages. Mythical and magical, this auspicious creature, a composite of the physical features of nine different animals and reptiles, captured the imagination of Asian artists and provided rich ground for artistic invention.

The facing half, which was symmetrical in all respects, disappeared long before the piece slipped out of the treasure house of a famous Nara temple into the collection of the powerful Muto family at the beginning of this century. When joined, the two halves provided a circular opening in which was suspended a large drum. The Museum's drum stand itself is enormous—almost eleven feet high. The entire ensemble of golden, flickering flames and golden dragons set amidst bright green clouds would have been set into a low stand and housed in a special pavilion or placed to one side of a great altar, there to sound the bass percussion parts in elaborate Buddhist ritual dances. The particular rituals with which this large drum was associated were confined to a handful of early temples having close ties to Chinese Buddhist theology. Practice of these rituals and the manufacture of such drum stands passed out of favor by the end of the 14th century, leaving only obscure indications about the particulars of their use.

Among the dozen or so surviving examples, this one ranks along with the very best in terms of artistic quality and state of preservation. A comparison with other surviving examples of the period suggests that the Nelson-Atkins piece and the complete stand at the Tachibana-dera should be considered products of the same hand.

M.F.W.

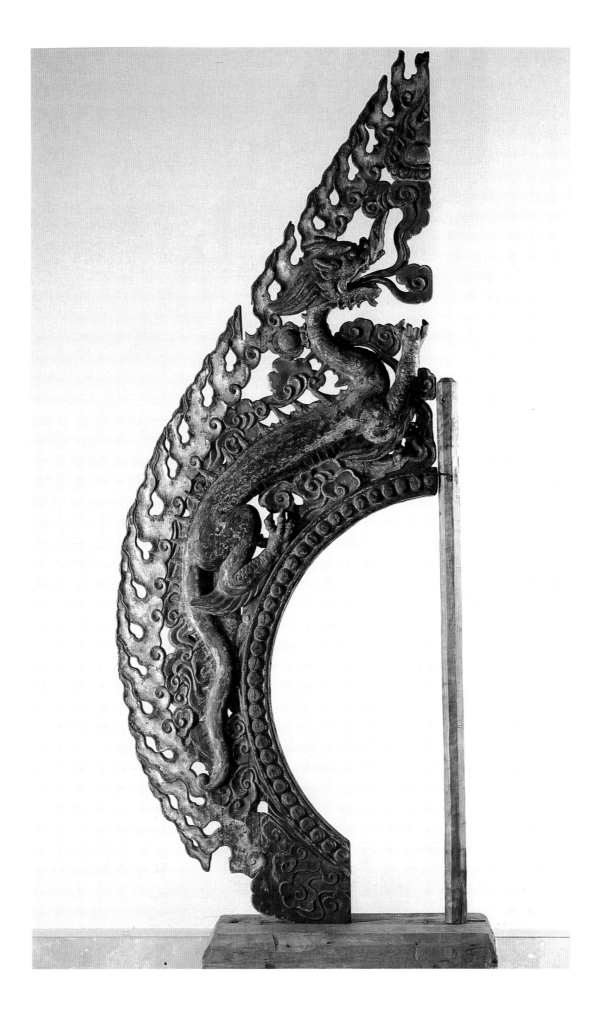

JAPANESE

Edo Period (1615-1867)

Dish with Everted Rim, second half of 17th century

Arita ware, Imari type. White porcelain with fishnet design in underglaze blue, 21.7 cm. (diam.)

Bequest of Mrs. George H. Bunting, Jr. 81-27/1.

Fishnet designs were among the earliest used on wares produced at Hizen, one of the most important centers of porcelain manufacture in Japan during the Edo Period, and have remained in continuous currency. The simple attractiveness of the design, its ease of execution, and its relevance to the life of a fishing nation all combined to insure the persistence of the motif. Because of the long continuum of production, the dating of Hizen wares is particularly difficult. Earlier wares usually are recognizable by certain characteristics of the body of the porcelain and the quality of the blue underglaze, but with later pieces the process of arriving at an accurate date of execution is a more complicated one. In the present example the design is especially well drawn and covers the entire surface of the dish apart from the foot, which is marked with the crudely painted characters *Ta Ming Nien Chih.* The dish is well and thickly potted with an everted lip and a short, slightly rounded, flat foot.

E.W.

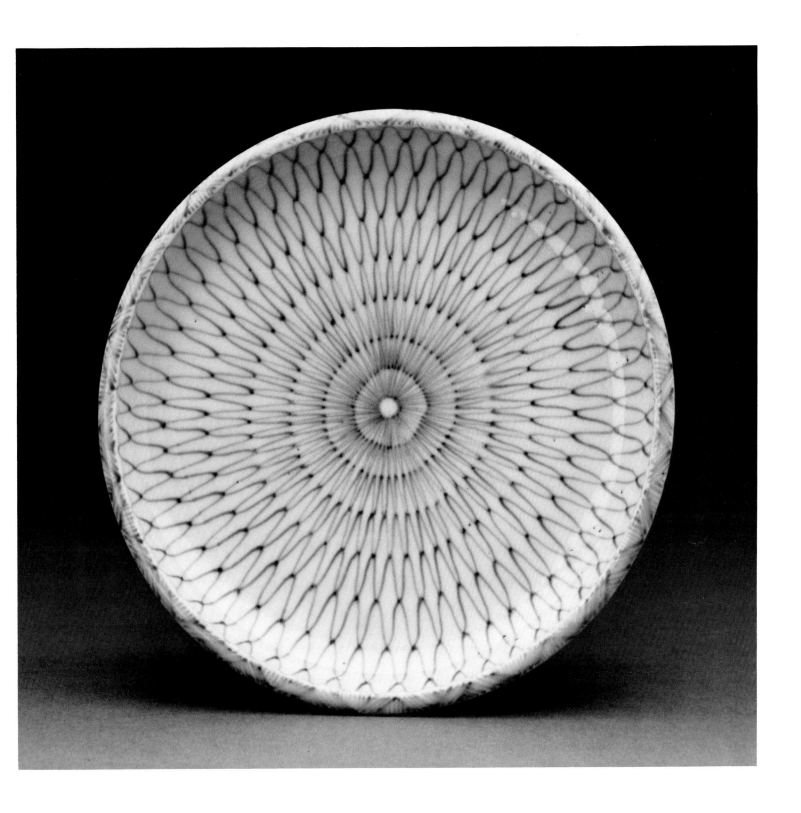

25

JAPANESE

Edo Period (1615-1867)

Shallow Footed Bowl, first half of 18th century

Nabeshima ware. White porcelain with underglaze blue and overglaze enamel decoration, 20.2 cm. (diam.)

Bequest of Mrs. George H. Bunting, Jr. 81-27/2.

In many ways Nabeshima wares can be considered the zenith of Japanese porcelain manufacture. They are technically as free of flaws as may be expected. And in aesthetic terms, the treatment of motives, composition, and colors is quintessentially Japanese. Precision and elegance with a taste, albeit restrained, for opulence mark the best of the Nabeshima kilns.

The Nabeshima family, who were Lords of Saga Province, established a kiln in 1675 at Okochi, located a short distance north of the city Arita on Kyushu, the southernmost of Japan's major islands. It was here that this boldly but elegantly decorated bowl was produced, probably between 1710 and 1740.

Our bowl typifies Nabeshima ware at its very best. The shallow bowl, which has been crisply shaped to form a perfect section of a sphere, rests upon a high circular foot. The combination is the most common shape in Nabeshima porcelain. This shape also appears in a size about ten centimeters large and in a reduced version having a diameter about six centimeters smaller. Small oblong footed dishes and large bottles round out a limited repertory of shapes.

The clay body of Nabeshima wares is fine, white, and without blemish: the best Japan could produce. Decoration generally combines underglaze blue and three colors of overglaze enamels—a muted iron red, a fresh yellow, and an aqua green. Apart from depicting major design motifs, underglaze blue provided the outlines and coloring guides for many motives that were to be completed in overglaze enamel. On the Nelson-Atkins dish, for example, the flowing water and the bundled rafts bobbing helter-skelter on the waves have been rendered in underglaze blue. The cherry blossoms have been drawn in overglaze red, but note that the outlines and veins of the cherry leaves show up in underglaze blue beneath the yellow and green enameling.

Native Japanese aesthetic impulses have reduced flowing water to flat bands of alternating light and dark blue. The idea of fluid movement has been subjected to the Japanese love of flat pattern, so that schematic bands mediate between the geometrically conceived rafts and the more freely and naturally drawn cherry blossoms. The ability to reduce natural elements to abstract pattern and then to juxtapose these patterns in visually dynamic ways is preeminently Japanese—a sensibility that lies behind the excellence of modern Japanese industrial design.

Blossoms floating on a passing current have long symbolized the fleeting quality of life and the transitoriness of all things. In Japan the cherry blossom was seen as a poignant example of these same notions.

M.F.W.

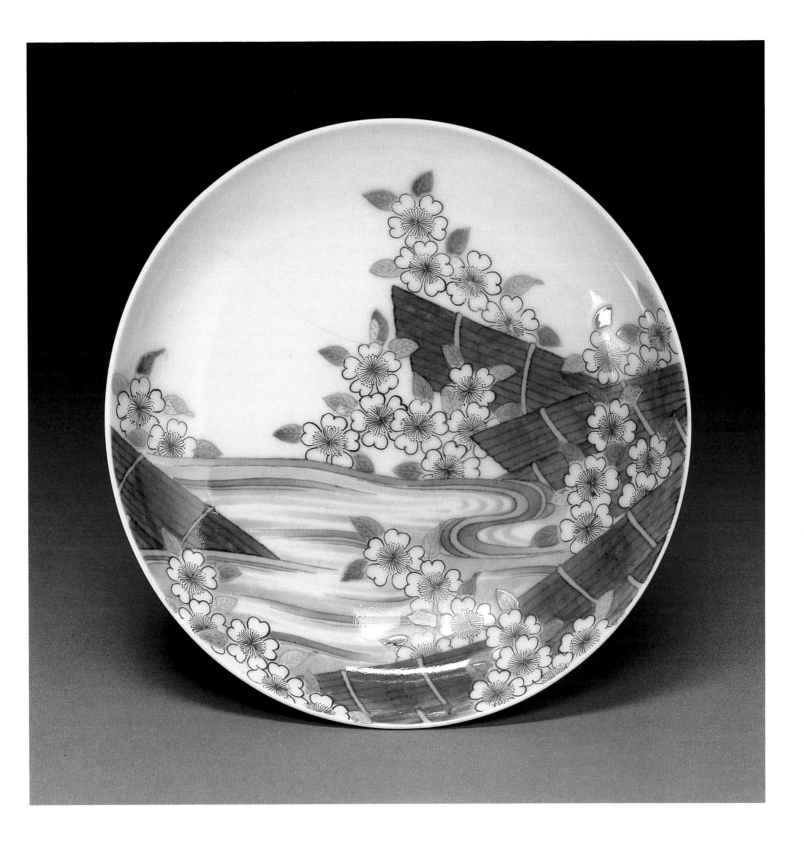

INDIAN (Amaravati)

Satavahana Dynasty (c. 130 - mid 3rd century) or Ikshvaku Dynasty (mid to late 3rd century)

Bust of a Buddha, 3rd century

Greenish limestone, 30.8 cm. (h.)

Bequest of Mrs. George H. Bunting, Jr. 81-27/25.

The earliest images of the Buddha were created in North India beginning about the 1st century B.C. In Southeastern India, the first such images, which were all in bas-relief, date to the last two decades of the 2nd century A.D. Free-standing images such as the present example appeared early in the 3rd century. These were probably set up as objects of worship around or near the Great Stupa which formerly existed at Amaravati.

The style of this image is typical of those found at this site. The hair and the low *ushnisha* (the supernatural bump on the head symbolic of the Buddha's great knowledge) are covered with flat curls that curve in a sunwise direction. The Buddha has a full, round face with open eyes, and slightly smiling mouth, and a round *urna* between his eyebrows, another symbol of his great knowledge. He also has long earlobes, another Buddha attribute. His robe covers the left shoulder only, leaving the right shoulder bare. Images in this style usually stand with the left hand held before the body, palm inward, holding an edge of the robe, and the right at shoulder level, palm outward, performing the gesture of reassurance (known as *abhayamudra)*.

Art historians traditionally labelled the sculptures from Amaravati as composed of marble, but recent tests demonstrate that the stone is actually a pale-greenish limestone.

<div align="right">D.H.F.</div>

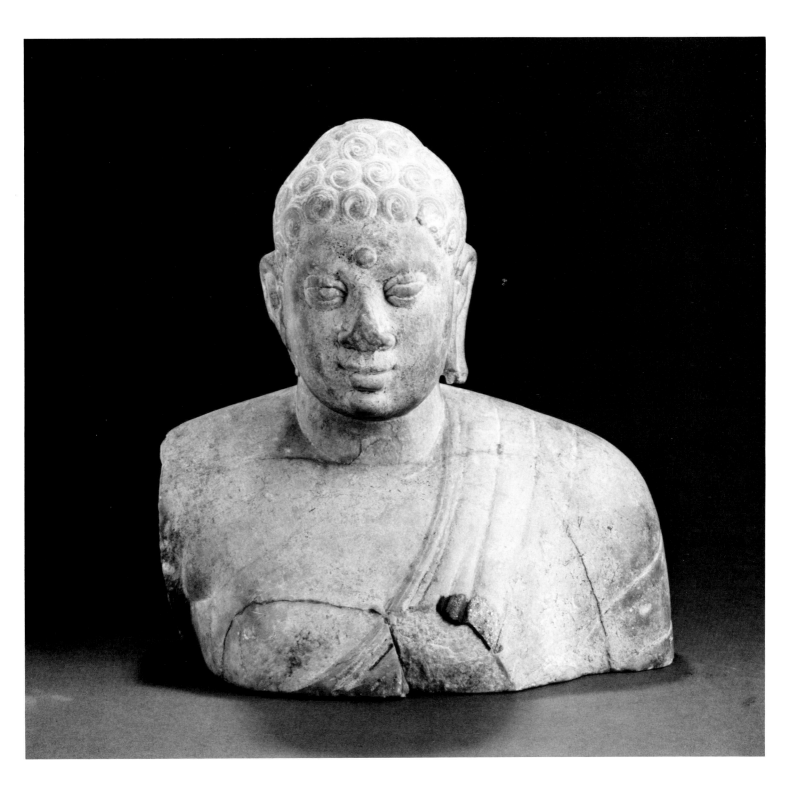

27

INDIAN (Khajuraho)

Chandella Dynasty (c. 825-1310)

A Celestial Nymph Plaiting her Hair, 10th century

Buff sandstone, 60.4 cm. (h.)

Bequest of Mrs. George H. Bunting, Jr. 81-27/26.

The entire surface of the exterior of a medieval temple in India is richly covered with sculpture, both with figures of important deities, often in niches, but also with rearing animals, minor deities, loving couples and heavenly maidens, demonstrating the rich teeming life of the universe. This beautiful maiden is one example of this class of sculpture. She stands with her back to the viewer, holding with one hand her slipping garment and with the other attempting to braid her hair, lowering her head beneath the upraised arm. A small figure pulls at her garment from below. The sensuous twists and curves of her body are beautifully accentuated. Her long thin eyebrows, elongated eyes, pointed nose and unsmiling lips are all hallmarks of this 10th-century style from North Central India.

D.H.F.

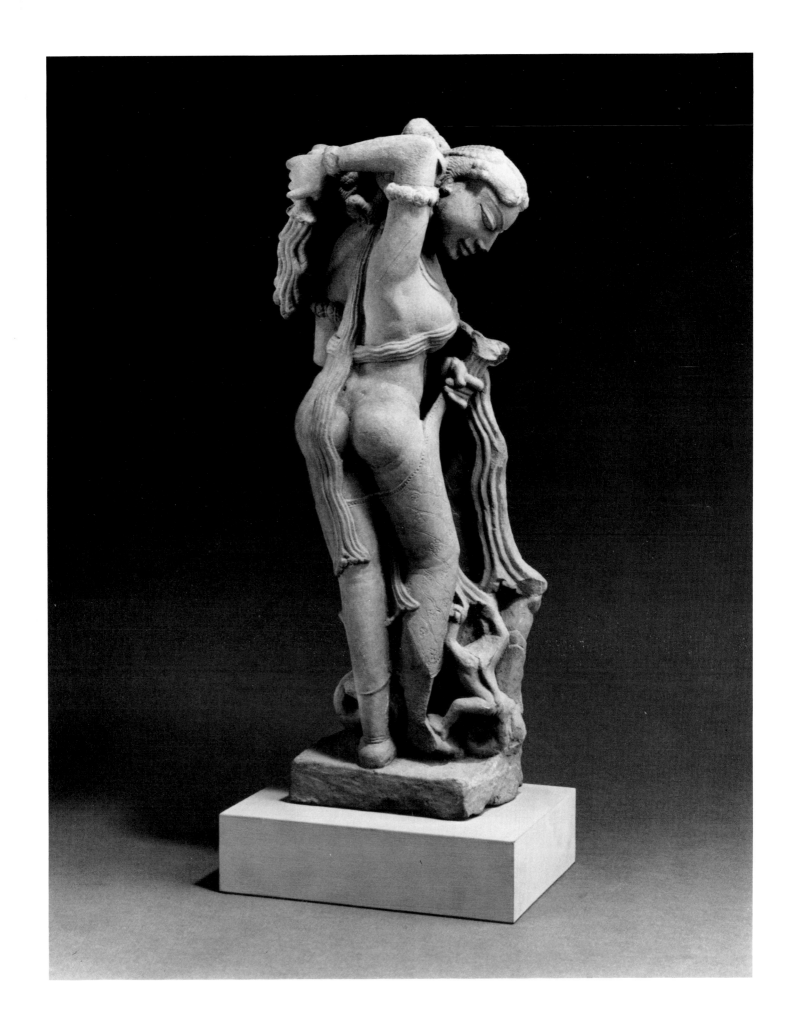

28

JAPANESE
Muromachi Period (1392-1568)
Episode from the "Pillow Book of Sei Shōnagon," 15th century
Ink on paper, 13.4 x 40.3 cm.
Bequest of Mrs. George H. Bunting, Jr. 81-27/28.

The handscroll is the oldest form of narrative illustration in the Far East. Invented by the Chinese to illustrate sacred texts, important historical episodes, and moral and literary tales, the earliest handscrolls were painted with thick colored pigments and ink on silk. When Buddhism was introduced to Japan in the 6th century and, along with it, Chinese civilization, the handscroll had become eminently suitable to continuous narrative and a naturalism which combined ideographic landscape elements with human protagonists.

Although the Japanese adopted Chinese formats and materials for painting, this fragment—cut from a much longer handscroll—shows clearly how the Japanese transformed the handscroll into something distinctly their own. To begin with, they preferred interior scenes. (The Chinese had always shied away from illustrating interiors.) This one shows a view down into some rooms, as if the roof had been removed. Beams and curtains indicate the division of space. Their angularity and the composition's extreme asymmetry have long been recognized as uniquely Japanese.

The merging of the human figure and garments into complicated geometric patterns appeared early as a characteristically Japanese representational device. While much of the aesthetic vocabulary of this painting draws upon antecedents invented in the 12th century, there is a delicacy and precision about the brushwork that reveals a master hand who worked in the early decades of the Muromachi Period (1392-1568).

There survive many versions of the *Pillow Book of Sei Shōnagon*, a diary kept by a court lady during the early 11th century. Most date from late in the Kamakura Period (1185-1333) or Muromachi Period. The absence of color, with forms confined to plain drawing in ink only, is characteristic of this group. The Kansas City version ranks at the very top by virtue of its draftsmanship which combines full-bodied strength with lightness of touch.

The picture's present form is due to the frequent practice of dealers who, in order to maximize their profits, would cut the long horizontal scrolls into fragments which were then individually mounted as vertical ones suitable for a Japanese display alcove or *tokonoma*.

M.F.W.

CHINESE

Ming Dynasty (1368-1644)

Pair of High-Back Armchairs, late 16th century

Huang-hua-li rosewood, 113 x 64.8 x 59.7 cm. (each)

Bequest of Mrs. George H. Bunting, Jr. 81-27/40a, b.

For the first three millenia of the Chinese civilization furniture played only a minor role in daily life. In the absence of an elaborate system of furniture that elevated the body and activities to heights familiar to us today, life in ancient China was lived mostly at floor level. Mats and cushions protected one from the floor and afforded a measure of comfort. Arm rests eased sitting, and low, tray-sized tables raised one's meals a few inches above the floor. These articles, though, functioned more as accessories than as the components of an integrated system of furniture.

The major exception to the above was the rectangular wooden platform, called a *ch'uang*, that placed one about twenty inches above floor level. It remained the most important element in the Chinese interior from its first appearance over twenty-five hundred years ago down to the advent of modern China. It was the focal point, the seat of honor, the locus of many daytime activities and through the T'ang Dynasty (618-906) served as a bed by night for most Chinese.

The high, straight-back chair was the next item of elevated furniture adopted by the Chinese. It was imported from the West through the agency of Buddhism and was in evidence in Buddhist disputations and meditation practices at least by the beginning of the 6th century. Curiously, despite the chair's obvious practicality, the Chinese did not begin to use it for secular purposes until an entire system of elevated furniture—including beds, tables and cupboards—was adopted with remarkable rapidity in the 10th century.

Two main traditions in Chinese furniture may be observed from this time onward. The first should be identified with complex ornamentation, ostentatious display, and conservative purposes. Decorated lacquer or elaborate carving were preferred techniques for depicting ornament. This kind of furniture was placed in throne rooms and palace reception halls, where pomp and splendor were intended. It was also deemed appropriate to religious ritual; thus sumptuously lacquered tables might have served as altar tables in Buddhist temples, in that context reminding the faithful of the grandeur of the church and the authority of its doctrine.

The second tradition, of which these chairs are perfect examples, is often referred to as classical Chinese furniture. It plays upon simple harmonious relationships of fully revealed structures. Lustrous hardwoods, particularly rosewoods, set standards in a refined taste marked by restraint. At its highest levels of aesthetic achievement, this style of furniture should be linked to the elite class of literati who dominated the society of dynastic China for its last thousand years. More specifically, it was during the 16th century that perfect, "classical" statements in Chinese hardwood furniture were made. Abstract values of proportion, weight and massing, and rhythm of line join with tactile values—grain, color and finish—as the criteria by which the quality of individual pieces may be judged.

The chairs from the Bunting Bequest to the Museum are among the most elegant armchairs surviving from this zenith of classical refinement. Their components are typical, but special is the insistence on the gentle interplay of curves in the arms and vertical members of the back. The maker has enhanced the elegance of this interplay by tapering these members and by avoiding abruptly intersected rhythms. He has employed rounded corner joins that suggest turning rather than intersection. The broad proportions of the seat and cant of the legs and side aprons induce a feeling of upward movement and "lift" that is echoed by the back. The carved decorations and burl panel of the back splat complement the restraint of the structural members with just the right touch of ornamental activity. The quality of the wood itself is unsurpassed, with the grain rich but not flamboyant. Tones of red, brown and orange blend in perfect harmony. The matting of the seat is exceptional as well in that the pattern of the weave fans out spiral-like from the center.

M.F.W.

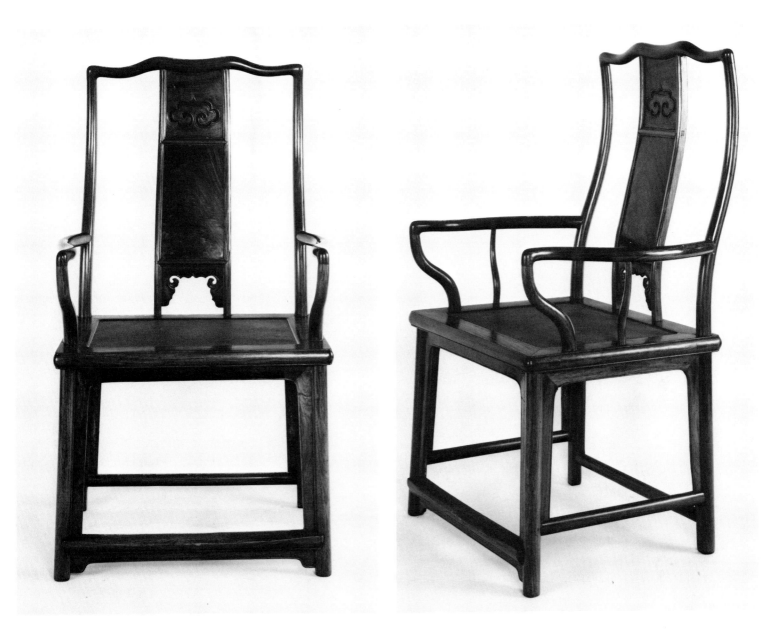

MORI SOSEN
Japanese, 1747-1821
Shussan Shaka (Shakyamuni Coming Down from the Mountains), undated
Ink and light color on paper,
107.2 x 54.6 cm.
Purchase, The William Rockhill Nelson Trust. 82-4.

Mori Sosen, the popular Edo painter renowned for his depictions of animals, epitomized the predominant trend of realism in Japanese art at the end of the 18th century. Coming from a family of painters in Osaka who maintained contact with various artistic circles, Sosen was influenced, since his formative years, by both the courtly "academic" tradition of the Kano school and the realistic, bourgeois art of the Maruyama masters. During Sosen's lifetime he was especially famous for his representations of monkeys, and forgeries of such animal paintings were frequently produced. Of the numerous works bearing his signature, there are only three known figure paintings; one of these, the *Shussan Shaka* now in the Nelson-Atkins Museum is different from all other examples in certain striking and important ways.

Unlike his *Buddha* (dated 1806) in Saifukuji, which is a precise copy of the well known painting in Tofukaji, Kyoto, the *Shaka* at the Nelson is anything but conventional. The Shakyamuni Buddha is portrayed in a startling manner, as he emerges from six years of extreme austerity in the forest of Uruvilva, having come to the realization that an ascetic life of self-denial and self-mortification would not lead to enlightenment. Unlike the usual full-length representation against a background of mountain landscape, here he is shown in a half-length format reminiscent of certain images of Daruma, the first Zen Patriarch. His wild look, unkempt hair, and overgrown beard are rendered in the same brush technique which Sosen employed for his monkey subjects. Quite possibly, the artist wished to depict the sage once more as an ordinary human being, with doubts and fears no different from those of any other person. Despite so realistic a treatment, this figure is the same Gautama Siddhartha who was destined to become the first Enlightened One; who, by coming down from the mountain, was able to transcend the world of suffering and defilement and so achieve the absolute, perfect state of *shinku* (true void) and *myou* (wondrous existence)—the marvelous nondifferentiated state of Buddhahood.

W.-K.H.

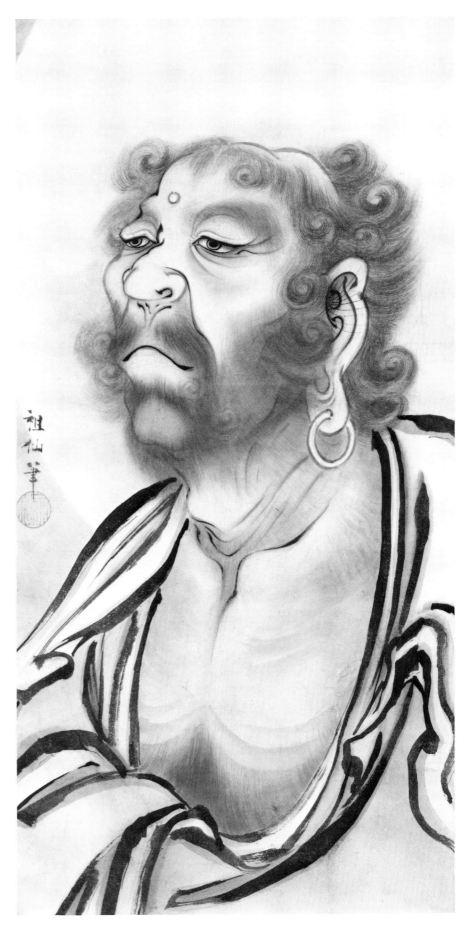

31

CHINESE

Ming Dynasty (1368-1644)

Pair of Book Cabinets (shu-kuei),
early to mid 16th century

Huang-hua-li rosewood with white
brass hardware inlaid with yellow
brass and copper, 186.7 x 93 x
52.1 cm. (each)

Acquired through the generosity
of George H. and Elizabeth O.
Davis. 82-32/1,2.

Chinese cupboards and cabinets show less variety in type and shape than do their European counterparts. Only two major categories exist in China. The first tends to be of monumental scale, often over eight feet high, and looks something like a large wooden box on short legs with all surfaces, including the doors, flush and largely undecorated.

The second major type is illustrated by the present pair of book cupboards, which are generally acknowledged to be the finest of their type. Whereas the first type is box-like, the second type emphasizes the visual distinction between frame members and the flat panels they hold.

Frame members stand out in full, rounded relief. Grooving and fluting applied to the major upright members enhance that distinction and, very importantly, accentuate the verticality created by the tall, slender proportions and inward cant of the sides. Similar detailing extends to frame members of the doors and horizontal frames of the top and bottom. The maker has not only thereby provided rhythmic reinforcement to the overall shape but also a unifying ornamental device.

In many examples, mostly of later date, visually restless panels of burl were placed in the door frame, thus exaggerating the contrast between flat and round, panel and frame. It is precisely the restraint of the present pair that contributes to their unparalleled gracefulness. The door panels are of broadly grained *huang-hua-li* rosewood whose grain has been not only matched from adjacent panel to panel but also from cabinet to cabinet. Chinese cabinetmakers generally employ inferior grades of wood for side panels. In this case, however, high grade *huang-hua-li* rosewood appears throughout, including the sides and interior fittings.

Because these cabinets are the best of their type, certain details of construction are worthy of mention. The size is unusual, being uncommonly tall and narrow. The especially high, thin legs contribute to that impression. The center stile slides out when both doors are open, thus affording unobstructed access to the removable drawers and shelves fitted inside. The use of white brass *(pai-t'ung)* hardware is rare and bespeaks the overall quality of the works. But even more special is the quality of the casting and the use of decoration inlaid with yellow brass that has, in turn, been inlaid with copper.

As with everything else about these cabinets, the state of preservation is remarkable. Chinese cabinetmakers customarily left those interior surfaces and exterior surfaces that would not be seen roughly cut and unfinished. In order to hide these crude surfaces, they applied cloth or a mud-like mixture which they then lacquered. Miraculously, most of the original pale, powdery green lacquer remains inside, while the exterior back and top surfaces, albeit cracked and a little battered, retain their original brown coatings.

The date of this exceptional pair of cabinets may be inferred from the proportions, both overall and those of specific members, the detailing, the quality of wood, the composition of the hardware, and finally, the use of green lacquer to finish interiors. Another early feature is the mode of hinging the doors. Later examples often employ surface mounted brass hinges. Early cabinets such as these form a hinge by extending the lateral vertical members of the door frame to form dowel-like projections that fit into sockets in the upper and lower horizontal frames.

Cabinets of this sort stored books, scrolls and rolled paintings. Symmetry was such an overriding principle in the arrangement of Chinese interiors that chairs, cabinets, and sometimes tables, too, were made in pairs. We are fortunate that these two superlative examples of the art of the Chinese cabinetmaker have passed through the centuries together and remain intact as a pair today.

M.F.W.

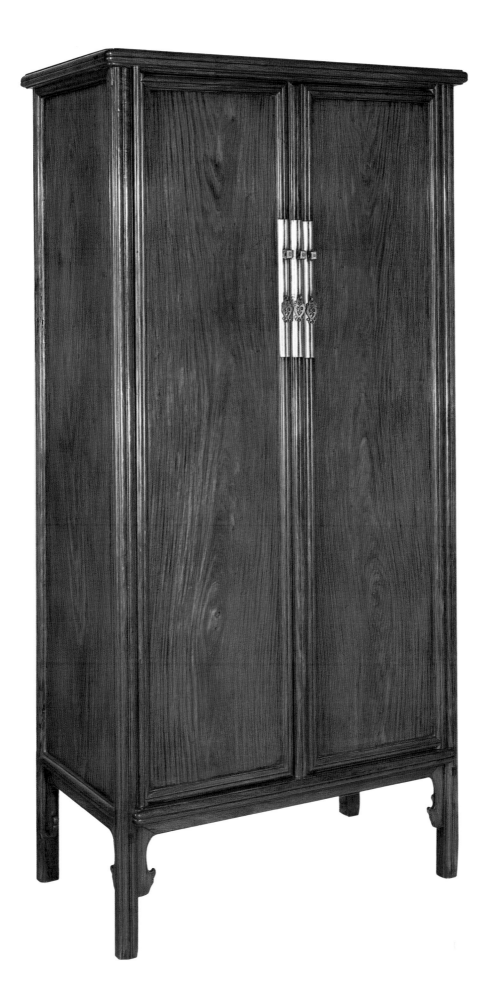

CH'IU YING
Chinese, 1494/5-1552

Fisherman's Flute Heard over the Lake, c. 1547

Ink and light color on paper,
159.7 x 84.2 cm.

Gift of John M. Crawford, Jr. in honor of the Fiftieth Anniversary of The Nelson-Atkins Museum of Art. F82-34.

Paper mattress, stone pillow and
 bamboo square bed.

The book falling off from my wearied
 hand, my noon-time dream
 wanders afar undisturbed.

Waking up from the sleep I smile
 a lonely smile to myself,

While a few notes from the
 fisherman's flute were heard over
 the hazy wavelets.

Although the great Ming painter Ch'iu Ying left no inscription except his signature on the lower right edge of this picture, there is absolutely no doubt that his painting was meant to illustrate these enchanting lines composed by the Northern Sung poet Su Shun-ch'in (1008-1048). The poet's famous garden Ch'ang-lang t'ing (Pavilion of hazy wavelets) was in Suchou, the adopted hometown of Ch'iu Ying. Every pertinent object singled out in Su's poem—the book, the pillow, the square bed, the fisherman's flute, even the boy half hidden in a side house who is making tea for the waking-up ritual after a long nap—are readily identifiable in *Fisherman's Flute Heard over the Lake*.

The mood of the painting is one of a lazy summer afternoon, reflective and self-contented. The pictorial devices are simple and uncomplicated. Ch'iu Ying has done his best to convey the literary theme of the "lonely smile" in his typically straightforward manner. The composition is superbly conceived according to the Southern Sung aesthetic principle of *hsu* (void) and *shih* (substance) with its solid forms and open spaces, its dark and light areas, with contrasting vertical and horizontal elements, and brushwork that varies from bold and broad to the most meticulous.

"Fisherman's Flute Heard over the Lake is a painting of great quality and demonstrates Ch'iu Ying's ability to combine a number of stylistic elements with consistency and freshness," wrote Laurence Sickman in 1960. "The painter, also known as Shih-chou (the ten islands of the immortals) and one of the Four Great Masters of the Ming Dynasty, more than any other of the leading Ming Dynasty painters approached the European idea of a professional artist. He held no literary degrees, served in no public office, and was neither a calligrapher nor a poet. His livelihood derived from the sale of his pictures and what patronage his art would command."

Like some professional artists of the period, Ch'iu Ying lived as a house guest with several collectors who supported him for a number of years in return for his paintings. In the years around 1547, when the artist was in his early fifties, Ch'iu Ying was known to have stayed at the T'ien-lai Ke (The Tower of Celestial Sounds) in Chia-hsing, the estate of Hsiang Yuan-pien (1525-1590), the greatest collector of the 16th century; it is thought that the *Fisherman's Flute* was created during this period. Together with a well-known handscroll entitled the *Lute Song*, the Museum's collection contains two of the most outstanding examples of two significantly different aspects of Ch'iu Ying's highly original style.

W.-K.H.

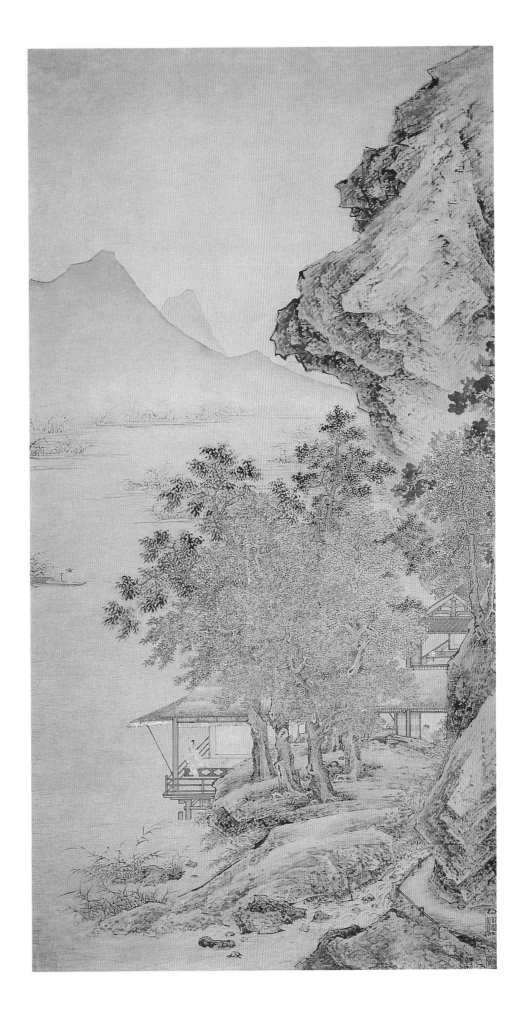

33

CHINESE

T'ang Dynasty (618-906)

Bactrian Camel with Packsaddle
c. 750-55 (not illustrated)

Glazed pottery with three-color glaze and polychrome glazes, 91.8 cm. (h.)

The Buddhist Guardian Lokapala,
c. 750-55

Glazed pottery with three-color glaze and polychrome glazes, 90.2 cm. (h.)

Acquired through the Joyce C. Hall Funds of the Community Foundation, the Joyce C. Hall Estate, the Donald J. Hall Designated Fund of the Community Foundation, the Barbara Hall Marshall Designated Fund, and the Elizabeth Ann Reid Donor Advisory Fund. F83-8/3,9.

For thousand of years, Chinese beliefs about the afterworld dictated that the dead be buried with grave goods meant to provide the deceased with the same sort of objects he or she had enjoyed on earth. When a king died, for example, the resources of the state, such as weapons, chariots, and real horses, were called upon to provide for him in the afterworld. At a very early stage in Chinese civilization the real item was buried with the dead, no matter how costly. The practice of burying the real thing with the deceased was not confined to inanimate objects or animals only. At the king's death, his ministers and warriors, concubines and slaves, were sacrificed and placed in the tomb with their leader.

Human sacrifice, however, was largely abandoned by the succeeding Chou Dynasty (1045-356 B.C.), when the concept of the substitute model *(ming-ch'i)*—made of wood or clay—evolved. This captured the essential spirit of the original, it was believed, and could serve just as effectively in the spirit world. Thus was born the long tradition of ceramic mortuary sculpture whose apogee is represented by the 8th-century examples exhibited here.

The manufacturing process of tomb sculpture plays a major role in the quality of a particular example. Almost at the outset, tomb figures were mass-produced using assembly line techniques. By the early years of the Han Dynasty (206 B.C.-220 A.D.), molds were introduced, thus allowing efficient, uniform production. The number of molds needed to complete a piece eventually increased in response to a desire for more sculpturally complex figures. Extremities, such as limbs, heads, and hands, were often cast separate from the main body of a figure, being joined to it only after firing. Later it was realized that the separately cast units could be assembled after they were removed from their molds and before firing, thereby eliminating seams and allowing for more fluid and varied shapes. It was often the practice, particularly in the T'ang Dynasty, to rework a piece by hand at this same point in its manufacture. In this way, a variety of effects could then be achieved that were beyond the capabilities of the mold process.

The most vivid examples in the Nelson-Atkins set (comprising ten figures) are the guardians. The delicate, complex projections of their armor, facial features, and the thinness of the clay of their sweeping skirts—all are the result of extensive handwork. This supplementary modeling of the figures accounts for their vitality and wonderful expressiveness. A number of very special elements may be pointed out, such as the glazing of the faces of the civil officials and of one guardian. The green bisque reserves seen on the breast plate of one guardian and on the face of the other are unique. The subtle modeling of the demons' heads and the moustaches and goatees of the civil officials are found in few other figures of the time.

The sizes of tomb figures were controlled by sumptuary regulations. The greater the status of the deceased, the larger the tomb figurine permissible. The Museum's figures are as large as any other glazed tomb figurines known from the 8th century. Because of this and their exceptional quality, it can be assumed that they probably came from one of the satellite tombs in the imperial burial ground surrounding the monumental imperial tumulus Ch'ien-ling, situated to the northwest of the modern city Sian, in Shensi Province.

M.F.W.

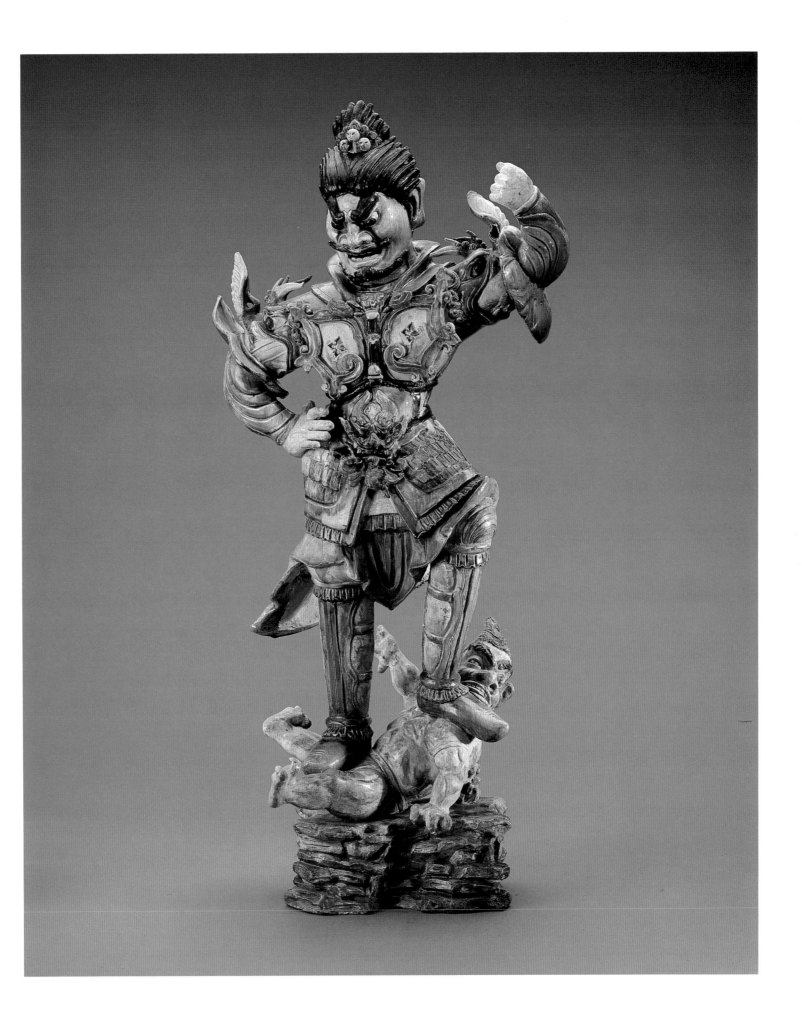

34

INDIAN

Gupta Dynasty
(319 - mid 6th century)

Relief of a Makara, 5th century

Terracotta, 24 x 38 cm.

Acquired through the generosity of Mr. and Mrs. Earl D. Wilberg. F83-38.

This spirited terracotta sculpture depicts a motif important in Indian art since the 3rd century B.C. The marine beast is used as a symbol for the sea, for water, and for all watery realms. Since the source of life is associated with the waters, the makara is also a fertility symbol. It represents the feminine, creative, nurturing aspects of life. In decoration it is often combined with a masculine symbol, such as a monster-mask, the two together signifying the creation and sustaining of the visible universe.

The makara motif began as a crocodile, but by the time of this sculpture, it had become a hybrid of many elements. The Nelson-Atkins image has the head and trunk of an elephant, the body and fin-like ears of a fish, two feline paws, and a tail that dissolves into a luxurious mass of spirals. The mouth is open, although the lower jaw is missing. It may have been spewing out an arch, a garland, or even a human being.

Frequently depicted in pairs at the end of lintels, architraves, arches, and throne backs, makaras also appear individually on medallions on gateways, balustrades, and the facades of Buddhist monuments. Pairs of makaras adorn belts, armlets, and crowns of deities. In a mask-makara combination, the mask is placed at the center of the lintel or the apex of an arch, with the makaras at either end. The sculpture now in Kansas City probably originated at the right-hand end of a lintel.

During the Gupta Period, terracotta art reached a peak in India. This dynasty erected many temples, with surfaces freely embellished with terracotta decoration. Gupta stone sculpture is renowned for its beauty, tranquillity, and abstraction. In contrast terracotta sculpture is vibrant, alive. The ductility of clay enabled the artist to give full rein to his creative imagination. Forms are softly modeled with smooth transitions from one plane to another. The deep relief permits exciting contrasts of light and shade. The vivacity of the spiral curls — a Gupta trademark — imparts a feeling of restless movement to this fantastic monster of the depths.

D.H.F.

SHIH-T'AO (Yüan-chi)

Chinese, 1641-1707

After Rain, from the *Landscape Album*, 1703

Ink and color on paper, 47.4 x 31.5 cm.

Acquired through the generosity of the Hall Family Foundations. F83-50/5.

Shih-t'ao was the greatest of the so-called "individualist" painters of the 17th century; he was also known by his Buddhist name, Yüan-chi. (The name Tao-chi commonly used in Western publications is probably a mistake.) A descendant of the Ming imperial line, Shih-t'ao was born just a few years before the fall of the Dynasty. As a youngster he took refuge in the Buddhist monastic order and spent most of his life as a monk. Torn by loyalty to his family, on the one hand, and on the other by the policital opportunism of his own church, Shih-t'ao never really made peace with himself and his religion. It has even been theorized that after 1697, when Shih-t'ao built his family Ta-ti t'ang (Hall of Great Purification) in Yang-chou, he gave up his old faith and became a Taoist. This alleged occurrence may also mark the beginning of the last phase in Shih-t'ao's art, as his steady withdrawal from reality was accompanied by an ever more complete break with artistic tradition.

One of the most important and representative of the artist's later works, this album of twelve leaves has a marvelous, almost child-like quality, matched by unusual verism and technical control. Underlying its improvisation and virtuoso effects are a structural logic, order, and design described by the artist as "the method of no method," or the "single brushstroke that engenders all brushstrokes."

In an astonishing display of rich and striking varieties of styles and brushwork, each scene in this album reveals the changing images in the mind that are analogous to the changes of the seasons. Some are tenderly lyrical while others are nervous, explosive even to the point of being brutal and crude. Leaf by leaf the viewer experiences the evolving visions of the scholar-artist: from the awakening of springtime on the rain-soaked mountainside, through the mid summer flight of fantasy over the flooding Yellow River, to the quiet of a lakeside conversation in the autumn twilight, to the wintry seclusion of the introspective scholar.

The present album, entitled *Ku-kua miao-t'i* (wonderful conception of the Bitter Melon), is dated 1703, within the last phase of Shih-t'ao's Yang-chou Period. The first published notices about it appeared in 1891 in the catalogue of the collection of its owner, Lu Hsin-yu'an (1834-1894). Toward the end of the Ch'ing Dynasty it entered the famous collection of the Manchu governor general, Tuan-fang. After the governor was assassinated, the album was acquired by the painter Chin Ch'eng. In 1926, as head of an art delegation, Chin Ch'eng brought the album to Japan, and there it stayed in private hands for more than a half century until it was purchased by the Museum in 1983.

W.-K.H.

CHINESE

Southern Sung Dynasty (1127-1279)

Boys at Play in a Garden, mid 13th century

Ink and color on silk, 173 x 99 cm.

Acquired through the generosity of the Hall Family Foundations. F83-51.

Sung painting remains the foundation for the study of Chinese painting as it survives today. It was a fountainhead that time and again refreshed later painters with inspiration.

The very subject matter of this painting epitomizes the vicissitudes of fashion. The theme of small boys, barely out of infancy, was a worthy and respected subject of painting until the 14th century. Great artists had taken it up and specialists had formed traditions of interpretation. A change in the aesthetic goals of what constituted serious art then banished this subject from the realm of "acceptable" painting.

To a mid 13th-century viewer, however, *Boys at Play in a Garden*, by an unknown painter, would have brought immediate delight. He would have recognized a hand working in an academic tradition centered on the Imperial Court in Hungchou. The precision of the drawing and its complex composition were typical of this style, as were the sumptuous colors and facile application of colored washes that depicted transparent garments and subtly modeled heads and fat little bodies and limbs. This scene also would have confirmed certain social values to the 13th-century Chinese viewer, such as the good fortune implicit in so many offspring.

This work offers a variety of beautiful passages. The canopy of flowers is remarkable for its complexity and rich coloring. The variety of animated facial expressions gives delight as each boy is seen participating in mischievous play. Admirable, too, is the painter's technical virtuosity, as in his lively but articulate brushwork and in his ability to coordinate such complex diversity into a unified composition. There is joy and humor in this work, witness such details as the revealing baby clothes and the playful cat.

M.F.W.

37

CHINESE

T'ang Dynasty (618-906)

Buddha, 8th century

Sandstone with traces of pale green pigment, 66 cm. (h.)

Acquired through the generosity of the Hall Family Foundations. F85-11.

This statue is an idealized representation of Shakyamuni, the historical Buddha who lived in India from 566 to about 486 B.C. His teachings stressed detachment from the bonds of material existence and compassion in response to the world's suffering. Only by this means was it possible to emancipate oneself from the endless cycle of life, death, and reincarnation. Although Shakyamuni had not intended to found a religion or to set himself up as a deity, a religion nevertheless developed. It was not long, moreover, before conventionalized images of the great teacher began to appear. The Nelson-Atkins *Buddha* expresses this codified Buddhist imagery, as in the figure's schematized anatomy and in individual features, like the broad, arched eyebrows and the eyes half shut in contemplation.

Although this statue is undocumented, several of its features imply a date within the High T'ang tradition. The greenish grey sandstone is identical to that of the early T'ang carvings in the caves at T'ien-lung-shan in Shansi Province. Additionally, certain motifs—such as the two feet crossed with the soles turned up and concealed within the Buddha's mantle—recall details from the sculpture at T'ien-lung-shan. The usual costume also helps to establish the sculpture's approximate date. The Buddha poses with the right shoulder bared, a sign of deference and humility according to early Buddhist monastic code. Instead of leaving the right shoulder entirely uncovered, however, the outer garment is arranged so that the bare right arm is partially wrapped and concealed under the robe. This motif was common to early Christian art, as in certain stucco images found as far east as the Hadda region of Afghanistan. Another Hadda motif is the stylized pattern of the hair, which differs from the usual "snails" or Gupta spirals. Such Indo-Roman elements are likewise found in the caves at T'ien-lung-shan.

Especially beautiful is the design of the base, in which the Buddha's robe hangs over the lotus throne. The noble rhythm of these sweeps of drapery and the harmony with which they interact with the figure itself beautifully epitomize High T'ang qualities of serenity and repose.

W.-K.H.

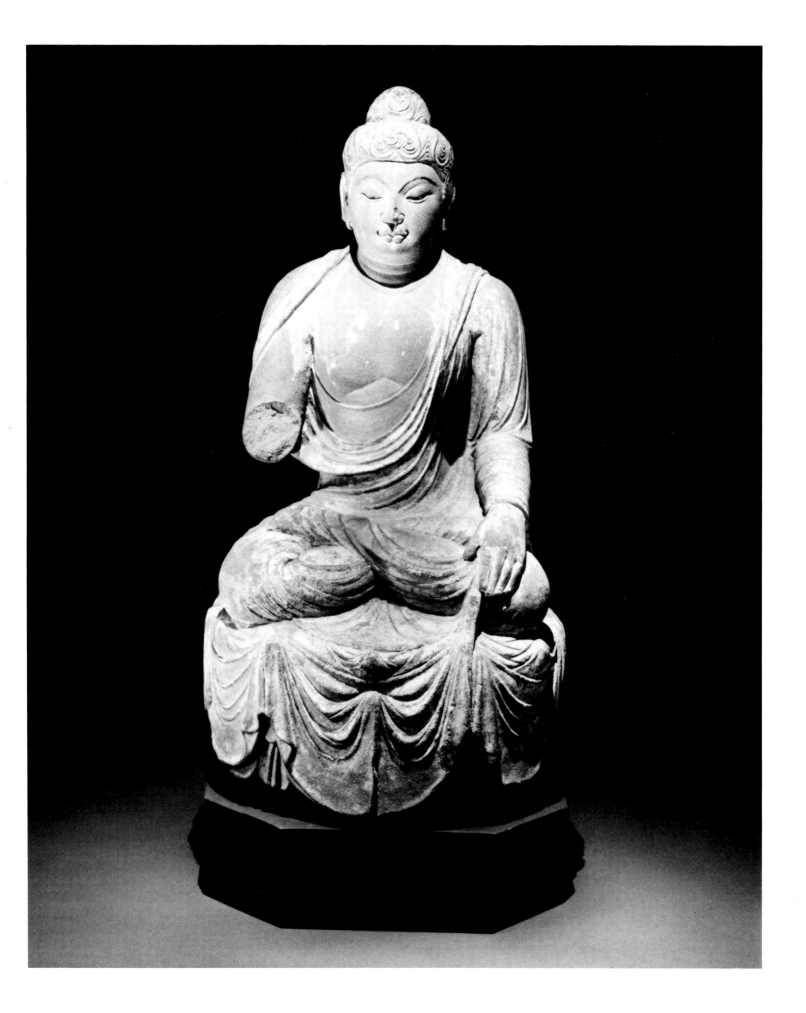

38

JAPANESE
Edo Period (1615-1867)
Covered Bowl, c. 1690
Arita ware, Kakiemon type. White porcelain with molded and overglaze enamel decoration, 14.5 (h.) x 21.3 cm. (diam.)
Bequest of John S. Thacher. F85-14/6a,b.

This outstanding example of Kakiemon ware forms part of the legacy of Chinese and Japanese art bequeathed to the Museum by John Seymour Thacher, the distinguished scholar of Oriental art, who was Assistant Director of the Fogg Art Museum from 1940 to 1946 and, after that, Director of Dumbarton Oaks until 1969.

Kakiemon ware, produced in the Arita area on the south Japanese island of Kyushu, was never meant for the domestic market. Being close to the seaport of Nagasaki, this location meant that Arita ware was exposed to the influence of imports from Ming and Ch'ing China. The introduction and mastery of an overglaze enamelling technique similar to the exquisite one practiced in late 17th-century China was the key to the development of this ware, which appeared in various stylistic forms. Essential to its production was the secret of firing with brilliant enamel colors. According to legend, the most sought-after color was that of a ripe persimmon, or *kaki*. Known thereafter as Kakiemon ware, this famous white porcelain ware soon dominated the market and was a major inspiration to the earliest European porcelain makers. The technological innovation which led to this type of porcelain has been commonly attributed to Sakaida Kizaiemon (c. 1660-1690), who was awarded the nickname "Kakiemon," a name carried on by his descendants.

The Museum's covered bowl is decorated with an incised and molded design of crested waves with floating chrysanthemums and flying plovers *(chidori)* in overglazed enamels; its interior is decorated with phoenixes and flame jewels in medallion. In overall design, it combines Chinese concepts with Yamato-e design, and the pictorial realism of the Shijo school with the originality of the Rimpa tradition. Along with nearly identical pieces in The Idemitsu Museum in Tokyo, The Cleveland Museum of Art, and the Tokyo National Museums, this bowl is one of the finest examples of the *nigoshi-de* type of Kakiemon ware, which was renowned for its lustrous "milky white" body.

W.-K.H.

39

CHINESE

Ming Dynasty (1368-1644)

Hinged Box, first half of 17th century

Lacquer with white brass inlay and frame with basketry panels, 11.5 × 41.3 × 21.6 cm.

Gift of Robert H. Ellsworth in honor of Laurence Sickman. F85-32.

This sumptous box combines three entirely different traditional Chinese materials—white brass, bamboo basketry, and lacquer—in such a manner that each sets off and complements the other two. The black lacquer panels on top and bottom stabilize the form as well as give a shiny and resonant background to the elaborately pierced white brass frame. The complex phoenix and peony decor of the brass border are mere foils for the pictorially arranged central panels on the top and bottom, representing two scenes from a marriage or engagement ceremony. The basketry of which the sides are made uses elaborate patterns of checks and twilled weave to create two layers of design and background.

Works featuring the combination or juxtaposition of the very ancient media of lacquer and elegant basketry exist from as early as the 2nd century B.C. in China, but the extensive elaboration within the severely rectilinear frame of this box is typical of a new fashion among the affluent Southern Chinese of the Ming Period. It is probable that this hinged box is the finest extant example of its type.

E.W.

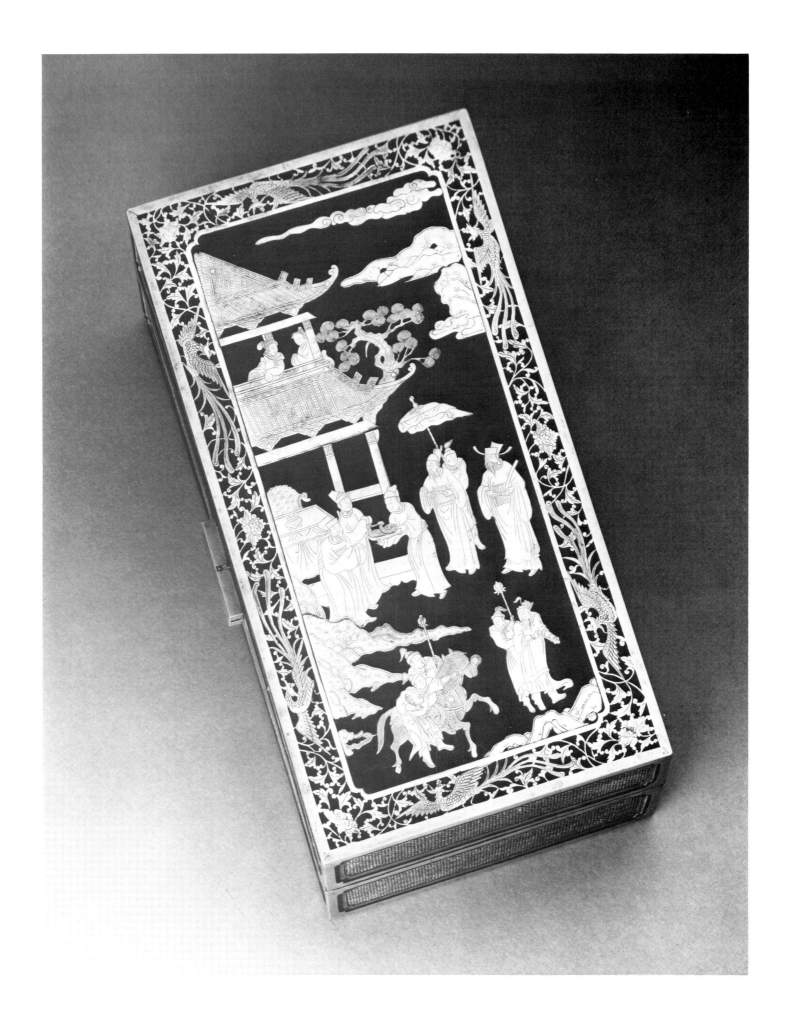

TUNG CH'I-CH'ANG

Chinese, 1555-1636

Landscape after Wang Meng and *Landscape after a Song by Yang Yung-hsui*, 1623, from the album *Landscapes in the Styles of Old Masters*, 1621-24

Ink on paper, 62.3 x 40.6 cm. (each)

Acquired through the generosity of the Hall Family Foundations, The Hallmark Oriental Operating Surplus, The William Rockhill Nelson Trust (by exchange). 86-3/3,9.

"The *Way* of painting is to be found in the master who has the universe in his own hands. Wherever he looks, he sees only life, or the potentials for life." The master who made this provocative statement was the Ming Dynasty painter Tung Ch'i-ch'ang; it succinctly summarizes his philosophy of art and style of painting. After the death of Wang Shih-chen (1526-1590), leader of the late Ming intelligentsia, Tung Ch'i-ch'ang became the undisputed dean of this circle of artists, collectors, and connoisseurs. For almost a half century he led a new critical movement which evaluated the history of calligraphy and painting and set a new course of development for both. His work influenced the taste not only of his own time but indeed for centuries to come, and as one modern critic has noted, "After him, Chinese painting was never the same again."

Tung Ch'i-ch'ang was unique for the historical consciousness which he brought to his art. It was as if he were engaged in constant dialogue with the past, acting in his role as both advocate for and heir to the line of great masters which began with the founders of his favorite "Southern school," Wang Wei and Tung Yüan. He was the last true representative of the Chinese tradition of the scholar-official artist. Furthermore, for three centuries after the time of Chao Meng-fu (1254-1322) of the Yüan Dynasty, Tung Ch'i-ch'ang enjoyed the singular distinction of claiming the double laureate for both calligraphy and painting.

His album of ten *Landscapes in the Styles of Old Masters*, from which two selected examples are included in the exhibition, is generally considered to be the equal of its magnificent counterpart in the Shanghai Museum. Three of the ten leaves, which have amazingly fresh and exuberant colors, show unmistakably the master's impact on later modes of coloring. Each leaf is supposedly an imitation of an old master—Lu Hung of the T'ang Dynasty, Li Ch'eng and Chao Ta-nien of the Northern Sung Dynasty, Chao Meng-fu, Ni Tsan and Wang Meng of the Yüan Dynasty. As in other so-called "imitations" by the painter, however, the works of these earlier masters only served as stylistic points of departure. Tung Ch'i-ch'ang then invariably transformed their compositions and elements of their brushwork into the artist's own aesthetically exciting images and provocative abstractions.

This album was first in the collection of the famous historian of the late 17th century, Wang Hung-hsu (1645-1723). It was then recorded in the catalogue, *Mo-yuan hui-kuan*, by the great Chinese-Korean connoisseur An Ch'i. After the collapse of An-Ch'i's fortune, the album was confiscated by the Ch'ing Emperor and became part of the Imperial Ch'ien-lung collection.

W.-K.H.

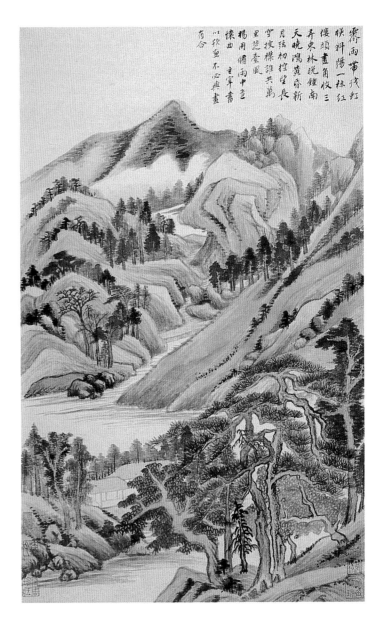

零雨帶殘虹
映斜陽一林紅
樓頭畫角收三
弄束林晚鐘南
天曉鴻莧奇新
月結初控望長
空披襟誰共萬
里楚豪風
楊用脩雨中意
懷曲主宰書
以衫魚不必與畫
有合

41

JAPANESE

Muromachi Period (1392-1568)

Shakyamuni Triad with Sixteen Rakans, first half of 15th century

Ink, colors, and gold pigment on silk, 99.5 x 39 cm. (each)

Acquired through the generosity of the Edith Ehrman Memorial Fund. F86-27.

This set of paintings illustrates a complete iconographic program of the tenets of Mahayana Buddhism and its Zen Buddhist offshoots. Shakyamuni is shown in the central panel enthroned above the clouds in Paradise. Flanking him are two bodhisattvas, the advocates of the faithful and the manifestation on earth of the Buddha's great virtues. Manjusri, seated enthroned on the back of a lion, embodies the Buddha's wisdom and spiritual insight; Samantabhadra, on his six-tusked elephant, embodies the meditative practices and active teaching of the Buddha.

In both side panels are a total of sixteen rakans, the aged and wonder-working monks who remain on earth and sustain the faith. Because of their virtue, they possess supernatural powers and are shown taming wild beasts, walking on water, and performing other deeds of spiritual and physical prowess. Because they are mortal beings and not yet fully enlightened, they are shown as distinct individuals, most of them ugly and aged as though marked by their long struggle for salvation. Some of the rakans are quasi-historic figures. As monkish ascetics, the rakans symbolized the arduous and lonely path to enlightenment in the Southern Buddhist creed, and were contrasted, as here, with the beatific and ideal grace of the bodhisattvas. In Chinese Buddhist art, rakans or disciples were relatively prominent. They had a special appeal to the Zen Buddhists, due to the rakans' emphasis upon seated meditation and self-discipline. For this reason, images of them proliferated greatly from the Sung Period on. In Japan, the spread of Zen Buddhism in the 13th century led to their becoming a major icon type. The Nelson-Atkins triptych could well have come from a Zen context, although this is now difficult to prove.

Because of its extraordinarily fine state of preservation, this triptych offers a rare opportunity to examine the painting techniques and color schemes that first became widespread in the 13th century and continued in use for several hundred years. Here, for instance, the viewer can see the effects of *urazaishiki*, the technique of applying the pigments from the back of the scroll. An example of this is the detail of the rabbit or the horse in the right-hand panel, where the more softly colored areas of the bodies were painted from the back; the brighter highlights, suggesting musculature or shading, were painted from the front. Similarly, in the deity figures of the central triad, tan (red lead) was applied from behind, and the surface was then enriched by *kindei* (gold paint) applied from the front. The red lead background gave the gold a subtle sheen; without it, the color would have been more strident. The resultant effect is one of extraordinary richness and subtlety.

The process of transmission and copying of Buddhist paintings can be illustrated by the existence of three paintings formerly in the Asada collection, Tokyo, which are unusually close to the Museum's triptych. The central portion lacks the figures of Manjusri and Samantabhadra; that of Shakyamuni and his throne are somewhat more elaborate. However, the rakans in each are almost identical, the primary difference being that the Asada triad is filled with even more circumstantial detail. Differences in execution suggest that the Asada painting is somewhat older; the two sets, though, must have come from the same atelier, or else have been very closely linked via a common prototype.

With such careful adherence to compositional and iconographic programs, paintings such as these are difficult to date precisely. The linear treatment of the clouds, the handling of the waves, and the play of light and dark—these characteristics suggest that the Museum's triad represents one of the finest of traditional Buddhist paintings from early 15th-century Japan.

W.-K.H.

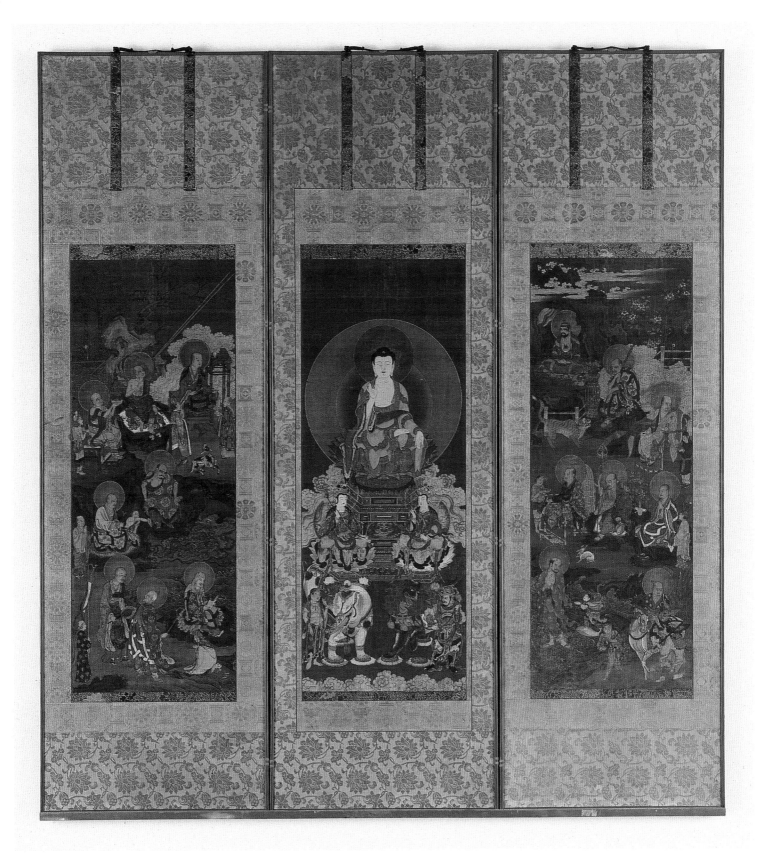

42

NEPAL

Malla Dynasty (1482-1769)

Chintamani-Lokeshvara, c. 1600

Gilt copper inset with semi-precious stones on wooden base, 25.3 cm. (h.)

Gift of Karen Ann Bunting and Mr. and Mrs. O.G. Bunting. F86-44/1.

Chintamani-Lokeshvara is the wealth-giving form of the great Buddhist bodhisattva Avalokiteshvara. The word *chintamani* means "wishing gem": the name thus alludes to his wealth-giving powers. The known images of this Buddhist deity all originated in Nepal, beginning in about the 16th century.

The bodhisattva stands in a relaxed posture with his legs crossed. His right arm is extended, holding a jeweled circlet. His left arm, at shoulder level, holds a jewelled pendant. His hair is arranged in a high chignon, topped with a jewel, and fronted with a five-pointed crown with bows and ribbons. His garment is a short *dhoti* and he wears many pieces of jewelry. A long scarf passes across his hips and up over the left shoulder, falling in cascades at the sides. On his forehead appears a round dot called an *urna,* a symbol of great knowledge.

D.H.F.

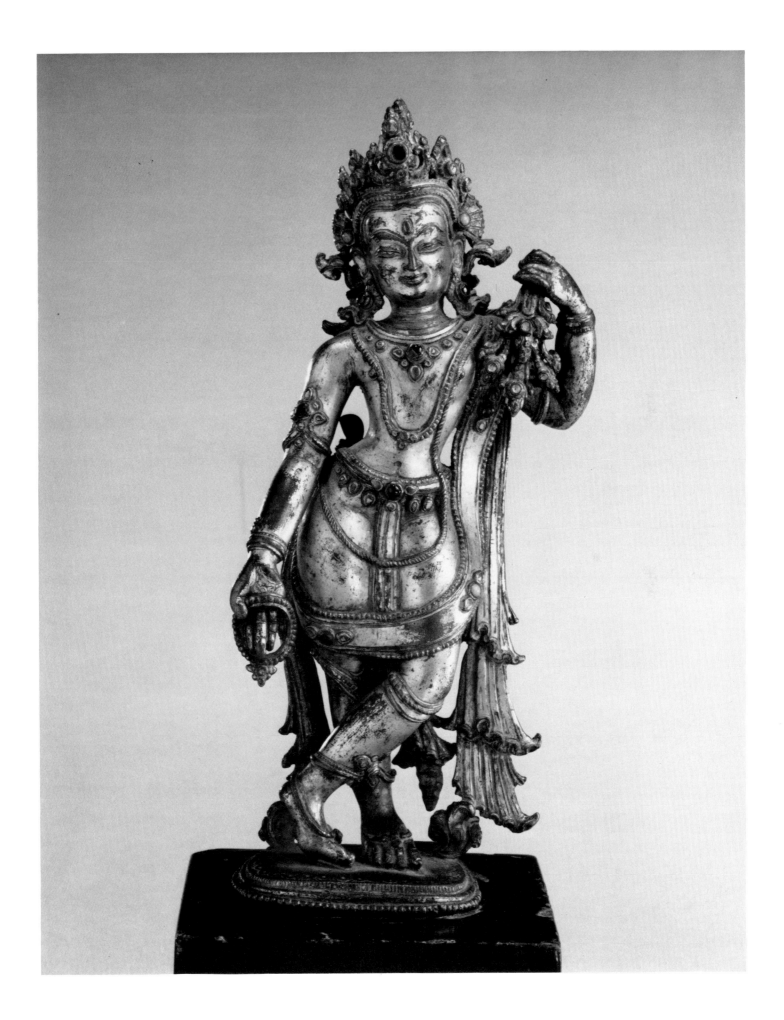

Department of European Art

Donors to the Department 1977-1987*

Anonymous Fund
Ben H. Bagby
Mrs. Thomas King Baker
Geraldine M. Barrows Bequest
Mrs. Raymond A. Barrows (in memory of Raymond A. Barrows)
David T. Beals III Fund
Elizabeth Hay Bechtel
Mrs. Ralph O. Beistle Fund
Mrs. E.B. Berkowitz Fund
Mr. and Mrs. Henry W. Bloch
Mr. and Mrs. Robert L. Bloch
Mr. and Mrs. Robert L. Bloch (in honor of Geraldine E. Fowle)
Mrs. Peter T. Bohan Bequest
W.J. Brace Charitable Trust
Cora C. Brown Bequest
Mrs. Joseph Real Brown Fund
Mrs. Edgar J. Bumsted Bequest (in memory of Mrs. Charles C. Madison)
Mr. and Mrs. John B. Bunker
Clarke S.P. Bunting (in memory of Catherine Conover Bunting)
Ruth Burrough
Margery Byram
Mrs. Henry F. Cabell
Mr. and Mrs. George R. Chatburn
Mrs. Logan Clendening Estate
Ralph T. Coe (in memory of Saemy Rosenberg)
Griffith Coombs
George H. and Elizabeth O. Davis Fund
Mr. and Mrs. George C. Dillon
Maurine F. Dillon Bequest
Mrs. Rex L. Diveley
The Rt. Hon. Lord Donaldson of Kingsbridge
John S. Doud
Mr. and Mrs. Myron S. Falk, Jr.

Mrs. Edward B. Garnett
Sophia K. Goodman
Mrs. Moulton Green, Jr.
J.V.C. Gregory
John K. Havemeyer Bequest
Jewish Federation of Kansas City
Airy Smeltzer Jones Fund
Herbert V. Jones, Jr.
Enid Jackson Kemper Memorial Fund
Mary Barton Stripp Kemper and Rufus Crosby Kemper, Jr. (in memory of Mary Jane Barton Stripp and Enid Jackson Kemper)
Mrs. Leonard Charles Kline
Joseph Kuntz Memorial Fund
Mr. and Mrs. Richard M. Levin (in memory of Marion Berger Levin)
Mr. and Mrs. Frank Lipari
Mrs. Wesley H. Loomis, Jr.
Mr. and Mrs. Charles Russell Luger
Mrs. William M. McDonald
The McGreevy Family (in honor of the Fiftieth Anniversary of The Nelson-Atkins Museum of Art)
Mrs. Edward G. McLean
Phoebe Mooney
Katherine Kupper Mosher
Mr. and Mrs. William Navran
Mrs. Herbert O. Peet
Dr. and Mrs. Nicholas S. Pickard
Mr. and Mrs. Elmer F. Pierson
Mrs. George Reuland
Elmer C. Rhoden Fund
Mrs. Franklin Studebaker Riley (in memory of Franklin Studebaker Riley)
Mary Withers Runnells Fund
Mr. and Mrs. F. Forsha Russell
Mrs. Robert Sainsbury
Neil Sellin

Mr. and Mrs. Lester Siegel, Jr.
Miriam Babbitt Simpson Bequest
Mrs. Louis Sosland
Helen F. Spencer Bequest
Helen F. Spencer Estate
Mrs. Kenneth A. Spencer
Mrs. Kenneth A. Spencer Fund
Steuben Glass
Mr. and Mrs. C. Stephen Stubbs, III
Barbara Welch Sutherland (in honor of the Twenty-fifth Anniversary of the Jewel Ball)
Robert Q. Sutherland
Charles T. Thompson Fund
The Westport Fund
Mr. and Mrs. Earl D. Wilberg
Richard A. Wood (in memory of Virginia Conklin Wood)
Mr. and Mrs. Richard A. Wood

* *The list recognizes donors to the Department of European Art, comprising all painting and sculpture from the early medieval period until the year 1900, as well as to the Departments of Ancient Art and Decorative Arts — both recently defined as areas of independent curatorial jurisdiction.*

43

PAUL GAUGUIN
French, 1848-1903

Landscape (Paysan avec un chien près d'une barrière), 1894

Signed and dated lower left:
P. Gauguin 94

Oil on canvas, 92 x 69.8 cm.

Acquired through the generosity of an Anonymous Donor. F77-32.

Following Gauguin's return in 1893 from his first trip to Tahiti, the artist again worked in the picturesque French province of Brittany. In this work the standing peasant and his dog introduce a highly stylized landscape seen beyond the fence in the foreground. The combination of these elements and the canvas's vertical format recall Gauguin's earlier Breton landscapes such as the famous *Bonjour, Monsieur Gauguin* of 1889. The same standing figure was used by the artist in his *Drame au village* (Art Institute of Chicago). The identical dog appears in his *Moulin David* in the Louvre.

The present painting is notable for its large flat areas containing clear, blondish shades of blue and green. Their total lack of chiaroscuro is symptomatic of the painter's self-declared revolt against the European naturalistic tradition. Moreover, the choice of a coarse, burlap-like support — symptomatic of his rejection of the slick polish and preciosity of conventional Salon painting — has rendered Gauguin's works unusually vulnerable to drying and flaking; yet in the present case the picture is remarkably well-preserved. It has never been lined.

E.R.

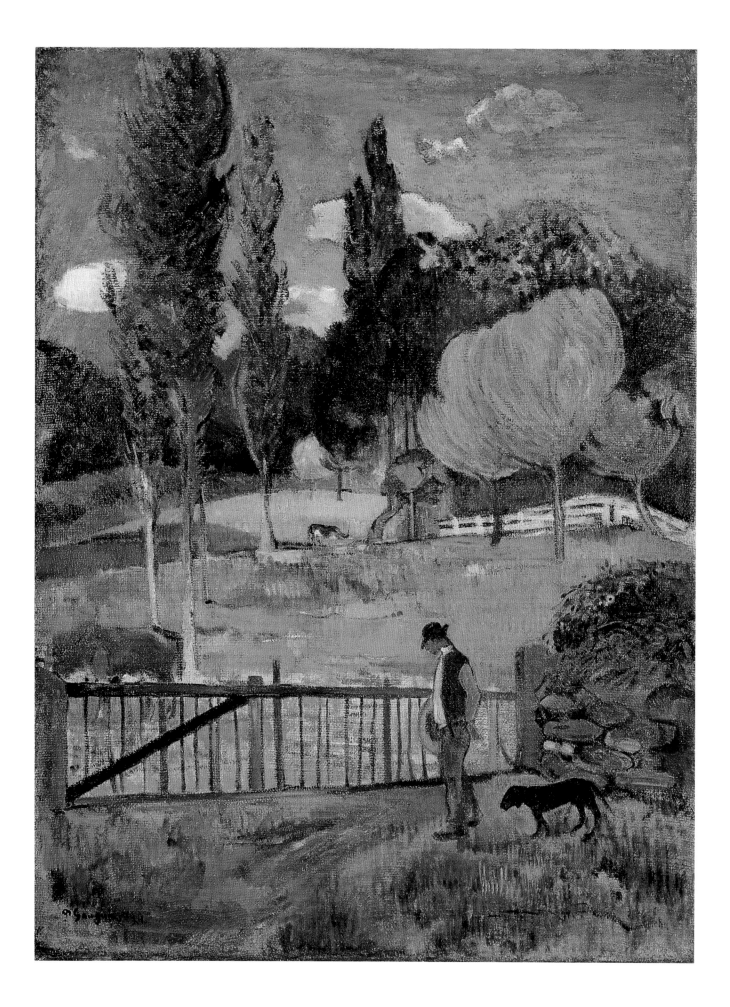

44

PAUL SIGNAC

French, 1863-1935

Le Château Gaillard, Les Andelys,
1886

Signed lower right: *P. Signac*

Oil on canvas, 63.5 x 55.3 cm.

Acquired through the generosity
of an Anonymous Donor. F78-13.

Les Andelys is a small village on the Seine between Paris and Rouen. Signac travelled there in June 1886 in the company of Pissarro's eldest son Lucien. The view here is taken from Signac's room, looking over the rooftops to the castle built by King Richard the Lion-Hearted of England in the twelfth century.

The present work is one of Signac's earliest ventures into what he called "Neo-Impressionism." Its pointillist technique — that of applying dots of primary colors in order to replicate the effects of bright light — was modelled on that of his friend Georges Seurat. He was converted to this way of painting upon first glimpsing the latter's *La Baignade, Asnières* of 1884.

One of the greatest champions of Neo-Impressionism was Felix Fénéon, the subject of an important portrait by Signac. Writing in late 1886, he praised the four canvases Signac painted that summer at Les Andelys as "the most luminous and the most complete."

E.R.

45

JEAN SIMEON CHARDIN
French, 1699-1779
Still Life with Cat and Fish, 1728.
Signed at center of ledge: *chardin*
Oil on canvas, 80 x 64.2 cm.
Acquired through the generosity of an Anonymous Donor. F79-2.

Chardin was the greatest painter of still life in the 18th century. He matriculated in the Royal Academy of Arts as a "painter of animals and fruits" on September 25, 1728, presenting as his admission piece *La Raie* (now Musée du Louvre), which astonished the Parisian art world. Despite its lurid subject matter — a disemboweled skatefish set between a prowling cat at left and a still life of pots and pans at right — critics agreed that the resultant picture was a work of utmost beauty, in terms of composition, technique and its particularly sensitive color scheme.

The present, simpler composition shares with early works, such as *La Raie,* Chardin's device of introducing a live animal at left into a static scene of inanimate objects. Its composition is both simple and masterfully controlled. The two herrings (or hakes) establish the dominant vertical element, which is countered by the horizontal lines of the table and the broad curves of the cat and salmon. A similar refinement exists in the colors, essentially a triad of green, pink and greyish white set against a monotonal backdrop. The same white and russet cat appears in The Metropolitan Museum of Art's large *Cat Stalking a Partridge and Hare.*

The Kansas City picture was executed with a pendant, the *Still Life with Cat, Ray, and Oysters,* now in the Burrell Collection, Glasgow. What are probably slightly earlier versions of these two compositions exist in the Edmond de Rothschild collection at Pregny, Switzerland, one of which bears the date 1728.

E.R.

110

GIOVANNI PAOLO PANINI
Italian, 1691/92-1765
View of the Piazza del Popolo, Rome
Signed and dated lower right:
I. PAUL PANINI/ROMAE 1741
Oil on canvas, 96.6 x 134 cm.
Acquired through the generosity of an Anonymous Donor. F79-3.

Right up until the age of railroads, the Piazza del Popolo was the main entrance into Rome for all visitors coming from the north. This "grand and noble spectacle" (as one 18th-century visitor described it) is the subject of the present painting, which is signed and dated 1741. The view, seen probably from the top of the Porta del Popolo itself, faithfully records all of the architectural features of the Piazza and its surroundings. In the left foreground is the entrance to the garden of S. Maria del Popolo, and high above is the Villa Medici and the church and convent of S. Trinità dei Monti. Isolated in the center of the Piazza, and partially eclipsing the view of the fountain of Gregory XIII immediately behind, stands the Egyptian obelisk transported there from the Circus Maximus in 1589. Across the square are Carlo Rainaldi's twin churches of S. Maria di Montesanto and S. Maria de' Miracoli. On the left horizon are visible the campanile of S. Andrea delle Fratte and the Quirinal Palace; at the right of the obelisk may be seen the cupola of the Gesù, the dome of the Pantheon, and the cupolas of S. Carlo ai Catinari, S. Andrea della Valle, and S. Agostino. From the southern end of the square, three streets — the Babuino, Corso, and Ripetta — radiate between the Pincio and the Tiber, each of them leading into the heart of the ancient city. (The present-day appearance of the Piazza is due to Giuseppe Valadier, whose renovations were carried out between the years 1816 and 1820.)

The most celebrated view painter in 18th-century Rome, Giovanni Paolo Panini was born in Piacenza, where he studied with Ferdinando Bibiena and others who specialized in painting architecture. In 1711 he was in Rome, where he became a pupil of Benedetto Luti. During his early years he established himself as an architect and as a fresco decorator of the villas and palaces of the Roman aristocracy. In 1719, Panini was elected to the Academy of St. Luke in Rome; between 1754 and 1755 he served as its Principe. Patronized by powerful French emissaries such as the Cardinal de Polignac and the Duc de Choiseul, he had a profound influence on later French painters such as Claude Joseph Vernet and Hubert Robert.

During the last thirty years of his life, Panini specialized in painting the views of Rome which secured his lasting reputation. These were of two main types, showing either imaginary views or actual places. A painting of the latter category, such as *The Piazza del Popolo,* was commissioned as a souvenir of the Eternal City. Panini often matched one view with another to create complementary pairs of uniform size and scale, the specific choice of subjects probably having been left to his clients. Thus, *The Piazza del Popolo* was, until 1970, accompanied by a pendant view of *The Piazza di S. Pietro,* today in the Toledo Museum of Art.

That this pair of Roman views should have been conceived as pendants is natural, for each represents a superlative example of the monumental public spaces which contribute to the unique character of Rome.

The popularity of Panini's views of both these sites is confirmed by the existence of multiple versions of each composition. Earlier, in 1738 and 1739, the artist had produced a fine pair of nearly identical views (now at Kenwood, London), distinguished by their cool, grey tonality, suggestive of winter light, in contrast to the 1741 canvases, which are conceived in lighter tones and a generally brighter palette. Two additional versions of *The Piazza del Popolo* were owned by Alberto di Castro, Rome and Thomas Agnew & Sons, London (as of 1961), respectively. Although unsigned, there is no doubt that both paintings were based upon drawings and sketches in Panini's studio and executed c. 1738-41. Lastly, a roughly contemporary oil sketch appeared on the New York art market some twenty years ago.

In his views of Rome, however, Panini was clearly indebted to an earlier painter, the Dutchman Gaspar Van Wittel (1652/53-1736). The latter painted at least six views of the square, one of which is dated 1680. Panini has clearly based his view of *The Piazza del Popolo* on Van Wittel's treatment of the square, adopting the same high point of view but bringing his subject closer to the picture plane to eliminate the facade of the church in the left foreground. He has compressed the length of the square, both to avoid the exaggerated sense of distance in Van Wittel's scene and to bring forward the backdrop of obelisk, fountain, and church facades.

The obvious point in which the two painters most differ is the comparative importance given to the human figure in Panini's compositions. If the primary requisite of a good topographical landscape in the 18th-century was its accuracy, the purchasers of such works were nevertheless interested in the way the scenes recalled their own experiences of foreign travel. Panini shrewdly perceived the interest of his audience in seeing itself depicted in his canvases, with the result that views like *The Piazza del Popolo* possess a social as well as a topographical dimension. Much of the charm of this urban landscape resides in the *staffage,* the coaches and horses, ladies of fashion, beggars, washerwomen, clerics, and British *milordi* traversing the great Piazza. The variety of figures Panini painted into his composition reminds us how dry and serious these topographical renderings would be without them. They also remind us what an exciting and cosmopolitan place Rome was in the middle of the 18th century.

E.P.B.

47

GIULIO CESARE
PROCACCINI
Italian, 1574-1625

The Holy Family with Saint John and an Angel, c. 1617

Oil on canvas, 189.9 x 124.8 cm.

Acquired through the generosity of an Anonymous Donor. F79-4.

Giulio Cesare Procaccini began his career as a sculptor, but by the turn of the century had turned his talents to painting. With Giovanni Battista Crespi (called Il Cerano) and Morazzone, he became one of the foremost painters in Milan during the early Baroque period. The exaggerated gestures and neutral settings in all three artists' oeuvre recall Mannerist art, yet their religious intensity and large, energized compositions (as in the Kansas City picture) are likewise Baroque in feeling, owing much to the Counter Reformation spirit propagated in Milan by Saint Carlo Borromeo.

This work, whose original destination is unknown, may properly be assigned to a date soon after 1616. By that year Giulio Cesare had delivered his *Circumcision* to the Emilian city of Modena and so had renewed contact with the elegant art of Parmigianino (1503-1540). The latter's influence is especially apparent in the heads of the Virgin and the angel at left. In contrast with Procaccini's earlier works, the *Holy Family with Saint John and an Angel* shows a more balanced composition and a greater breadth of handling — characteristics which students of Procaccini have attributed rightly to the artist's later years. Especially beautiful are the *alla prima* passages of the central figures, painted wet into wet over a dark ground, and the soft shadows which set the figures in sharp relief. The two subsidiary figures are handled with a more blurry, delicate touch so that they appear to recede naturally into the background. Procaccini's choice of colors in this important altarpiece is unique. Against an overall hue of reddish brown, the artist has introduced rich areas of deep red and medium blue and enlivened the whole relief-like composition with golden highlights (as in the hair) and swirls of white.

E.R.

48

EDGAR DEGAS

French, 1834-1917

The Milliners (L'Atelier de la modiste)

Signed and dated upper left: *1882/Degas*

Pastel on paper, 48.3 x 68.6 cm.

Acquired through the generosity of an Anonymous Donor. F79-34.

Degas has chosen here the mundane scene of a Parisian hat shop. The figure at left seems intent on a purchase; at right what is probably the sales clerk looks on. The candor with which Degas depicts this scene is enhanced by cropping of the figures and by overlapping. A beautiful effect is the contrast between the black forms of the figures, the light background, and the colorful hats passed laterally between them. Both Degas's use of cropping and the outline of dark, flat forms against a light background show the influence of Japanese prints, of which the artist was an ardent devotee.

The Milliners was included in the Eighth Impressionist exhibition of 1888. It belonged to the artist's friend Alexis Rouart and was later bought from Durand-Ruel by Mr. and Mrs. H.O. Havemeyer, whose collection of Degas pastels, drawings and oil paintings was unrivalled. The bulk of the Havemeyers' collection was bequeathed to the Metropolitan Museum of Art, New York, whereas the present pastel passed to one of their daughters, from whose son it was purchased in 1979.

E.R.

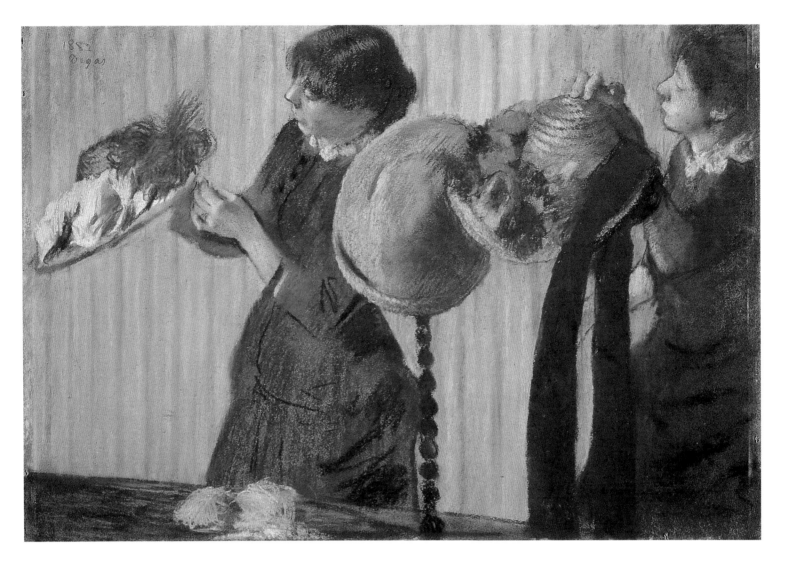

117

49

JEAN BAPTISTE CAMILLE
COROT

French, 1796-1875

View of Lake Garda, c. 1865-70

Signed lower right: *COROT*

Oil on canvas, 60 x 92 cm.

Gift of Mr. Clarke Bunting in
memory of his wife, Catherine
Conover Bunting. 80-44.

In his later career Corot executed landscapes
more in the seclusion of his studio than in his
early years when he painted to a large degree *en
plein air*. In fact Corot's one and only visit to
Lake Garda, in the north of Italy, occurred in
1834. The present painting is thus a
remembrance of this idyllic setting rather than
an on-the-spot record, presumably worked up
from early studies and infused with
recollections of Mortefontaine (a town
northeast of Paris) where Corot painted some
of his most romantic landscapes of the 1860s.
Like them, the *View of Lake Garda* is marked by
soft brushwork and silver-grey tones, and then
heightened by the smallest fleck of red forming
the lounging figure's cap. Equally characteristic
of such late pictures is the inclusion of a rustic
couple at leisure.

E.R.

50

WORKSHOP OF LEPAUTE

French

Clock, c. 1810-14

Signed on dial: *Lepaute /
h.*[orlogiers] *de l'Empereur à Paris*

Gilt bronze and marble,
61.3 x 33.3 x 15.2 cm.

Purchase, The William Rockhill
Nelson Trust. 82-8.

The design of the gilt bronze trophies and ornaments attached to the marble block so far cannot be attributed to any particular craftsman, although the relief of the Greek helmet and the twisted bugle-and-wreath motif suggest the inspiration of designs by Percier and Fontaine. Military glory, on which Napoleon's empire depended, is glorified by the *all'antica* armor, *fasces* (bundle of rods), and victory wreaths. Just possibly, the striding lion on the plaque above the Roman cuirass may provide a clue to the clock's patron or to some French military affiliation.

The clockwork itself was the product of the Lepaute workshop, which was established in the reign of Louis XV by Jean André Lepaute; the firm's direction then passed to Lepaute's brother and finally to his nephews Pierre Henry (1745-1805) and Pierre Basile (1750-1843), both of whom seem to have been named Horloger du Roi ("Clockmaker to the King") in the fateful year 1789. Appointed clockmakers to the Emperor Napoleon, the Lepaute firm continued to furnish clocks of all descriptions until the beginning of the 20th century.

E.R.

51

JEAN BAPTISTE PATER
French, 1695-1736
Le Goûter, late 1720s
Oil on canvas, 56.1 x 64.2 cm.
Acquired through the generosity of Helen Foresman Spencer. 82-35/1.

Pater, the son of a sculptor, was born in Valenciennes in 1695. In 1713 he entered the Paris studio of the great Watteau, likewise a native of Valenciennes. No doubt due to Watteau's quixotic temperament, their association was short-lived, but eight years later, when Watteau lay dying of tuberculosis, he regretted the rupture with his colleague and summoned Pater to his bedside for a final month of instruction. This proved crucial to Pater's subsequent activity, since he inherited the contents of Watteau's studio and many of the master's patrons. In 1728 Pater was elected to the Académie Royale as a painter of *fêtes galantes*; his productive and successful career was cut short by an untimely death in 1736, at the age of 41.

Le Goûter and its pendant *Les Baigneuses* (only the former is exhibited) are amongst Pater's most beautiful works and are especially well preserved. *Le Goûter* (literally, a party in the countryside) depicts a gathering of exquisitely-dressed ladies and gentlemen. Amorous couples relax on a gentle slope at the edge of a wooded grove, taking refreshments. Several of the figures are particularly reminiscent of Watteau, especially the woman in the center of the group who wears pink over green, her companion, and the blackamoor who carries a tray. The rather grand lady at the left, however, reminds us of the influence of Rubens on Watteau and his followers. (Her costume is, in fact, 17th-century Flemish in style.) The two paintings came to this country early in the 20th century and formerly were in the possession of Mr. and Mrs. John W. Simpson of New York, whose collection was especially notable for its works by 18th-century French artists.

R.W.

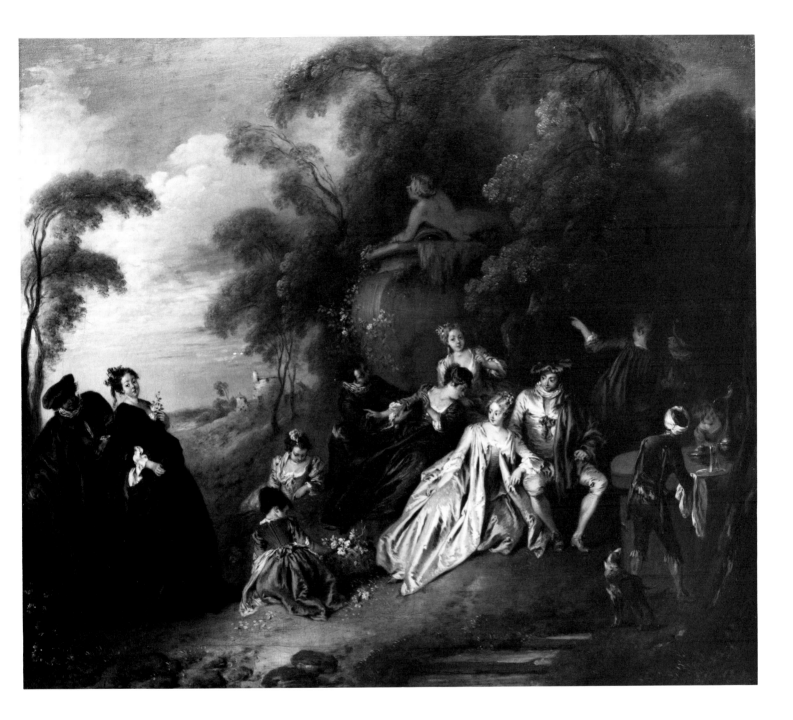

52

JEAN FRANCOIS DETROY
French, 1679-1752

A Lady Showing a Bracelet Miniature to her Suitor, 1734?

Oil on canvas, 64.8 × 45.7 cm.

Purchase, The William Rockhill Nelson Trust. 82-36/2

The French painter Jean François Detroy remains less well known to Americans than artists of the same generation—like Jean Baptiste Oudry—due to the comparative scarcity of his works in this country's public collections. Son and pupil of the eminent portraitist François Detroy, Jean François studied at the Royal Academy before an extended sojourn in Rome, Florence, and Pisa. Shortly after his return to Paris he was elected a member of the Academy. He achieved considerable success and widespread popularity with his large canvases of mythological and historical subjects and was eventually appointed Director of the French Academy in Rome and President of the Accademia di S. Luca (the Roman guild of artists). His life was, however, scarred by tragedy and disappointment, for he never achieved his great ambition of becoming First Painter to the King; a victim of nepotism and political intrigue, he was ousted from the French Academy, while his wife and children all died prematurely.

Although Detroy aspired to make his mark as a history painter in the "grand manner," his finest and most original contribution to art was made with his modestly-scaled and deliciously painted *tableaux de modes*, wherein the manners, amusements, and comforts of polite Parisian society are exquisitely documented. It is a type of painting that he seems to have invented, thereby influencing younger contemporaries such as François Boucher. The first examples appear to be two pendants exhibited in the Salon of 1725 and now in the Wrightsman Collection, New York; his masterpiece of the genre is the *Reading from Molière* (1728?) in the collection of the Dowager Marchioness of Cholmondeley at Houghton Hall in Norfolk. These are the works which were preferred over his history paintings by connoisseurs of Detroy's own time. Given their inherent attractiveness and general importance in the history of art, it comes as something of a shock to discover that hardly more than a dozen examples of his *tableaux de modes* are known to exist.

The exhibited painting is one of a pair of pictures — the other shows *A lady attaching a bow to a gentleman's sword* — that came to light only a few years ago. They would appear to be the primary renditions of two compositions known through slightly larger and more highly finished versions in the collection of Baron Edmond de Rothschild at Prégny, Switzerland, though it is possible that the Kansas City canvases are autograph replicas of the Rothschild pictures. In any event, the bravura under-painting revealed by laboratory analysis, and the creamy *impasto* technique specifically comparable to that in other works of the late 1720s and 1730s, leave no doubt about Detroy's personal responsibility for the pictures now in the Nelson.

The exhibited painting is a depiction of a young woman in her boudoir, being helped into her attire by a delicately poised attendant. Seated beside the dressing table is the lady's young suitor. She shows him a bracelet with a prominent locket which contains, presumably, a miniature portrait of the young man himself. The lady is being grandly outfitted for some special social occasion such as an appearance at Court. She wears a white silk chemise adorned with exquisite lace ruffles over which there is a tight fitting sapphire-colored petticoat. The servant helps her into an open-fronted velvet gown know as a *manteau*; ornamented in the front with embroidered lace and satin appliqué, it cascades gently in the back to form a short train. The lady's dressing table is furnished with a red lacquer mirror and jewelry caskets as well as silver containers for make-up, powder, combs and pins, etc. On the shelves, behind, there appear highly fashionable and slightly exotic Chinese porcelains — a blue and white elephant *kêndi* and a baluster vase — of the kind made in great quantities for export to Europe during the seventeeth and eighteenth centuries.

R.W.

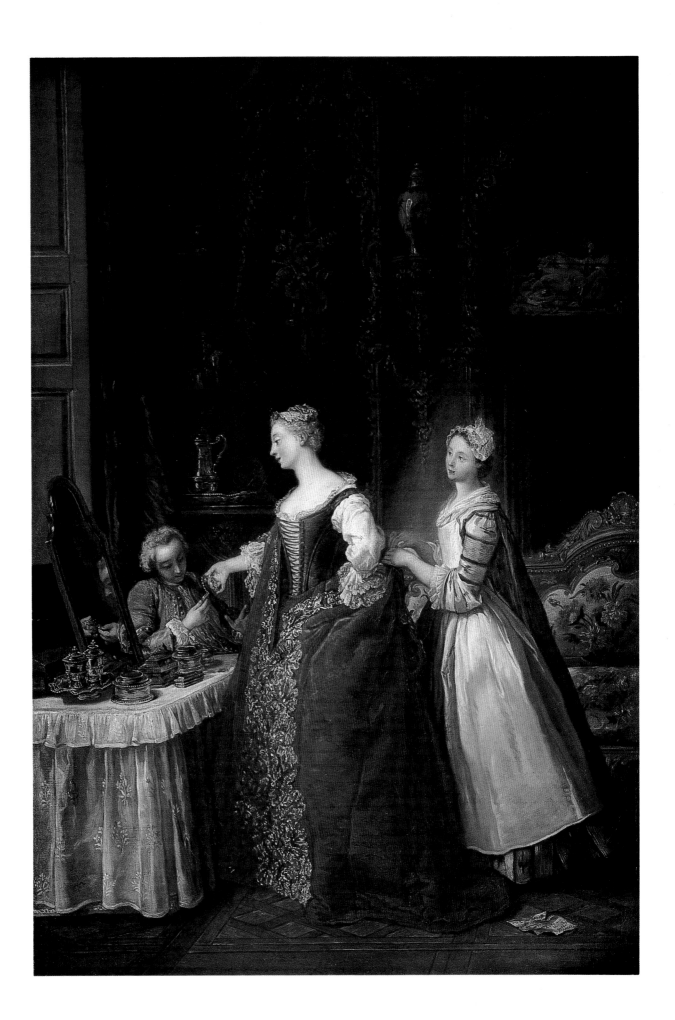

53

AUGUSTIN PAJOU

French, 1730-1809

Jean François Ducis, 1779

Terracotta, mounted on a white marble socle, 78 cm. (h.)

Gift of the McGreevy Family through the Westport Fund in honor of the Fiftieth Anniversary of The Nelson-Atkins Museum of Art. F83-22.

Born in Paris, Pajou was one of a whole cluster of talented young sculptors who emerged in France during the middle years of the 18th century. He had the good fortune to receive his early training from Jean Baptiste Lemoyne, and at the age of 18 he won first prize for sculpture at the Académie Royale. This entitled him to a place at the Académie in Rome, where he studied drawing and sculpture from 1752 to 1756. Upon his return to Paris, Pajou executed his early masterpiece, a portrait bust in bronze of Lemoyne. With the success of this work his official career was launched; from that year until 1802 he exhibited regularly at the annual Salons. In 1760 Pajou became a full member of the Académie Royale and rose steadily through the ranks, being appointed Rector in 1792.

Among his many royal commissions were portrait busts of both Louis XV and Queen Marie Leczinska. In addition, Pajou's delicate and flattering portraits of Mme. du Barry, the King's mistress, enjoyed extraordinary popularity. He also executed small-scale decorative pieces, nearly a hundred portrait busts, tomb sculpture and other monumental figural groups, and architectural ensembles such as the decorations in the Opéra at Versailles.

Although Pajou moved in an illustrious orbit and portrayed a number of the great political personalities of the age, his finest portraits are those of people within his circle of acquaintances. They constituted something of a cross-section of Parisian cultural and intellectual life. Among the most colorful of these figures was Jean François Ducis (1733-1816). A poet and a playwright, Ducis rose to prominence during the reign of Louis XV and served as Secretary to the Count of Provence, younger brother of Louis XVI. His adaptations and productions of the plays of Shakespeare were immensely popular, and he was elected one of the 40 members of the Académie Française. Ducis was officially received into that organization on March 4, 1779, and to commemorate this honor his portrait was sculpted by Pajou, then at the pinnacle of his career.

Executed in terracotta, Pajou's bust is both direct and unexpectedly forceful, made all the more striking by Ducis's memorable physiognomy. The poet appears nonchalant and relaxed. His momentary expression — the mouth slightly open and an eyebrow arched — appears spontaneously caught. The *Jean François Ducis* provides a virtually unrivalled example of Pajou's delicate handling of the terracotta medium, as in the treatment of the hair, the tightly pleated silk chemise, and the fine lines around the eyes and lips which define the facial expression.

The bust was first exhibited at the Paris Salon in 1779, at which time it presumably had been mounted on the handsome, inscribed white marble socle. So far as is known, the Museum's sculpture is the unique version of the *Ducis* bust, for there are no recorded or extant repetitions in other media (eg. plaster or marble).

R.W.

JEAN CHARLES DEVELLY
French, 1783-1849
Plate, 1821 and 1829
Sèvres porcelain, 23.5 cm. (diam.)
Purchase, The Nelson Gallery
Foundation. F83-52.

The Sèvres porcelain factory just outside Paris enjoyed the patronage of Louis XV and his mistress, Madame de Pompadour, in the mid 18th century when it produced the apple-green, royal blue, and pink glazed porcelain for which it is best known. The present plate demonstrates, however, the continuing vitality of Sèvres design after the Revolution and well into the 19th century. It is one of approximately 118 pieces that comprised the "Service des Arts Industriels," one of the last great porcelain dinner services made before the Victorian era. Designed and painted by Develly between 1823 and 1835, it was presented by Louis-Philippe, King of the French, to Prince Metternich, the leading protagonist of the Congress of Vienna. A wealth of detailed information documents the history of the set from its commission to its production — typical of the greatest undertakings at Sèvres during the 19th century. The individual pieces themselves are also dated: in this case, once for the porcelain blank (1821), and again for decoration, 1829, with the subject *Jardinier Fleuriste* ("The Florist-Gardener") inscribed beneath the scene. Six other plates featuring the same handsome "beau bleu" rim and scenes showing, for example, the interior of the Sèvres factory itself, are preserved in the Musée de Sèvres.

J.K. and R.W.

GIOVANNI FRANCESCO
BARBIERI, called GUERCINO

Italian, 1591-1666

*Saint Luke Displaying a Painting of
the Virgin*, 1652/53

Oil on canvas, 221 x 181 cm.

Purchase, The Nelson Gallery
Foundation. F83-55.

Guercino's *Saint Luke Displaying a Painting of the
Virgin* was painted in 1652 to adorn the high
altar of San Francesco in the north Italian city of
Reggio Emilia. The church, constructed during
the Middle Ages, had had a continual
dedication to Saint Luke, despite the fact that in
1274 its name was changed to San Francesco
when it became a monastic church of the
Franciscan order.

Because he had been described by Saint Paul
as the "beloved physician," Luke was popularly
imagined also to have been a painter, for within
the medieval guild organization doctors,
apothecaries, and painters were members of
the same guild. By extension, Saint Luke was
supposed to have painted the Virgin Mary, and
numerous "portraits" of her can still be seen in
Roman Catholic churches from Poland to
Portugal. In the 17th century the most famous
of all was the Byzantine icon worshipped (then
as today) in the Sanctuary of the Madonna of
Saint Luke in Bologna. With dusk approaching,
Guercino's Saint Luke gestures eloquently
towards his just-completed "portrait," which
would have been instantly recognized by
Guercino's audience as this renowned and
miraculous *Madonna and Child* of Bologna. The
inkpot with its quill pen and the sculpted bull
refer specifically to the Saint's primary
doctrinal role as one of the Four Evangelists.

This well-preserved painting is a product of
Guercino's later years, when his style
epitomized the term "Bolognese Classicism."
Essentially the invention of Annibale Carracci
(1560-1609) and his cousin Ludovico (1555-
1619), this mode's later practitioners in both
Rome and Bologna were Guido Reni (1575-
1642), Domenichino (1581-1641), and finally
Guercino. Based on the art of the earlier
masters of the High Renaissance, especially
Raphael, it was a style characterized by carefully
constructed compositions, clarity of
draftsmanship, monumental figures, and the
use of richly saturated, jewel-like colors.

Following a renovation of the church of San
Francesco in 1709-10, the *Saint Luke* was sold; in
about 1713 it came into the possession of a
minor Bolognese painter Antonio Fratacci (or
Fratazzi). In the 1730s, most likely, the picture
was acquired and taken to England by the
Honorable John Spencer (1708-1746), who
travelled widely and collected extensively in
Italy. By 1750 it was hanging at Althorp House
(Northamptonshire), the seat of the Earls
Spencer and repository of the family's
innumerable art treasures. For more than two
centuries the picture remained at Althorp: it
was neither moved nor sent to public
exhibitions, which undoubtedly accounts for
the picture's extraordinary condition.

A recently discovered letter (dated April 17,
1635) from Guercino, in the Modena state
archives, reveals that the artist still had not
received his final payment for the altarpiece.
Nevertheless, as a gesture of good will towards
his friend Aurelio Zanaletti, who had
commissioned the painting on behalf of the
church, he had added a separately framed
canvas with two angels, which was intended to
crown the framed *Saint Luke*. Formerly at
Althorp, it now belongs to an anonymous
private collector.

R.W.

56

JOHANN GREGOR
HOEROLDT

German, 1696-1775

CHRISTIAN FRIEDRICH
HEROLD

German, 1700-1779

Plate, c. 1730-35

Meissen porcelain,
29 cm. (diam.)

Acquired through the generosity
of Mr. and Mrs. Richard M. Levin
in memory of Marion Berger
Levin. F84-7.

This large, chinoiserie style plate was made at the apogee of the Meissen factory's long existence (see cat. 59). Once the mechanics of production and decoration had been mastered in the second decade of the 18th century, there followed a period of invention and experimentation as the artisans at Meissen developed a wide range of wares and figures. In 1723, with the appointment of Johann Gregor Höroldt as Court Painter at Meissen, there entered upon the scene a painter whose technical virtuosity was matched by the originality of his compositions. Höroldt's sophisticated and amusing chinoiserie designs quickly became the rage in porcelain decoration thanks to the broadly based European fascination with the Orient; ironically, though a wide variety of wares with Höroldt-type chinoiserie decoration still exists, the individual pieces actually documented as from his hand are surprisingly few in number. Most attributions to him are made on the basis of style of composition and drawing and quality of execution. A further complication is introduced by the similarity of his surname to that of his most famous colleague (probably his cousin), Christian Friedrich Herold, who often reproduced Höroldt's compositions but in doing so rendered the figures more monumental than their prototypes.

The sumptuous plate now in Kansas City is the product of just this sort of collaboration. It is decorated in polychrome with large chinoiserie figures who stand on a platform, flanked by two consoles supporting additional figures. The lower section is richly gilt and lustred, with interpolating vignettes painted in purple monochrome, while the borders are painted with quay scenes. Despite its high quality and luxuriousness the series of which this large plate once was a part apparently has not been identified.

J.K. and R.W.

57

DIRCK VAN BABUREN
Dutch, c. 1595-1624
Christ Crowned with Thorns,
c. 1621/22

Oil on canvas, 127.5 x 168.3 cm.

Acquired through the generosity of The William Rockhill Nelson Trust, Mrs. Kenneth A. Spencer Fund, and Mr. Robert Lehman (by exchange). 84-25.

In the 1830s the eminent Dr. Gustav Friedrich Waagen, Director of the Royal Museums in Berlin, made several tours of Great Britain with the intention of visiting as many as possible of that country's private art collections — at that date almost certainly the finest in Europe. His innumerable observations on the tens of thousands of paintings he saw in the homes of the nobility and the merely rich were compiled and published in four volumes entitled *Treasures of Art in Great Britian* (1857). These quickly became the indispensable tools of connoisseurs, collectors, and "art researchers." During the last 130 years the frontiers of art historical knowledge have been rolled back so relentlessly that today we are aware of many lapses, omissions, or wrong attributions on Waagen's part, but seldom are these inaccuracies without some foundation in fact.

As Waagen surveyed the illustrious Drury-Lowe collection, displayed at Locko Park, Derbyshire, his attention fell upon the *Christ Crowned with Thorns* by "Michael Angelo de Caravaggio." "The Christ," he noted, "is of unusually elevated character for him, and shows the influence of Guido [i.e., Guido Reni]. The picture otherwise displays his power of colour and energy of treatment." Not until 1953, however, did Sir Ellis Waterhouse publish the correct attribution to the short-lived Dirck van Baburen.

Baburen came from Utrecht, a city whose affiliation by and large remained with the Roman Catholic church while the other provinces of the Netherlands became Protestant. This explains the market in that city for artistic representation of religious scenes. Like other Utrecht painters of his generation — for example, the slightly older Terbrugghen — Baburen traveled to Rome and brought back to the North a boldly dramatic style of painting that had been inspired by Caravaggio and his Italian followers.

He apparently made the journey in the course of 1612: certainly by 1617 he had received an important commission from the Franciscans to decorate the Chapel of the Pietà in San Pietro in Montorio, Rome. Profoundly affected by painters like Manfredi and Valentin, Baburen returned to Utrecht in 1621 and for the following two years he almost certainly shared a studio there with Terbrugghen. In about 1621/22 he painted *Christ Crowned with Thorns*, his last religious composition and the most significant work executed during the few short years between his reestablishment in Utrecht and his premature death on February 28, 1624, no more then 30 years of age.

In the *Christ Crowned with Thorns* brutality is presented straight-forwardly and without apology. The rough, unidealized figures are evidence of the artist's susceptibility to the naturalism found in works from Caravaggio's late Roman period. The overt violence, exaggerated movements, and saturated colors create a high-pitched clamor; this is without doubt one of the most powerful and inventive responses to the art of Caravaggio in the entire production of the Utrecht School. A smaller and autograph variant of the composition, which is signed *Baburen f.*, was recently acquired on behalf of the Catharijne Convent Museum, Utrecht.

The frame was acquired separately from the painting. It was chosen because it is both historically correct for the painting, and, with respect to craftsmanship and aesthetic effect, an exceptionally fine example of its type. Made in Rome between about 1600 and 1620 — i.e., contemporaneous with Baburen's sojourn there — for a picture just slightly larger than the *Christ Crowned with Thorns,* the frame has been reduced to fit the Kansas City painting. It is of the Italian *cassetta* form, meaning that the plane of the outer edge is notably higher than that of the sight edge. This sight edge is a shallow gilt scotia (concave molding) which curves up to a string of semi-circular pearls. The frame's broad panel is embellished with running gilt arabesques made by the *sgraffito* technique, meaning that the panel was first gilded, then covered with a thin coat of blue-grey tempera on which the arabesque pattern was drawn with a stencil or template; the gilding beneath was revealed by scratching away the stenciled pattern with a knife. Next there comes a boldly carved egg and dart molding followed, in turn, by an astragal (narrow half-round molding) featuring spaced pairs of semi-circular pearls.

R.W.

58

WENZEL NEU
German, died 1774
Columbine, 1764-65
Kloster-Veilsdorf porcelain,
15.9 cm. (h.)
(reproduced actual size)
Acquired through the generosity
of Elmer C. Rhoden and The
Nelson Gallery Foundation.
F84-32.

This figure represents the servant girl Columbine, and forms part of a set of characters from the *Commedia dell'arte*, a type of improvised comic drama popular in 18th-century Europe. It was made by the German firm of Kloster-Veilsdorf, the most important Thuringian porcelain factory of its day. Wenzel Neu, the only artist to receive the title of master modeler at the firm, sculpted the set in 1764-65. For his design sources he relied upon Johann Balthasar Probst's engravings which were published in Augsburg in 1729.

In addition to the recently acquired Columbine there are two other *Commedia dell'arte* figures in the collection, *Pierrot* and *Dr. Baloardo*. Although undoubtedly from different sets, they come from the same series. Ensembles such as these were often created for display on banqueting tables and so represent sculpture in the true sense of the word, despite their small size. The fine modeling and vivacity of Neu's statues ranks them among Kloster-Veilsdorf's finest productions.

J.K.

59

Attributed to JOHANN
JOACHIM KRETZSCHMAR

German, 1677-1740

Augustus the Strong, c. 1715-20

Meissen porcelain, 11.1 cm. (h.)
(reproduced actual size)

Purchase, The Nelson Gallery
Foundation. F84-33.

The porcelain statuette of Friedrich Augustus (1670-1733), King of Poland (1697-1706 and 1709-1733) and Elector of Saxony (1694-1733) is one of the rarest and most important original creations of Meissen's earliest years. Significantly, Augustus owned the Meissen firm, which he established in Meissen, Germany, in 1710, and as his nickname Augustus the Strong implies, he was a man of great strength and consuming passions, of which china was not the least.

Meissen produced the figure of Augustus during only the first two decades of its existence; versions of the statuette are known in both porcelain as well as the unpolished, reddish brown stoneware the factory made until about 1730. It has been learned that this model, which dons German armor, along with another model of the king in the guise of a Roman emperor, was created for a chess set that Augustus ordered but never received. The Museum's statuette joins another representation of the king already in the collection, a painting of about 1714/15 by Nicolas de Largillierre.

Johann Melchior Steinbrück, the factory's inspector, wrote in 1713 that Johann Friedrich Böttger promised several times to complete the chess set commissioned by Augustus. Böttger planned to make two copies of the game, one in porcelain and one in stoneware. According to Steinbrück, Böttger had the two statuettes produced in 1713 for the porcelain version. Steinbrück described the clothing of the Nelson-Atkins model as German and that of the other model as Roman.

Though few examples of either model survive, the porcelain version of the king in German armor is the rarest: only eight specimens, including the Nelson-Atkins's recent acquisition, are recorded. An example of the statuette in Roman armor is preserved at the Metropolitan Museum of Art, New York. The two models of Augustus have been attributed to the Dresden sculptor Johann Joachim Kretzschmar, whose large-scale statues they resemble. Kretzschmar's involvement accounts for the vigor and masterful composition of the Kansas City version, which despite its diminutive size is in every way a fully realized work of art.

J.K.

60

JOHANN PETER MELCHIOR
German, 1742-1825

The Love Letter (Der Liebesbrief)

Höchst porcelain, 16.2 cm. (h.)
(reproduced actual size)

Gift of Mrs. E.B. Berkowitz.
F84-34.

Johann Peter Melchior, chief modeller at the Höchst porcelain factory (near Mainz) from 1767 to 1779, is thought to have created many of the firm's sculptures representing children in a very sweet, Neoclassical style. Also possibly by Melchior, the present figure of a classically draped woman with a letter (currently known as *The Love Letter*) provides a new dimension to the Museum's large collection of Melchior children in contemporary dress.

The restrained, distinctive palette and grassy, mound-like base seen here are typical of many Höchst works dating from the 1770s.

J.K.

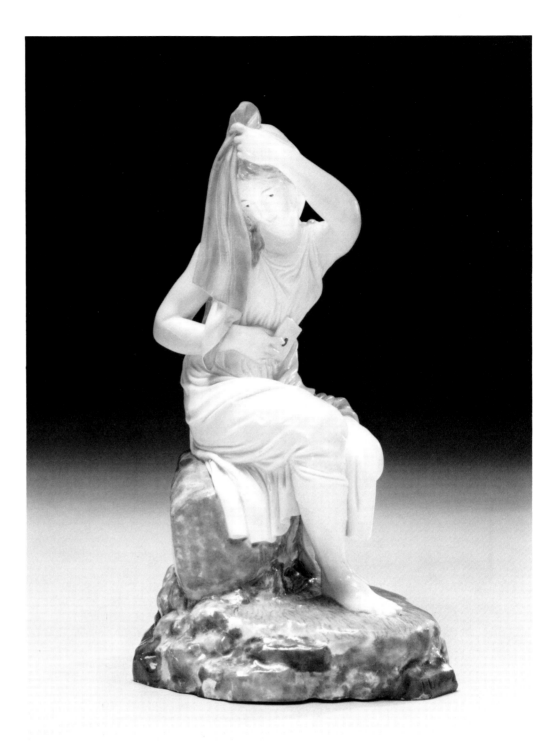

FRENCH
Tankard, c. 1753
Vincennes porcelain,
15.3 (h.) x 9.3 cm. (diam.)
(reproduced actual size)

Purchase, The Nelson Gallery
Foundation. F84-53/a,b.

If the Meissen statuette of *Augustus the Strong* (cat. 59) exemplifies the vigor of the Baroque as seen in Europe's first porcelain factory, this tankard (c. 1753) epitomizes the playful, feminine Rococo style which succeeded it. The production of porcelain near the French capital of Paris can be traced to 1740, when the Dubois brothers deserted the Chantilly firm to begin porcelain experiments at Vincennes with the support of Orry de Fulvy, Louis XV's Intendant des Finances. The china which the firm first produced in 1741 was of the soft paste type, a porcelain characterized by a tactile, visual warmth in sharp contrast to the glittering white surface of Meissen's hard paste porcelain. In 1745 the venture obtained a royal patent, assuring it an exclusive 20-year license to produce china. Outgrowing its accommodations, the company eventually moved from Vincennes to Sèvres in 1756. Four years later it was taken over by Louis XV, thus becoming, like Meissen, a royal enterprise. Between 1745 and 1756 Vincennes experienced a period of great artistic and technical creativity, encouraged, no doubt, by the king's early involvement.

The vitality of Vincennes is perhaps no better seen than in the Museum's beautiful tankard. The piece bears gilded pictorical reserves, or panels, on an attractively mottled, dark cobalt ground the firm named *bleu lapis*. The scenes in the reserves feature birds flying and walking among bullrushes, weeping willows, palm trees, and other flora. The quality of the richly tooled gold is exceptional. Sparkling linear detail, the result of burnishing the gold with a dog's tooth or a smooth, agate-tipped tool, contrasts with the matt, unburnished areas to create exquisitely rendered scenes unsurpassed by any other European porcelain firm.

Though this vessel held beer or other alcoholic beverages, its sumptuous decoration indicates that it was as much a status symbol in its own time as it was a functional piece of tableware. Vincennes china was in fact extremely fashionable among members of Louis XV's court. The daybook of Parisian art dealer Lazare Duvaux contains numerous entries for china tea or coffee cups decorated like the Museum's example. In June 1752, M. le Comte de Sponheim (the Duc des Deux-Ponts) purchased "Six Vincennes porcelain cups and saucers in lapis blue with cartouches bearing gold birds." The description closest to the Museum's piece in this important sourcebook for students of 18th-century decorative arts occurs in August 1755 when "A handled *litron*-shaped cup and saucer, lapis blue with gold birds," was sold to M. Le Président de Lamoignon. *Litron*-shaped vessels were a smaller version of the Nelson-Atkins tankard. Their name derives from the *litron*, the old French cubic measure.

Other important evidence that relates to the tankard is the absence of a date letter on the object's underside. The company's custom of marking a piece with a letter from the alphabet to indicate the year of manufacture commenced in 1753. Hence, the Museum's vessel probably dates from around that time.

J.K.

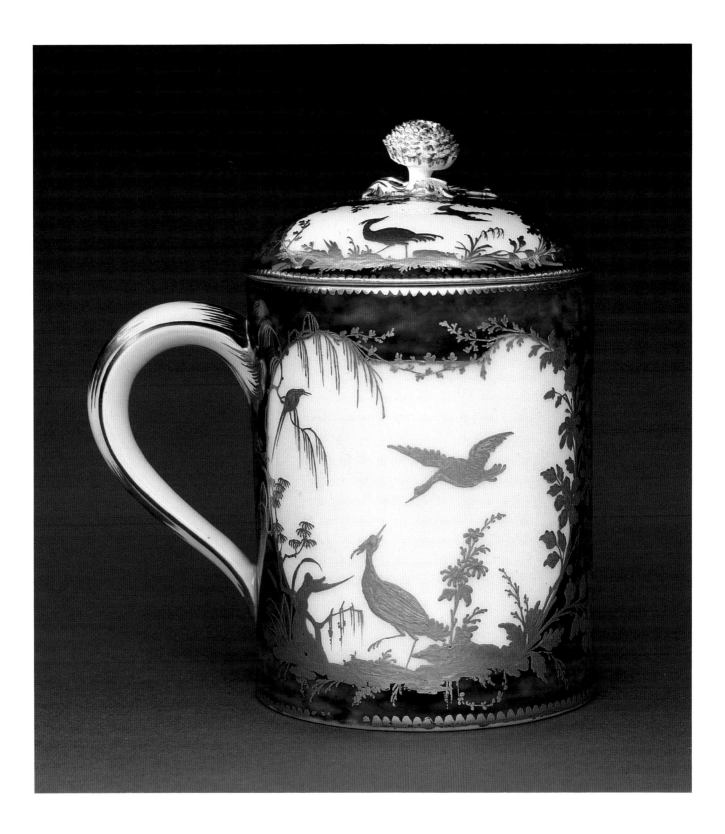

62

CLAUDE JOSEPH VERNET
French, 1714-1789
Coastal Harbor with a Pyramid: Evening

Signed and dated lower right: *Joseph Vernet f. / Roma 1751.*

Oil on canvas, 66.8 x 86.7 cm.

Acquired through the generosity of Sophia K. Goodman. F84-66/2.

Claude Joseph Vernet plays a central role in the history of landscape painting in 18th-century France. Born in Avignon, the son of a humble coach painter, he was sent to Rome at the age of 20 by a local aristocratic *amateur*. There he settled, marrying an English wife in 1745. By this date he had attained an international reputation as a painter of idealized interpretations of the Roman Campagna and of the exceptionally beautiful coastline—alternately dramatic and poetic—between Rome and Naples.

Vernet exhibited regularly at the Paris Salon from 1746 on, always with great success. Critics such as Diderot declared that Vernet's art surpassed even that of Claude Lorrain, whose example was crucial for the young painter's development. Such enthusiastic critical reception was due in part to a change in taste that occurred towards the end of the first half of the 18th century. Contemporary observers and collectors began to reject the earlier Rococo style (epitomized, say, by the art of François Boucher) as both frivolous and "merely" decorative. In Vernet they found a welcome alternative, a champion of direct observation from nature, achieved through the use of normal, descriptive coloring and the juxtaposition of different times of day, climatic conditions, and even seasons of the year. Often conceived as pendants or in sets of four canvases, his paintings were meant to record with some specificity the characteristics of natural phenomena in realistic and identifiable terms. It is for this reason that they have been regarded as a visual manifestation of the 18th-century interest in taxonomy: it might be said that Vernet classified a variety of different experiences of the physical world. This concern with particular effects increasingly challenged the old notion of the "ideal" in landscape painting, but the subject was not fully explored until the 19th century.

The exhibited painting is one of such a pair of pictures (its pendant, *Seaport with antique ruins: morning,* remains on view in Gallery 126). Both works are carefully composed, delicately balanced in terms of light and color, and painted with a freshness of touch that characterizes Vernet's early works. This technical quality—one that was enthusiastically praised by the artist's contemporaries—can be fully appreciated in the Kansas City pictures because they are especially well preserved. Their history is similarly distinguished. Commissioned in November 1750 by a certain *monsieur* Peilhon, Conseiller-Secrétaire du Roi and one of Vernet's two most important patrons during the 1740s and '50s, they are listed by Vernet as number 112 in his account book of commissioned works. Sent from Rome probably late in 1751, they were shown at the Paris Salon of 1753, along with several other Vernet paintings from Peilhon's large collection. Their subsequent presence until 1980 in four French private collections is well documented, and the pictures have been continuously noted in the literature on the artist, but after their appearance at the Salon the paintings were never publicly exhibited until they entered the Museum's collection in 1984.

R.W.

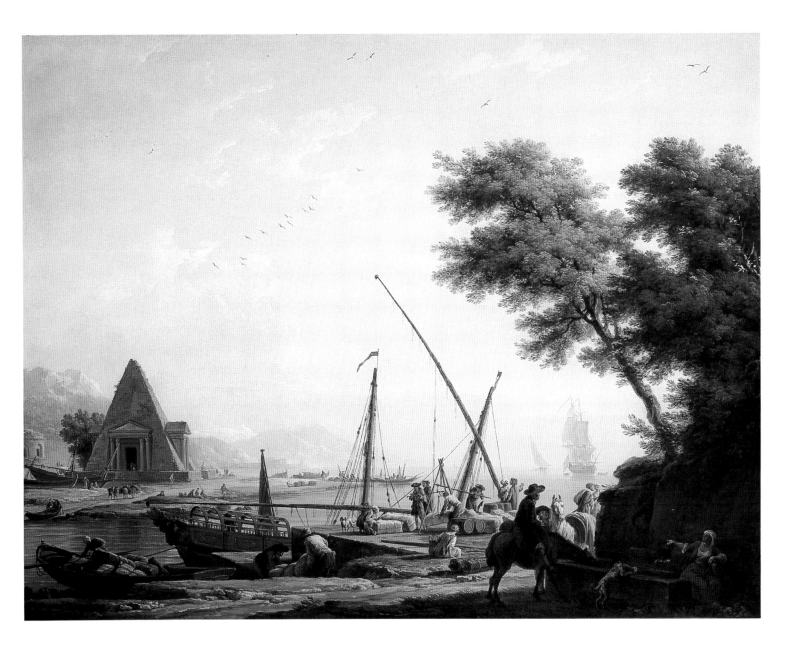

JOACHIM ANTHONISZ.
WTEWAEL

Dutch, 1566-1638

Saint Sebastian

Signed and dated lower left:
*JOACHIM. WTEN / WAEL.
FECIT / 1600*

Oil on canvas, 169.5 x 124.8 cm.

Purchase, The Nelson Gallery
Foundation. F84-71.

Wtewael (pronounced "Oot-vahl"), a native of Utrecht, trained under his father, a glass painter, until the age of 18. Two years of study with the city's foremost masters were followed by a further two years of travelling in France and Italy. There Wtewael's aesthetic sensibility seems to have been decisively affected by the works of the 16th-century painters of Parma and Bologna like Correggio, Parmigianino, and Tibaldi. Resident in Utrecht from 1592, he was active in local politics as well as artistic affairs, helping to establish an independent guild for artists in 1611. About 1630 Wtewael apparently abandoned painting and died a wealthy merchant in the flax-trading business.

The career of Wtewael coincides with the high-water mark of Mannerism in northern European art. During the 16th century the princely courts of Europe fostered a taste for the unusual, the exquisite, even the bizarre. Seeking to satisfy this demand, artists self-consciously strove to display the richness of their imaginations and their technical virtuosity in the execution of all kinds of works of art. Such works are characterized by elongation and complication of the human figure and its poses; ambiguous spatial arrangments; and exotic, highly ornamental coloring.

Wtewael was a specialist in the painting of tiny copper panels, like the exquisite *Mars and Venus surprised by Vulcan* recently acquired by the Getty Museum. He frequently made more than one autograph version of his small-scale paintings, which nearly always bear some form of a signature, but most of the large canvases usually attributed to him are of conspicuously lower quality and seem to be the products of his workshop. The Kansas City *Saint Sebastian* — an uninhibited visualization of the ecstasy of anticipated martyrdom — is exceptional as Wtewael's unique treatment of the theme, and as one of his larger works whose authenticity is beyond any doubt. Signed and dated 1600, the painting is a transitional work between the prevailing styles of the 16th and 17th centuries, for while the exaggerated musculature of the figures, the complexity of their poses, precise brushwork, and rarified colors are hallmarks of Mannerism, the painting's simplicity of composition, grandeur of conception and dynamism anticipate the Baroque art of Rubens, only eleven years Wtewael's junior.

The earlier history of the Nelson-Atkins painting is unknown (the first recorded owner was Sir Edward Cockburn, whose collection was sold at Christie's in 1903), but a general notion of its origins may be inferred from its subject. According to legend, the third-century martyr Sebastian was a handsome young Gaul who served as a centurion in the Praetorian guard of the Emperor Diocletian. He was secretly converted to Christianity; when this fact was exposed he was condemned to be shot with arrows and left for dead by his executioners. Miraculously, Sebastian survived this ordeal, though later he was beaten to death with clubs and his body dumped into the Cloaca Maxima, the main sewer of Rome.

Because the ancients believed that the plague was spread by Apollo's arrows, there began in the 14th century the cult of Saint Sebastian as protector against the plague, for he had not died from the wounds of arrows. It is, therefore, conceivable that Wtewael's painting served as an altarpiece in a chapel dedicated to the saint, but this seems unlikely since Sebastian has not yet achieved Christian martrydom.

More probably Wtewael made the picture for the workman's guild of *Sebastiaandoelen*, the municipal militiamen who were equipped with bows and arrows, of whom Sebastian logically was the patron saint. The atypical iconography, the unrestrained exploitation of the physical beauty of the male model, and the emphatic display of archery equipment in the foreground of the picture suggest that the picture was intended for a secular context of this sort, not a sacred one.

R.W.

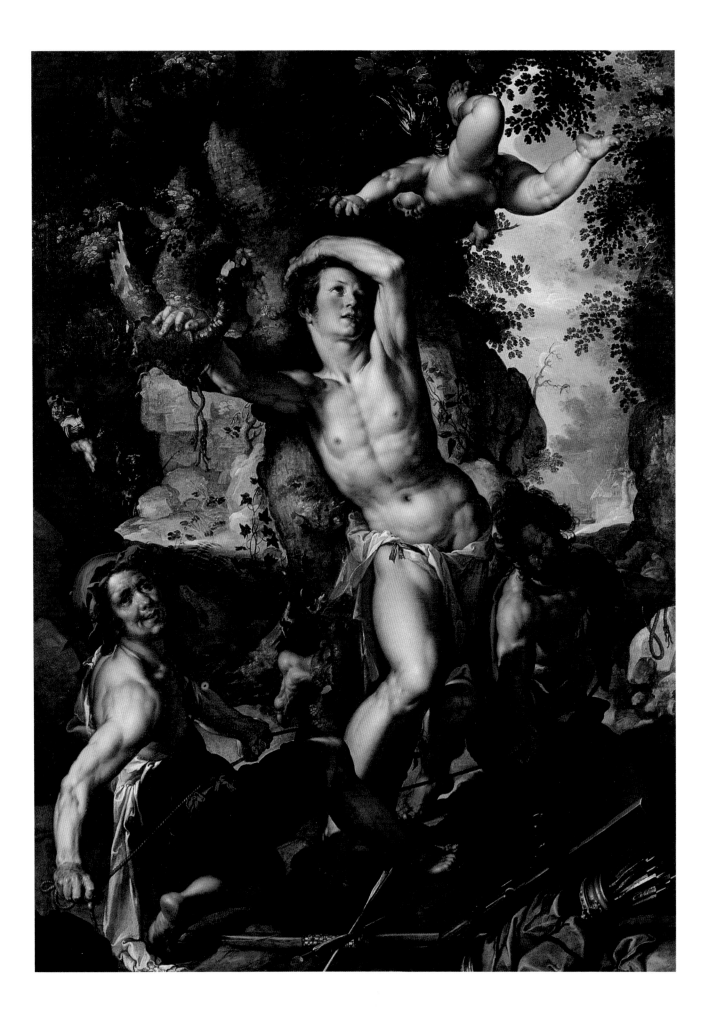

64

CAMILLE PISSARRO

French, 1830-1903

Wooded Landscape (Paysage sous bois à L'Hermitage), 1879

Signed and dated lower right: *C. Pissarro/79*

Oil on canvas, 46.5 x 56 cm.

Gift of Dr. and Mrs. Nicholas S. Pickard. F84-90.

This is one of the artist's last renditions of L'Hermitage, that part of the (present) Parisian suburb of Pontoise which Pissarro had immortalized in the late 1860s. The composition is a subtle and fascinating one: in the foreground the intricate linear pattern of the trees blends with the bushy area below by means of the same greenish hue and rich impasto brushwork. At the same time, one is equally drawn to the vista beyond, visible between the screen of trees. There the village roofs form a geometric design worthy of Cézanne, who in fact was painting similar scenes in this same locale in company with Pissarro. The rugged volumes of the roofs contrast with the lacy pattern of trees, just as their colors—orange-red and greyish blue—contrast with those of the verdant foreground. The view through a screen of trees and the rustic figure at right who looks deep into the background scene are motifs inspired by Corot, whom Pissarro had particularly idolized in his youth. This composition was reproduced in reverse in one of the artist's most accomplished etchings (see cat. 105).

E.R.

65

Attributed to IGNAZ PREISSLER
German, 1676-1741

Atilius Regulus Battling the African Serpent, c. 1720-25

Porcelain, 21.6 cm. (diam.)

Acquired through the generosity of Mr. and Mrs. Earl D. Wilberg. F85-5.

The German word *hausmaler,* meaning a painter who works at home, denotes the freelance painters of Germany who enameled faïence and china blanks. The tradition began during the 17th century when it occurred mainly on glass, silver, and copper items, but later both Meissen and Vienna porcelain, as well as Chinese export ware, became the preferred medium for these independent artists. The great era of *hausmalerei* was the early 18th century when such wares were made primarily for a courtly market. By the 1760s, with the spread of porcelain manufactories throughout Europe, *hausmalerei* was an artform in decline.

The Museum's dish has been convincingly attributed to Ignaz Preissler. Although no signed pieces by Preissler are known, his artistic activity is well documented. From at least 1719 to around 1726, he was employed by Dr. Ernst Benjamin von Löwenstadt in Breslau, Silesia, when he made only "grey on grey or black paintings" on porcelain. From 1729 to 1732 he worked for Count Franz Karl Liebsteinsky von Kolowrat in Kronstadt, Bohemia. Receipts and letters, some in Preissler's own hand, have been found in the Kolowrat family estate, Schloss Reichenau, and these record that Preissler decorated some 285 porcelains and 12 glass objects in *schwarzlot* and gold, and in iron-red and gold, on behalf of his patron; some of these are described as "Indian grotesques" and "poetic subjects painstakingly executed." The additional discovery of a small group of early 18th-century glasswares in the collection at Schloss Reichenau, which correspond to descriptions found in the documents, has made it possible to identify Preissler as the painter of many unattributed or misattributed porcelain wares, including the present dish.

A beautifully painted Latin inscription on the back of the piece identifies the scene. The fantastic serpent symbolizes the great north African city of Carthage, Rome's traditional rival. Atilius Regulus, Roman Consul in 267 and again in 256 B.C., enjoyed victories in the Punic Wars until being defeated and taken prisoner in 255 B.C. According to legend he was despatched to Rome by his captors to negotiate a peace treaty, having given his oath he would return to Carthage upon conclusion of the matter. Once in Rome he urged the Senate to reject the terms offered, but true to his word he went back to Africa where the Carthaginians promptly tortured him to death.

European china painters often relied on engravings and illustrated books as sources for their decorations. The scene on this plate is based on an engraving designed by the 16th-century Flemish painter Jan van der Straet (called Stradanus) and published as part of a series entitled *Venationes Ferarum Auium Piscium* that appeared in Antwerp in 1578. The decoration of the Museum's dish is similar in style and technique to that of a number of comparably painted wares on which Preissler depicted a wide variety of hunting and combat scenes. Regarded as one of his finest works, the *Atilius Regulus* dish is remarkable for its lavish detail and the way in which the Stradanus composition has been subtly altered and rendered more pictorially successful. The effect of the blackish brown enamel on the pale blue china is particularly handsome.

R.W.

ELISABETH LOUISE VIGEE
LE BRUN

French, 1755-1842

Portrait of Marie Gabrielle de Gramont, Duchesse de Caderousse

Signed and dated lower right:
L.se Le Brun. f. 1784

Oil on panel, 105 x 76 cm.

Acquired through the generosity of Mrs. Rex L. Diveley; Mary Barton Stripp Kemper and Rufus Crosby Kemper, Jr. in memory of Mary Jane Barton Stripp and Enid Jackson Kemper; The Nelson Gallery Foundation; Mrs. Herbert O. Peet; Mrs. George Reuland through the W.J. Brace Charitable Trust; the Estate of Helen F. Spencer, by exchange. 86-20.

Elisabeth Louise Vigée Le Brun was one of the greatest portraitists of her age. In terms of reputation and wealth, she ranks as probably the most famous and successful female artist in the annals of European painting. A pupil of her father and much influenced by Jean Baptiste Greuze, Madame Le Brun became Painter to Queen Marie Antoinette of France whom she first portrayed in 1778. Her artistic prowess was made manifest by a succession of masterpieces created during the 1780s, bringing her both financial reward and international acclaim from important contemporary painters such as Jacques Louis David and Sir Joshua Reynolds. Her close association with the Royal Family meant that Vigée Le Brun had to flee France during the Revolution of 1789; she was not to return to Paris until 1802. Moving from Naples to Vienna to St. Petersburg to London, she painted scores of portraits of royalty and the nobility, and sometimes of celebrities such as other artists, actors, and opera stars. Considered as a group, these provide us with a remarkably rich and nuanced picture of European society during the reign of Louis XVI and the Napoleonic era.

In this signed and dated portrait of 1784, the extremely attractive Marie Gabrielle de Sinéty, Comtesse and later Duchesse de Gramont Caderousse (1761-1832), is rather improbably depicted as a country girl who has just returned from the orchard, carrying a basket brimming with summer fruit. With her slightly flushed face, sparkling eyes, and fetching smile (the bared teeth were considered mildly erotic at the time), she invites the viewer to sample its luscious contents. That the painting elicited this sort of reading or response from Vigée Le Brun's contemporaries is made clear by a poem written about the picture on the occasion of its first exhibition in the Salon of 1785.

The portrait was an instant success with both critics and the public. Certainly it was admired for its technique, comparable to that of the Flemish masters of the 17th century, whose works Vigée Le Brun had studied during a trip through the Low Countries in 1781. An oak panel approximately one-fourth-inch thick was first covered with a thin layer of gesso and then covered with an undertone of ochre paint. Vigée Le Brun's brushwork records a remarkable range of surface qualities and textures, namely silk, straw, velvet, flesh and fruit. One of the finest of the artist's choice panel paintings, it is unusally well-preserved, having remained until very recently in the family of the sitter's descendants.

The *Duchesse de Gramont Caderousse* is one of those rare paintings that not only recorded but actually influenced contemporary fashion. In her *Mémoires* Vigée Le Brun recounts that she detested the usual custom of powdering the hair and that she refused to do it herself. Madame Le Brun admired the luxuriant dark hair of the young countess and at length managed to persuade her to leave her hair unpowdered for this portrait. After one of the sittings the Comtesse de Gramont Caderousse went to the theater, leaving her hair as it had been during the day; the unorthodox appearance of a well-known beauty not surprisingly attracted public attention, and within a short time the habit of leaving one's hair natural had become widespread.

To some extent this was reinforced by Queen Marie Antoinette's very favorable reaction to the finished portrait. She was so impressed by it that she invited the Comtesse de Gramont Caderousse to wear the costume of the portrait and thus attired to walk with her in the gardens at Versailles, discreetly observed and commented upon by invited courtiers and attendants. The Queen would not, however, abandon powdering her own hair for fear that gossips would say that she was trying to minimize the considerable width of her forehead.

R.W.

67

GUIDO RENI
Italian, 1575-1642
Saint Francis Adoring a Crucifix,
c. 1631/32

Oil on canvas, 82 x 67 cm.

Acquired through the generosity of Katherine Kupper Mosher. F86-32.

In 1986 the Museum's holdings of Italian Baroque painting — which include the great Caravaggio *Baptist* and the recently-acquired *Saint Luke Displaying a Painting of the Virgin* by Guercino — were enriched by the acquisition of a rediscovered work by the Bolognese painter Guido Reni. In this picture, Saint Francis of Assisi (c. 1181-1226), his arms crossed over his chest, prays before a crucifix. Heavenly rays pour into his cave from upper left, highlighting the scene. So intense is Saint Francis's devotion that the miniature figure of Christ seems to be metamorphosing into actual human flesh. This image of intense prayer was meant to inspire the viewer with a similar devotion. The half-length format, frequently used in 17th-century devotional painting, concentrates our attention on the essentials of the scene. True to the didactic requirements of Counter-Reformation art, nothing could detract from the object of devotion. Instead of a narrative scene or irrelevant detail, we see only the saint at prayer.

The *Saint Francis Adoring a Crucifix* was probably painted in Reni's native Bologna, a city twice visited by the saint. Datable to around 1632, its fame was considerable. It was known to Carlo Cesare Malvasia (1616-1693), whose life of the painter remains the fundamental source for Reni's career. No less than six painted copies of the work survive and three engravings from the 17th and early 18th centuries reproduce the composition. The Nelson-Atkins picture remained in private hands in Bologna until at least 1865, when it was lent to a local exhibition. It then disappeared from sight and only became known to scholars recently, when it resurfaced in a private collection in Great Britain.

The *Saint Francis Adoring a Crucifix* seems an especially apt subject for Reni, whose religious images came to be seen as almost canonical expressions of Counter-Reformation piety. In fact, right up to the mid 19th century Reni's reputation was second only to that of Raphael. From then on, his art fell into disfavor; to influential critics such as Baudelaire and John Ruskin, it smacked of the neo-classical ideals of the previous generation, who idolized Reni. The reappreciation of his critical contribution to Baroque art dates only from the last two decades.

Reni trained in Bologna with the Flemish painter Denys Calvaert, but in about 1595 he transferred to the very center of reformist trends in art: the academy founded by Ludovico Carracci and his cousin Annibale. He then followed the latter's example and travelled to Rome. From 1600 to 1614 he won highly important commissions there, returning frequently to Bologna to execute others. He was the only figure from the Carracci circle seriously to study the works of Caravaggio (who is said to have threatened Reni's life). On the other hand, his most famous work, the fresco of *Aurora* (1613-14), depends more on the Raphaelesque classicism of the Carracci Academy; this and other masterpieces seemed to Reni's contemporaries an almost exact recapitulation of antique art. Although from 1614 on he worked almost exclusively in his native town, he continued to paint for an international clientele. In his later years he took up gambling; biographers such as Malvasia record how Reni's steady losses led him to take up more and more commissions. He died in his sixty-seventh year.

Reni was considered one of the most brilliant colorists in the history of painting. His *Saint Francis* is unusual for its more monochromatic palette. The more one contemplates this beautiful image, though, the more its subtle colors become apparent — from the grey background to the sandy brown of the saint's robes to the creamy flesh tones (for which Reni was particularly famous). The latter are modelled with delicate strokes of white, pink, and orange, recalling the artist's beautiful red chalk studies. The result is a compelling, lifelike image of one of the Catholic church's premier saints.

E.R.

68

ITALIAN

Panel frame carved with astragal and paired pearls, corner and center foliate strapwork motifs in the panel, egg and dart molding, and centered gadrooning at the outer edge, late 16th century.

Poplar with original gilding, 208.2 x 166.2 cm. (altered)

DUTCH

Eared corner portrait frame with spaced ripple moldings, and wave molding panels and upper rail, mid 17th century.

Ebonized fruitwood, 134 x 117 cm. (unaltered)

Purchase, The Nelson Gallery Foundation.

By virtue of its scale, design, and color, a frame can radically affect the appearance of a painting (for better or worse) and the viewer's perception of it. While this is no new discovery, it is certainly true that the subject of framing is enjoying a genuine revival in terms of the interest and attention devoted to it by curators and collectors alike. The frames included in this exhibition have been acquired as a result of recent efforts to provide high quality antique frames for some of the more important paintings in the collection, including those by Wtewael, Strozzi, Baburen, Terbrugghen, Rubens, Cavallino, De Ring, Van Huysum, Magnasco, Vigée Le Brun, Ingres, Monet, Pissarro, Van Gogh, and Gauguin. Replica period frames have been made for works by Gossaert, Guercino, and Van de Velde. This department's choices are guided by a general but not slavish concern for historical authenticity, that is, by the desire to unite a painting with a frame whose origins are similar in terms of geography and chronology and, if possible, was made for the same category or type of painting (e.g., a landscape frame for a landscape picture). Almost invariably, it is in such a visual context that an Old Master is shown to best advantage. For some periods or schools — like the French Impressionists — it is difficult to know whether all or individual artists had specific notions about the kinds of frames they wanted round their paintings, and in such cases relatively simple, traditional models prove most satisfactory.

These splendid frames are outstanding representatives of very different traditions. The larger and earlier of the two was purchased for the re-framing of Caravaggio's *Saint John the Baptist* (52-25). The pattern became popular in central Italy in the second half of the 16th century, but original examples can be found on paintings from the first quarter of the 17th century, too, by contemporaries of Caravaggio like Orazio Gentileschi and Jacopo da Empoli. The lines are simple and severe and the carved ornamentation has a quiet elegance due to its regularity and restraint. This large, upright version of the model (there are many related variants) would have been made for an average size altarpiece or perhaps a full-length portrait. Its height has been reduced by only a few inches to fit the Caravaggio painting, but otherwise its state of preservation — including the original gilding — is exceptional. The frame's generous proportions impart to it an air of dignity that befits the solemnity of the painting, while the geometry implied by the decoration of the panel is an effective foil to the geometry of the composition itself.

The other is a magnificent specimen of one type of mid 17th-century frame favored by the Dutch. Massive in construction and distinguished by prominent projecting corners, the original forged iron hanging hook has been retained at the top. Clearly the frame was made and has been continuously used for a portrait. In a coincidence of astonishing rarity, it was discovered that the unaltered frame exactly fit the Museum's *Portrait of a Youth* (31-75) by Rembrandt, signed and dated 1666. While it should not be inferred that this frame was specifically original to the Museum's painting, its date, type, and scale make them a perfect match. The sobriety of the frame's coloring emphasizes the monumentality of its design, the rigorous elegance of its carving, and the intricacy of the interplay of its many planes, surfaces, and shaped moldings. Against such a background — notable for its abstraction — the portrait emerges from its surroundings and acquires a volumetric presence which was severely inhibited by the picture's previous gilt French frame with organic motifs.

R.W.

Department of American Art

Donors to the Department 1977-1987

Mr. and Mrs. Adam Aronson
Mrs. R. Kirk Askew (in memory of R. Kirk Askew)
Mr. and Mrs. Joseph S. Atha
Mrs. Thomas King Baker
Mr. and Mrs. C. B. Ball
Geraldine M. Barrows Bequest
Thomas L. Beckett (in memory of Samuel F. and Ethyl Knapp Beckett)
Ralph A. Beebee
Mr. and Mrs. Robert L. Bloch
Eleanore C. Blue
Mrs. Peter T. Bohan Bequest
W. J. Brace Charitable Trust
Esmee and Shepherd Brooks
Mrs. Edgar J. Bumsted Bequest (in memory of Mrs. Charles C. Madison)
Mrs. George H. Bunting, Jr.
Ruth Burrough
Mrs. Alfred B. Clark Fund
Pauline Atterbury Dierks (in memory of Mae G. Sutherland)
Mr. and Mrs. Thomas Dunnicliffe
Mr. and Mrs. Robert A. Long Ellis
John Robert Flynn
The Friends of Art
Mr. and Mrs. John K. Goodman
Mrs. Frederic James
Maurine F. Jones
Mr. and Mrs. Ewing M. Kauffman (in commemoration of the Kansas City Royals Baseball Club's World Series Championship)
Enid and Crosby Kemper Foundation
Enid and Crosby Kemper Foundation (in memory of Jerome H. Scott)
Mr. and Mrs. R. Crosby Kemper, Jr.
Arthur M. Kraft
Roger C. Lee
Mrs. John D. Leland
Mr. and Mrs. Frank Lipari
Jacob L. and Ella C. Loose Foundation
Milton McGreevy Bequest
James Maroney
Felicia Meyer Marsh Bequest
Mila Mitchell

National Academy of Design (Mrs. William Troost Brewster Bequest)
Mrs. Edwin Neal
Mrs. Herbert O. Peet
Roma Wornall Powell
Mrs. George Reuland
Mr. and Mrs. Marvin Rich
Henry G. Riegner
Mr. and Mrs. J. Woodson Rollins
Miriam Babbitt Simpson Bequest
Mrs. Louis Sosland
Helen F. Spencer Bequest
Doris Jones Stein Foundation
Richard J. Stern
Charles T. Thompson Fund
Virgil Thomson
Julia and Humbert Tinsman
Elsa C. Trabold
Union Pacific Foundation
Charles van Ravenswaay (in memory of Clyde and Mae Reed Porter)
Yellow Freight System Foundation

MARY CASSATT
American, 1844-1926
Au Théâtre (Lydia Seated in a Loge),
c. 1879
Pastel on paper, 55 x 45.1 cm.
Acquired through the generosity
of an Anonymous Donor. F77-33.

After four years of dreary, traditional training at the Pennsylvania Academy of Fine Arts, Mary Cassatt left for Paris in the summer of 1866. Except for a few trips back to America, she was to remain in France for the rest of her life. She met Edgar Degas in 1877 and developed a lifelong admiration for his work.

Cassatt owed much of her knowledge of pastel technique to Degas. The French artist taught the American his elaborate method of mixing the chalks with turpentine or spraying steam on the work surface. This created a malleable paste which he could work with a brush. Cassatt, following the technique of Degas, built up layers of brilliant color, as one would in an oil painting, and then, to vary texture and lend a feeling of vibrancy, used the pastel on top in the normal linear fashion.

The Nelson-Atkins picture shows a young woman poised on the edge of her chair, enthralled by the performance and anxiously clasping her hands. It was first exhibited at the Fifth Impressionist Exhibition in 1880 under the title *Au Théâtre* where it elicited outrage among those opposed to Impressionism. Philippe Burty in his article for *La République Française* described it in memorable terms as: ". . . a young person with a fish face and orange hair who is dressed in yellow muslin seated on a tomato-colored sofa; the reflection of the furniture, costume, and hair in the mirror vaguely suggests the image of a basket of fruit." Several critics compared Cassatt's work to that of her mentor, Degas, and regarded it unfavorably as less skillful in execution. Today, on the other hand, it is generally regarded as one of her most brilliant and characteristic pastels—distinguished, especially, by its dazzling color and vigorous technique.

Numerous paintings and pastels by Cassatt have been described as likenesses of her elder sister Lydia, who came to live with her in 1877. The Nelson-Atkins pastel traditionally has been entitled *Lydia leaning on her arms, seated in a loge*. The figure represented differs noticeably in appearance from the firmly documented portait of Lydia in Cassatt's painting of *Five O'Clock Tea* (Boston, Museum of Fine Arts), executed about the same time as the Kansas City pastel. In fact, *Au Théâtre* seems to portray Lydia's companion in the Boston painting, an attractive, red-haired young woman who remains unidentified.

J.H.

70

WILLIAM SIDNEY MOUNT
American, 1807-1868
Winding Up, 1836
Oil on panel, 46.6 x 37.8 cm.
Gift of the Enid and Crosby
Kemper Foundation. F77-39.

William Sidney Mount's oeuvre contains many courtship scenes, their subjects derived not only from the genre traditions of 17th-century Netherlandish and 18th-century British painting, but also from uniquely American literary sources. Among the latter were the comic "Yankee plays" performed in New York City from the mid 1820s onwards—themselves much influenced by courting poems created by urbanites who sought to satirize the popular, romantic verse of their rural neighbors. A character appearing frequently in such plays was the bumbling rustic lad, "Yankee Jonathon," who pursued a variety of female characters but never managed to win the hand of any of them. Contemporary critics perceived a connection between the male figure in Mount's *Winding Up* and the hapless Jonathon, for presumably the young man in the painting hopes to win the favor of the rather stylishly dressed young woman standing before him. Like one of the *Parcae* of Antiquity she winds up a ball of yarn; when this is finished, the man's fate will be decided: the outcome of his suit, indeed his future happiness, are dependent upon her response. Given Yankee Jonathon's conspicuous lack of success it might be presumed that the young man will be rejected, but his female counterpart seems so demure, with her lowered eyes and dainty pose, that it remains uncertain whether she will, in fact, refuse him. The young woman is neither so brash as the females in the Yankee plays, nor does she, like them, seem to mock her suitor. Instead, her manner suggests she may accept his proposal. Possibly Mount was implying that this courtship is indeed "winding up" triumphantly, in marriage.

J.H.

71

FREDERIC EDWIN CHURCH
American, 1826-1900

Jerusalem from the Mount of Olives,
1870

Oil on canvas, 137.2 x 214.5 cm.
Gift of the Enid and Crosby
Kemper Foundation. F77-40.

In contrast to Church's journeys of the 1850s and '60s to the remote reaches of the Arctic and South America, his long trip to Europe and the Middle East from the autumn of 1867 until the spring of 1869 took him to lands of ancient cultures and continuous civilization. Beirut was his headquarters during an extended sojourn in the Levant, and he first encountered Jerusalem early in 1869 en route to the ancient Roman city of Petra, in modern-day Jordan. On the return, Church was disappointed to find that few of the city's original buildings had survived intact; nevertheless, he found that from the unspoilt Mount of Olives one enjoyed a breathtaking panorama of the city surrounded by the Judean hills. Enthralled, Church made scores of drawings and oil studies and even hired a photographer to complete his visual record. After two weeks in Jerusalem, Church returned to Beirut where, in his temporary studio, he made the sketches that later evolved into one of his most striking paintings.

After his return to America, Church finished the large canvas and exhibited it at Goupil's Gallery in New York. Its topographical accuracy and wealth of architectural detail created something of a sensation: the crowds who flocked to see it were provided with a printed key that identified approximately twenty-five major sites of the Holy City. While most critics gave positive reviews of the picture others were less favorably impressed and complained that the landscape was little more than a giant map of the densely clustered city. The spectacular sky has always been regarded as one of the more successful of Church's career, and the artist himself maintained that the *Jerusalem* was his finest work. His own estimation of the picture may have been due, in part, to its role in reaffirming Church's deeply-grounded religious convictions during a period of spiritual uncertainty.

J.H.

GILBERT STUART

American, 1755-1828

Portrait of Dr. William Aspinwall, 1814/15

Oil on panel, 71.1 x 57.5 cm.

Gift of Esmee and Shepherd Brooks. 81-35.

Like many other early American painters, Stuart studied with Benjamin West at the Royal Academy in London. However, because of financial and legal difficulties, Stuart returned permanently to the United States in 1793. There he lived successively in New York, Philadelphia, Washington, D.C., and Boston.

He proved to be especially popular in Boston. There he made the Nelson's portrait of Dr. Aspinwall during the years 1814-15. Aspinwall's daughter, Susanna, commissioned the portrait: she and her husband, abolitionist Lewis Tappan, were its first owners.

William Aspinwall participated in the American Revolution, first taking part in the Battle of Lexington and then serving in a different manner, as a surgeon. In 1778, Aspinwall again fought with the army in Rhode Island. On his return to civilian life, Aspinwall ran the second hospital in the United States to treat smallpox by innoculating the patients.

Stuart painted the doctor's left eye more brightly than his right. He did so because Aspinwall was blind in his right eye. Some explain this by blood poisoning, but a more intriguing story states that Aspinwall blinded himself as a youth while playing with a bow and arrow. The arrow slipped out of the bow as he pulled it back.

The bust format of *Dr. Aspinwall* is typical of Stuart's Boston work, as is the marvelous handling of flesh tones. Stuart created his skin color not only with whites and pinks but with blues, greens, and greys that evoke the appearance of veins showing through the translucent surface.

The portrait remained with the descendents of Dr. Aspinwall until it was presented to the Museum. According to one family story, the canvas was almost destroyed during the anti-slavery riots in New York when it hung in Lewis Tappan's home. A crowd mobbed the abolitionist's residence and burned his furniture but decided not to destroy the likeness of Aspinwall. They mistakenly took it for Stuart's Athenaeum portrait of George Washington.

J.H.

THOMAS EAKINS
American, 1844-1916
Portrait of Monsignor James P. Turner, c. 1906
Oil on canvas, 249.9 x 106.7 cm.
Gift of the Enid and Crosby Kemper Foundation. F83-41.

Thomas Eakins occupies a position of unique importance in American art. A man of varied accomplishments, he was a painter, sculptor, photographer, anatomist and teacher. So rich is the fabric of his life that it reads like a commentary on the visual arts in late 19th-century America.

Born and raised in Philadelphia, Eakins entered the Pennsylvania Academy in 1862 to study drawing and anatomy. A man of strong intellectual interests, equipped with a fine education, he was already fluent in French and Italian by the time he left for France in 1866 to study with Jean-Léon Gérôme at the Ecole des Beaux-Arts in Paris. After extensive European travel, Eakins returned to Philadelphia in 1869 and, except for occasional domestic trips, he remained there for the rest of his life.

Eakins emerged as America's foremost realist artist in the 1870s. He brought to his work a remarkable sense of time and place that prefigured his own pioneering efforts in photography and that still seems fresh and modern one hundred years later. Yet Eakins's career was crowded with controversy. His uncompromising attitudes concerning human anatomy and detailed accuracy, epitomized in his famous picture *The Gross Clinic* (1875), stirred antagonistic feelings within an audience more accustomed to the mundane platitudes of Salon-style painting. Whether depicting scull races on the Schuylkill, the surgical amphitheaters in Philadelphia, or the smoky atmosphere of the boxing ring, Eakins conveyed an uncanny sense of authenticity that often proved too strong for the conservative public of his day, however compelling it may seem a century later.

To a long tradition of American portrait painting, Eakins brought a capacity for character study and psychological insight that prompts comparison with Rembrandt and Velázquez. Given the generally negative reaction to his work, and modest record of commissions, Eakins frequently invited individuals in whom he took a personal interest to sit for portraits. As a result, Eakins's portraits are heavily populated with doctors, professors, musicians, and intellectuals of one variety or another. About 1900, he began a series of portraits of Catholic clerics, most of whom were associated with the Philadelphia seminary of St. Charles Borromeo. The last of this series, a full-length image of Monsignor James P. Turner, was painted in or around 1906. It ranks among the artist's greatest works.

Turner is depicted in the vestments of his office of Protonotary Apostolic, presiding at a funeral service. The narrow, vertical format of the canvas and statue-like stillness of the monsignor, who stares out into the space of the church as if completely absorbed in thought, impart a formal intensity to the portrait that is exceptional even in the work of Eakins. Amazing, too, are the bravura brushwork and scintillating color of Father Turner's robes. Eakins's normally dark palette becomes almost phosphorescent through a juxtaposition of hot reds and pinks. In a remarkable demonstration of pure painting, the artist has laid down water-thin glazes alongside rough, scumbling brushstrokes, revealing an enviable capacity to work his pigments wet into wet without losing the vibrancy of their color.

It is, of course, the vividness of the color that immediately commands the viewer's attention. Further contemplation is required to appreciate the depth of Eakins's characterization of the monsignor. In recording Turner's rugged, plain features, Eakins has painted a profoundly moving image etched by sadness but full of charity—one that is more than a convincing likeness, for it is also something of a symbol for the humanity of the Church. Thus he has achieved a kind of universality in a single figure that is the distinguishing feature of all great portraiture in the Western tradition.

J.G.

GEORGE BELLOWS
American, 1882-1925
Pueblo Tesuque, No. 2, 1917
Oil on canvas, 87.4 x 112.7 cm.
Gift of Humbert and Julia
Tinsman. F84-65.

Pueblo Tesuque, No. 2 was executed during the summer of 1917, when Bellows, his wife, and his two daughters, spent a month in Santa Fe, New Mexico, with Robert Henri. At the time, Santa Fe was just beginning to become a popular resort for artists. Bellows's friend Leon Kroll was in Santa Fe at the same time, and not far away in Taos, Mabel Dodge Luhan, who had married an Indian, maintained a coterie of artists and intellectuals that included such figures as Marsden Hartley and D.H. Lawrence.

Tesuque pueblo, located just north of Santa Fe, on a small tributary that feeds into the Rio Grande, was a natural spot for Bellows to paint. It is the Indian pueblo closest to Santa Fe, being less than half an hour away by car. Bellows painted the most prominent buildings on the plaza: the white adobe church on the left, and the house of the governor on the right. To increase the drama of the painting, he greatly exaggerated the height of Mount Baldy in the distance, a peak of the Sangre de Christo range.

Ceremonial dances are often held in front of the buildings Bellows depicted, but he chose to concentrate instead on daily life. Like many of Bellows's paintings, *Pueblo Tesuque, No. 2* was clearly executed in a short space of time—probably just one or two outdoor sessions. Bellows liked to work quickly and intuitively, wielding his brush with the spontaneous dexterity of a natural athlete.

The rich coloration of the work, with its lavish use of shades of purple, mauve, and cyan, reveals the influence of the paint manufacturer and color theorist, Hardesty Maratta, whom Bellows had met a few years before. When Bellows started his career, artists traditionally worked with just a few primary colors, and relied on mixtures of pigment to obtain intermediate shades. Maratta, however, introduced a wide range of colors in tubes, making possible a more brilliant and numerous range of hues without the dullness that comes about through mixing. Bellows enthusiastically adopted Maratta's palette, and consequently his late paintings are generally far more brilliant in tone than his earlier work. In *Pueblo Tesuque, No. 2*, the strange colors contribute to the exotic mood of the piece and bring to mind Delacroix's studies of Arab life, executed in North Africa a century earlier.

H.A.

75

JOHN FREDERICK KENSETT
American, 1816-1872
A Woodland Waterfall, c. 1855
Oil on canvas, 101.6 x 86.4 cm.
Acquired through the generosity of Mrs. George Reuland through the W. J. Brace Charitable Trust and The William Rockhill Nelson Trust, by exchange. 86-10.

For many years Kensett worked as an engraver of banknotes in New York City, and in this trade he developed the ability to handle meticulous detail that undoubtedly influenced his later style of painting. In New York he befriended John W. Casilear, a noted painter of scenery, who urged him to turn to landscape painting. In 1840 Kensett abandoned engraving and set off for Europe with Casilear and two other artists, Asher B. Durand and Thomas P. Rossiter. For seven years Kensett lived in Europe, spending much of his time in London, but also making sketching excursions to Germany, Switzerland, and Italy. After he finally returned to the United States in 1847, Kensett exhibited some landscapes of Italy at the National Academy of Design, where they received considerable praise. In the following year he was elected as Associate Academician, and in 1849 a full Academician. Kensett died tragically in 1872 while at the height of his powers. He contracted pneumonia after trying to save the wife of a friend whose carriage had slipped into the sea off the causeway to Contentment Island in Connecticut.

Kensett's fame today rests on his mastery of three types of painting: the luminist coast scene, usually the beach at Newport, Rhode Island; the inland body of water, usually Lake George; and the forest interior. His paintings are delicate and subdued in mood and painted with an extremely subtle and delicate tonal range. The execution is invariably detailed and fine, although it never becomes hard and linear but always retains a painterly character. Kensett favored intimate scenes and provided his contemporaries with an alternative to the more bombastic work of Albert Bierstadt and Frederic Church. He used his summers for sketching expeditions and tended to finish his paintings during the winter in New York City at the 10th Street Studio.

A Woodland Waterfall may well be the most masterful of Kensett's forest scenes. Its light effects and intensity of observation are reminiscent of Asher Durand's on-the-spot outdoor studies of woodland motifs. Most likely, though, Kensett's picture was executed in his studio. In fact, it probably does not depict an actual site. Once identified as Catskill Falls, the painting appears to be a composite, created from sketches made at various locations. One major pentimento is visible at upper left. There Kensett painted over some trees on a rocky ledge, to simplify the composition. The canvas contains no figures, which is relatively rare in Hudson River School paintings, though more common in the work of Kensett than that of the artists of the time.

H.A.

76

JOHN SINGER SARGENT
American, 1856-1925
Mrs. Cecil Wade, 1886
Oil on canvas, 161.25 x 134 cm.
Gift of the Enid and Crosby Kemper Foundation. F86-23.

John Singer Sargent, the greatest society portraitist of his age, was born in Italy, the son of American expatriates. Although he spent little time in the United States, he never gave up his American citizenship. He received his artistic training in Paris from the fashionable portraitist Carolus-Duran, who was much influenced by Velázquez. Sargent quickly assimilated his teacher's methods, and soon developed even greater facility than the French painter.

Mrs. Cecil Wade was painted at a time of crisis in Sargent's career, when he was just 30 years old. His painting *Madame X* (now in The Metropolitan Museum of Art, New York), a portrait of the notorious Madame Pierre Gatreau, provoked a scandal at the Paris Salon of 1884. The controversy that followed dried up Sargent's French clientele, and for a time he considered giving up painting to concentrate on business or music.

Instead of abandoning painting, though, Sargent abandoned France. In 1886, on the urging of Henry James, he moved to England, where he took up Whistler's former studio at 33 Tite Street. *Mrs. Cecil Wade* appears to have been the first significant commission that Sargent received after this move. The subject (née Frances Frew) was married in 1863 to a wealthy stockbroker with literary and artistic tastes, who commissioned the portrait when first introduced to the painter. Sargent executed it in the Wades' London home in Gloucester Place; it shows Mrs. Wade in the opulent gown of cool white satin in which she had been presented to Queen Victoria. She is seated on a settee that was later destroyed in an air raid in the Second World War, and in the dim background one can just make out a cabinet, a music stand, and a piano.

Mrs. Cecil Wade forms a fascinating pendant to *Madame X*, which Sargent executed in Paris just two years earlier. Both paintings stress the hourglass silhouette of the figure and the dramatic and elegant profile of the head. *Madame X*, however, with her black dress, lavender complexion, and daring decollatage, seems corrupt and jaded, whereas *Mrs. Cecil Wade*, in her white satin, appears prim and impeccably correct, and conveys a self-assurance remarkable for a young woman of twenty-three. According to a descendant of the sitter, Mrs. Wade "found the young artist very shy and difficult to talk to during the sittings. But then she was also very shy and reserved."

Sargent always placed his easel within a few feet of the sitter so that both his model and the canvas would rest in the same light. He would stand back, appraising the effect, and then rush forward at the canvas, wheezing and gasping and muttering imprecations to himself in the absorption of creation. He never retouched a brushstroke; if he erred he would scrape off the area completely and start again. In the 1880s Sargent's free brushwork was still considered "audacious" and "eccentric" in England, but his virtuosity commanded attention. "The painting is of a most dashing sort," a critic for the *Art Journal* noted in 1887 of the portrait of *Mrs. Cecil Wade*. "The wonderful rendering of the dress and background cannot fail to evoke admiration."

H.A.

CHILDE HASSAM
American, 1859-1935
The Sonata, 1893
Oil on canvas, 81.3 x 81.3 cm.
Gift of Mr. and Mrs. Joseph S. Atha. 52-5.

Although he became the central figure of the American Impressionists, Hassam discovered Impressionism relatively late in his development. His conversion took place shortly after his marriage in 1886, at the time of his second trip to France, a sojourn that lasted three years. Returning to New York in 1889, he painted *The Sonata* in 1893, the year that he moved from the Chelsea Hotel to a studio at 152 West 57th Street, where he worked for the remainder of his career.

Even though Hassam's work was considered advanced, by the 1890s Impressionism was no longer vilified by the public, and he exhibited regularly in the shows of such conservative organizations as the Society of American Artists. In 1898 he joined a group called "The Ten" which championed Impressionist techniques. From the 1890s on, he was showered with ever-increasing recognition until his death in 1935.

Unlike many of the other American Impressionists, Hassam never established direct contact with the grand masters of Impressionism, not even with Claude Monet, the figure whose work most closely resembles his own. Instead, he picked up the Impressionist style indirectly, from attending exhibitions and through academic imitators of the style. His Impressionism was never pure, but rather combined the rich coloristic effects of French Impressionism with more academic tendencies.

The Sonata, by no means a typical Impressionist work, lifts many features from other schools of painting. It is at once a figure piece and a still life, as suggested by one of the alternative titles under which it was exhibited in the artist's lifetime, *The Marechal Neil Rose*. The figure of the woman brings to mind a whole series of images of women in white by Victorian painters, such as the English Pre-Raphaelites and Whistler. The presentation of this mysterious female suggests the influence of the more decoratively oriented French symbolists such as Edmond Aman-Jean. Like many symbolist works, it exploits synesthesia (the evocaton of one sensation through another): the rose, for instance, evokes the sense of smell and the piano the sound of music. A second alternative title, *Beethoven's Sonata Appassionata*, highlights the picture's mood of romantic passion.

The present painting ranks among Hassam's masterpieces, not merely for the complexity of its thematic concept, but also for its remarkably skillful handling. The rendering of the figure (not usually one of Hassam's strong points) is accomplished and confident. The use of color displays exceptional originality, as in the pinks and mauves that lead into the white dress, and the dashes of vermillion that enliven the piano keys.

The painting has a complex and distinguished provenance: in the early 1920s, it belonged to the great collector of French Impressionist and American modernist painting, Duncan Phillips, the founder of the Phillips Collection in Washington, DC. In 1928, however, Hassam repurchased it through Mrs. Gerald Thayer, daughter-in-law of the American Impressionist Abbott Thayer. Hassam then bequeathed it to the American Academy of Arts and Letters in New York. They sold it, via the Milch Galleries, to Archer and Anna Hyatt Huntington, who in turn donated it to the Carolina Art Association. The latter deaccessioned it in 1951. Mr. and Mrs. Joseph Atha of Kansas City purchased *The Sonata* through the Milch Galleries and presented it to the trustees of The William Rockhill Nelson Trust a year later, in 1952; like cat. 78, the painting actually entered the Museum following Mrs. Atha's death in 1986.

H.A.

MAURICE PRENDERGAST
American, 1859-1924
Castle Island
Oil on canvas, 47 x 71.4 cm.
Gift of Mr. and Mrs. Joseph S. Atha. F58-27.

Except for occasional trips to Europe, Prendergast worked almost his entire life in Boston. In the 1890s he studied art in Paris and there fell in with the gifted Canadian painter, James Wilson Morrice, who had discovered the work of the Nabis and the Post-Impressionists. The two joined a small circle of writers and painters who frequented the café Chat Blanc in Montparnasse that included the English painters Walter Sickert and Aubrey Beardsley, and writers such as Somerset Maugham. Rejecting the advice of his teacher, Jean Paul Laurens, that he should work from the antique and plaster casts only, Prendergast instead drew entirely from life, choosing his subjects from the city's parks and boulevards.

Unlike other American painters of his time, Prendergast absorbed the innovations of the Post-Impressionists. He used color not simply to represent external reality, but for its own abstract, expressive qualities, applying his pigment in broken dots and patches to create a decorative, mosaic-like effect. At the time of the famous Armory shows of 1913, which introduced American artists to European modernism, Prendergast was the only American painter whose work was as advanced in formal terms as that of the leading French painters.

Prendergast gained notoriety in his lifetime as a member of "The Eight," the band of painters led by Robert Henri that led the revolt against academic painting. Yet in many respects, he stood apart from the rest. Most of the others practiced a dark toned, gritty urban realism, which won them the epithet "The Ash Can School." Prendergast, on the other hand, favored cheerful, sun-filled scenes in radiant colors, filled not with paupers and derelicts, but with well behaved children and pretty women. All the same his work was singled out for unusually strong criticism.

An eccentric perfectionist, Prendergast became notorious for repainting his canvases. By dragging dry pigment with a stiff brush across a rough, loosely stretched canvas, he built up an irregular, chalky surface which glowed with a mysterious brilliance. Because of this habit of constant reworking, paintings such as *Castle Island* are difficult to date. The Boston locale of *Castle Island* suggests that it was at least started in Boston, probably in the period between 1912 and 1914. When it was completed is another question. The canvas was apparently never exhibited in Prendergast's lifetime, and it may well have been reworked by him up until the time of his death. Close study of the surface reveals many alterations and changes. For example, the boulder on the hillock to the right seems to cover what was once a human figure. The Prendergast signature at the lower left may well have been added after the painter's death by his devoted brother Charles.

Castle Island in Boston harbor, the ostensible subject of the piece, has a gloomy history. Edgar Allen Poe perfected his morbid temperament there during a five-month stint with the army. In 1891, however, a long plank bridge from Marine Park finally linked the isle to the mainland, and it became a fashionable spot for picnics and promenades.

The title of the painting, indeed, seems almost arbitrary, for increasingly Prendergast arranged his figures in similar decorative patterns, whether his subject was Castle Island, Gloucester, Annisquam, or Franklin Park. Most of his oil paintings, in fact, were not painted from life, but were created in the studio. The present composition is often repeated in Prendergast's later work; an identical scheme appears in his *On the Beach, No. 3* (Cleveland Museum of Art), which he painted in 1918.

H.A.

79

THOMAS HART BENTON
American, 1889-1975

Persephone, 1938

Oil on canvas, 180.3 x 133.3 cm.

Acquired through the generosity of the Yellow Freight Foundation Art Acquisition Fund, Mrs. H. O. Peet, Richard J. Stern, the Doris Jones Stein Foundation, the Jacob L. and Ella C. Loose Foundation, and Mr. and Mrs. Marvin Rich. F86-57.

Generally considered the masterpiece of Benton's easel paintings, *Persephone* was created in 1938 in the midst of the artist's painting class in the old greenhouse painting studio at the Kansas City Art Institute. Roger Medearis, who was studying with Benton at the time, has recalled: "Other students, working from the same model, were making small *Persephones* as seen from various locations around their teacher. . . . My impressions of *Persephone* were so vivid that today I clearly remember one tiny bristle from Benton's brush, stuck to the surface of the painting and left to stay there as an integral part of the work, as if a token of the master's touch."

Persephone both pays homage to and is a spoof of Old Master painting: it revitalizes an ancient theme by placing it in a modern Midwestern setting. *Persephone*, the classical goddess of spring, has become a skinny-dipping, sunbathing corn-fed American girl, and Pluto, the lust-filled god of the underworld, a grizzled old hillbilly. Benton, in fact, already had stirred up a fuss with a similar painting of a nude, *Susannah and the Elders* (Fine Arts Museums of San Francisco), which was nearly banned from the exhibition *West of the Mississippi* held at the St. Louis Art Museum in 1939. Nudes, of course, were nothing new in painting, but Benton gave the subject an almost vulgar piquancy by showing Susannah with a modern cloche hat and high-heeled shoes, peered at by elders who had arrived in a Ford roadster. Like this painting, Benton's *Persephone* attracted attention from the moment it was conceived. A year after it was completed the influential critic Thomas Craven described it as "expertly composed and beautifully painted," and "unsurpassed by anything thus far created in America."

In 1939 *Persephone* was the central work in Benton's first major retrospective, held at the Associated American Artists Gallery in New York. This exhibition led indirectly to Benton's dismissal from the Kansas City Art Institute. Well aware of the controversy that was circulating about *Susannah*, Benton, in a rare moment of caution, decided to call his new painting *Persephone*, rather than *The Rape of Persephone*— its original title. But when Benton arrived in New York for the opening of his show, his tongue got the better of him. He remarked to a reporter that he considered art museums "graveyards" for art and declared that, "I would rather exhibit my pictures in whorehouses and saloons where normal people would see them." By the time Benton had returned to Kansas City he had been ousted from his job.

Not long afterwards, Billy Rose, the famous nightclub entrepreneur, invited Benton to display *Persephone* at the Diamond Horseshoe in New York. Benton accepted the offer but took back the painting when he discovered that the bright lights in the saloon were cracking and damaging it.

Benton's critics were not entirely wrong when they described *Persephone* as "a barroom nude." Benton had a long-standing interest in such paintings and years before, as a young artist in Chicago and New York, he had befriended Jack Armstrong, the creator of the first calendar girls. Benton's image of *Persephone*, however, is visually and emotionally more complex than a mere pin-up. Benton skillfully harmonized the sensuous figure of the naked woman with the sinuous curves of the landscape to create an equation between woman and nature. One contemporary critic even suggested the painting expressed environmental concerns.

From the technical standpoint, *Persephone* is the most complex and elaborate of Benton's easel paintings. An article of 1940 by Gibson Danes documents Benton's painstaking development of the composition from early sketches and a clay model to the finished canvas. Benton was interested at this time both in the work of the Flemish primitives and that of his friend Grant Wood, and this led him to take a new interest in textures. To get the rich color and detail he wanted he first executed the painting in tempera and then went over it with delicate glazes of oil to add depth and translucency to the effect. Every plant and flower was based on meticulous preliminary studies.

H.A.

Department of Twentieth-Century Art

Donors to the Department 1977-1987

Anonymous
Dr. and Mrs. John Arnold
Adam Aronson
Mr. and Mrs. Adam Aronson
Mr. and Mrs. Russell W. Baker, Jr.
Mr. and Mrs. Henry W. Bloch
Mr. and Mrs. Robert L. Bloch
Karen Johnson Boyd
Karen Ann Bunting
Coe-Kerr Gallery Fund
Byron and Eileen Cohen
Joseph and Robert Cornell Memorial Foundation
Douglas Drake and Elisabeth Kirsch
Gertrude B. Drake
William L. Evans, Jr.
Mr. and Mrs. William L. Evans, Jr.
Hermine Floch Bequest
The Friends of Art
Dorry Gates
Jennifer A. Gille
Mr. and Mrs. Ronald K. Greenberg
James Gross
The Guild of the Friends of Art
The Guild of the Friends of Art (in memory of Susan Buckwalter)
Hallmark Cards Incorporated
Richard A. Hirsch
Richard Hollander (in memory of Jean S. Lighton)
Rheta Sosland Hurwitt
Cynthia Warrick Kemper (in memory of Mr. and Mrs. Dupuy Goza Warrick)
Enid and Crosby Kemper Foundation
Enid Jackson Kemper Memorial Fund
David Kluger
James T. Lacy
Dr. and Mrs. Burnell Landers
Elizabeth Layton (in honor of the Sustaining Members of the Junior League and the Mid-Four Exhibition)

Jean S. Lighton
Jean S. Lighton and three Anonymous Donors
Mrs. Charles E. McArthur
Mrs. Milton McGreevy
Robert H. Mann
Mr. and Mrs. Robert H. Mann, Jr.
Felicia Meyer Marsh Bequest
Robert Miller
Mr. and Mrs. F. Russell Millin
The Morgan Family
The Morgan Gallery
Jim Morgan Memorial Clay Collection
Mr. and Mrs. Jerome Nerman
Norman and Elaine Polsky/Fixtures Furniture
John R. Rippey, Jr.
Mrs. Louis Sosland
Mr. and Mrs. David Soyer
Mr. and Mrs. Harry Spiro
Althea Viafora Gallery
Peter Voulkos
Mr. and Mrs. Earl D. Wilberg
Mrs. Oliver Wolcott
John R. and Mary Louise Womer

JOSEPH CORNELL
American, 1903-1972

Pantry Ballet (for Jacques Offenbach), 1942

Mixed media, 26.7 x 46 x 15.4 cm.

Acquired through the generosity of The Friends of Art. F77-34.

Cornell spent nearly all of his life in Flushing, New York. Since he had no formal schooling in art, most of his training was the result of the lively artistic climate that existed during the early 1930s in New York City. At the Julien Levy Gallery, which opened there in 1931, he met most of the painters and writers associated with the Surrealist Movement who were in the United States prior to the Second World War.

Cornell's fascination with the collage was inspired by seeing Max Ernst's collage-novel of 1929. This and other works were shown at the Levy Gallery in January 1932, in an exhibition that launched the Surrealist Movement in New York.

The *Pantry Ballet* is a light-hearted, fanciful production by America's foremost Surrealist. A lover of faraway lands who moved only once in his life (and then only thirty miles), a theater devotee whose claustrophobia prevented him from joining the audience, and an affectionate man who seldom saw anyone, Cornell is perhaps the ideal person to explore the dream world, since he lived in it the most. Exploration of memories and the world of dreams, emphasis on the unusual use of objects, incongruity of images and disregard for the laws of reason—all link Cornell to the European Surrealists, a number of whom (like Ernst) he met in New York during the late 1920s and '30s. Unlike such mainstream Surrealists, though, Cornell was not a public figure. He had no revolutionary political aims, nor do erotic or other "shocking" themes form the subjects of his "precise, mild, irrational encounters."

These encounters usually take place in boxes. Cornell wrote: "Shadow boxes become poetic theaters or settings wherein are metamorphosed the elements of a childhood pastime." While not strictly the originator of the use of shadow boxes, Cornell established and refined its form. *Pantry Ballet* reflects his passion for the ballet, and whimsical sense of humor. The red lobsters, he continued, ". . . cavort gaily about their partners, little silver spoons, while seashells and crockery nod in merry enjoyment." The fragile innocence and whimsy of Cornell's world are summed up in this dance.

D.E.S.

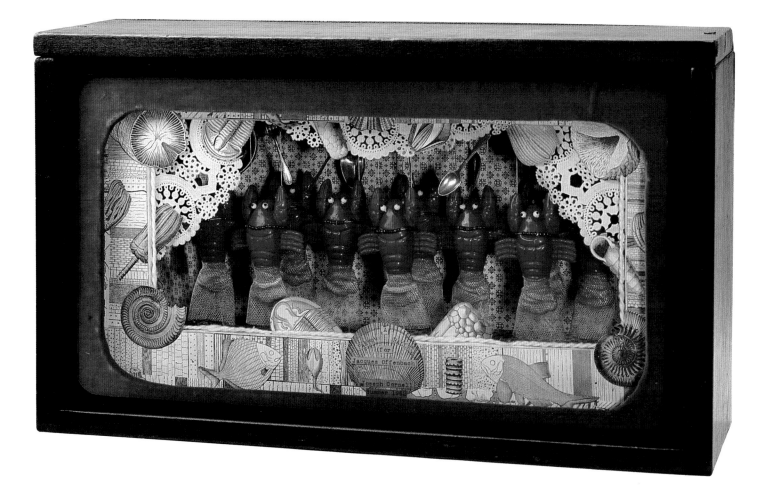

81

ROBERT ARNESON
American, 1930-
Pablo Ruiz with Itch, 1980

Glazed earthenware. Bust:
74.9 cm. (h.); pedestal column:
147.3 (h.) x 38.1 cm. (diam.)

Gift of The Friends of Art.
F82-38/a,b.

A West Coast artist, Robert Arneson couples large-scale figurative subjects with an insistent emphasis on visual pun and facetious narrative. *Pablo Ruiz with Itch*, done in 1980, is a collection of art historical puns which should, no doubt, have pleased the portrait's subject. Picasso is shown as he appeared in his *Self-Portrait* of 1907; the posture and angle of the arm are taken from *Les Demoiselles d'Avignon*. The pedestal mimics Picasso's portraits from his Dora Marr period by placing the ionic capital's volutes on the same side. In the fluting of the column Arneson includes references to the texture and form dear to Synthetic Cubism.

D.E.S.

RICHARD E. DEVORE
American, 1933-
Pot R #401, 1983
Multi-fired stoneware,
40 (h.) x 37.2 cm. (diam.)
Acquired through the generosity
of The Friends of Art. F83-62.

Born in Toledo, Ohio, Richard DeVore received degrees from the University of Toledo and Cranbrook Academy. He has taught widely and since 1978 has been Professor of Art at Colorado State University. During his tenure at Cranbrook, DeVore reexamined the aesthetic of clay from primitive times to the present. His goal was to make pottery which related to contemporary culture, while concurrently preserving links with the past.

DeVore uses two basic shapes: the deep vessel and the bowl. *Pot R#401* is the artist's largest piece to date, almost 16 inches tall. It is both delicate and elegant. The piece has an organic, subtly undulating rhythm that forces us to consider the breaks in the form and the irregular, wafer-thin edge. The creamy glaze is tinged here and there with a sensuous rose blush, creating a skinlike tonality. The color is built up slowly, the result of many firings which also create an elaborate *craquelure* pattern. Every inch of the vessel must be seen because DeVore endows the interior and exterior with a restrained but powerful surface articulation.

D.E.S.

JENNIFER BARTLETT
American, 1941-

Boy, 1983

Oil on canvas, 213.5 x 152.5 cm.
(each panel)

Acquired through the generosity
of The Friends of Art. F83-67/a-c.

Born in California in 1941, Bartlett received degrees from Mills College and Yale University. From 1972 to 1977, she taught at the School of Visual Arts in New York City, where she currently lives and works.

Bartlett's early work revealed her interest in elaborately conceived and precisely systematized formats. Her paintings were composed of 12-inch square steel plates painted with enamel and arranged together on a wall. While she now uses a more traditional medium, oil paint on canvas, she has maintained her interest in the formal quality of the unit.

Boy was conceived during Bartlett's six-month-long, less than ideal stay in Nice during the winter of 1979-80. The villa was in an unattractive part of town, it rained almost daily, and the view from where she stayed was uninspiring. Bartlett made nearly 200 exquisite drawings of the tiled pool, the reproduction *putto*, the cypress tree, and shrubs, thus revealing an ability to transcend her mundane environment. She also photographed the view and, upon her return to New York City, made eight large paintings, of which *Boy* is one, based on her photographs and recollections.

In three panels, each 7 feet by 5 feet, Bartlett juxtaposes three views of the poolside *putto* in an unpredictable and disjunctive way. From one panel to the next the boy loses his statue-like quality and becomes progressively more lifelike. Observed from different angles, he seems to gaze expectantly into the long, dark pool. Bartlett's change in viewpoint, as well as her painterly technique produces a powerful narrative effect. The mysterious quality of the painting is conveyed through a somber palette of dark blues and greens.

D.E.S.

84

NANCY GRAVES

American, 1940-

Zaga, 1983

Cast bronze with polychrome chemical patination, 182.9 cm. (h.)

Acquired through the generosity of The Friends of Art. F84-27.

A sculptor, painter, printmaker, and filmmaker, Nancy Graves studied at Vassar College and Yale University and was awarded a Fulbright-Hayes Fellowship in 1965. After spending the following year in Florence, she moved to New York City where she continues to live and work.

Graves has developed a visual vocabulary influenced by paleontology, archaeology, and anthropology, childhood interests fostered by visits to the Berkshire Museum in western Massachusetts. Unlike many artists working in bronze today, Graves uses a direct casting technique rather than the *cire perdue* method. She directly casts objects such as paper fans, sardines, fronds, and exotic vegetables. Each individual object retains its identity, acts as armature, and becomes an element of the organically shaped design. After welding the various objects together, Graves expertly applies the patina to achieve a brilliantly and eccentrically colored surface.

Zaga is an example of such assemblages of exotic, natural, and man-made objects. With monstrosa leaves, hupa ferns, and Chinese cooking scissors, Graves creates a sculpture that is at once figurative, abstract, and expressive. Anthropomorphic because of its scale (it is 72 inches high) and graceful pose, its abstract nature nevertheless dominates, as in the work's formal qualities of balance, proportion, plane, and color. The piece takes on a playful quality as it seems to deny its own weight. Elements are precariously placed on one another, seemingly suspended in motion, to form an organic and lyrical composition. Graves achieves a sense of airiness by introducing bright colors to the open three-dimensional spaces. She successfully combines the specific and the illusionistic in *Zaga* to create an exuberant and forceful work of art.

D.E.S.

85

JAMES ROSENQUIST
American, 1933-
Venturi and Blue Pinion, 1983
Oil on canvas, 197.1 x 502.9 cm.
Purchase, The Nelson Gallery
Foundation. F84-35/a-c.

From 1954 to 1960 Rosenquist earned his living as a billboard painter. This experience influenced his own work; it provided the initial impetus for dealing with issues of size, scale, distance, selectivity, and abstraction. The key to some of his earliest works, for example, is found in their presentation of scale, rather than in their commercial vocabulary. The images are so enormous we cannot see them in terms of their function or context. Instead, we are compelled to view them abstractly. In this way the images become pictures in and of themselves, rather than forms suggesting something else.

Rosenquist's current work reveals his continuing interest in such questions and problems. The recent paintings are, however, more precise, clearer, less "Pop," and more romantic. His images are more sophisticated, and further removed from popular culture. Several paintings from Rosenquist's most recent exhibition share the theme of space travel. Many elements in these works are reminiscent of his work of twenty years ago, but now the paintings seem richer and less predictable.

Venturi and Blue Pinion is an outstanding example from this latest period. Beautifully composed, the painting has an almost panoramic rhythm. The energetic center of the painting is the cosmetically perfect woman, both despite and because of the interrupting zig-zag forms. She is held in balance by the slickly painted pinion on the right, which reflects yet another set of eyes, and the ominous symbol of technology on the left. From the woman's eye issue linoleum samples. She stares out of the picture at the viewer, away from the outer space void on the left. The painting fulfills our curiosity because it is rich in imagery and energy. There is a tension created by the contrast of smoothly painted calm at left and the prominent angularity of the images on the right. The question of dominance arises, but Rosenquist, with typical skill and elegance, leaves it unresolved.

D.E.S.

ROBERT RAUSCHENBERG
American, 1925-

Tracer, 1963

Oil and silkscreen on canvas,
213.4 x 152.4 cm.

Purchase, The Nelson Gallery
Foundation. F84-70.

Robert Rauschenberg grew up in Port Arthur, Texas. It was not until he was drafted into the Navy in 1942 and stationed in San Diego that he visited the Huntington Art Gallery and there saw original paintings for the first time. The experience was a pivotal one, and led him, several years later, to enroll in the Kansas City Art Institute, and later at the Académie Julian in Paris. In 1949 he returned to the United States and entered Black Mountain College to study with Josef Albers. The following year Rauschenberg moved to New York City and commenced studies at the Art Students League. Shortly thereafter he began to exhibit his work, and his career developed steadily during the next two decades. In 1964 he received the grand prize for painting at the 32nd Venice Biennale (where *Tracer* was exhibited), and his works are represented in public and private collections around the world. Rauschenberg presently lives and works on Captiva Island, off the coast of Florida.

Together with Jasper Johns, Rauschenberg is often referred to as the co-founder of Pop Art, the school which rejected the subjectivity of Abstract Expressionism. He himself has said, "I don't want a picture to look like something it isn't. I want it to look like something it is. And I think a picture is more like the real world when it's made out of the real world." In his early works Rauschenberg employed unlikely materials, such as real stuffed animals, pillows, quilts, mirrors, clocks, furniture, and made collages and then "combines" from these non-traditional materials. In 1962 Rauschenberg temporarily abandoned the use of real objects in favor of a technique which enabled him to apply silkscreened images to canvas. The screened images derive from pictures Rauschenberg finds in newspapers and magazines and from his own photographs. Because the screens are reusable, Rauschenberg has been able to build a repertory of images which are applicable from painting to painting.

Tracer is one of Rauschenberg's most successful and beautiful screen paintings. A detail of Rubens's *Venus at Her Toilet* has been appropriated by Rauschenberg and dominates the painting as she gazes out at the viewer and at the Army helicopters. An American eagle majestically perches over an American street scene, which is possibly in turmoil. The Army helicopters and the helmeted policeman coexist with the eagle and the Venus, a symbol for beauty and love. Each image gains strength from its juxtaposition with the others, creating tension through their apparent incompatibility.

D.E.S.

JAMES DINE
American, 1935-

The Crommelynck Gate with Tools, 1984

Cast bronze in two parts with applied welded objects, 274.3 x 335.2 x 91.6 cm.

Acquired through the generosity of The Friends of Art. F84-76.

Born in Cincinnati, as Dine grew up he spent much of his time in the family's hardware store, surrounded by the tools that were later to become important images for his art. After receiving his Fine Arts degree from Ohio University, Dine moved to New York City in 1958 where he began to do performance art and exhibit work that gained him recognition as a Pop artist. Today Dine lives in Vermont and London. Early in his career, Jim Dine established a visual vocabulary which continues to nourish his work to this day. His treatment of these subjects—the robe, the heart, and the tools, for example—has gradually become more expressionistic and romantic through the years.

The gate, as a theme, is a recent addition to Dine's visual repertoire. In 1973 he began working with the French master engraver and printer, Aldo Crommelynck. For eight years Dine saw this gate—which serves as the entrance to Crommelynck's Paris home and studio—from the table where he made etchings; for him it became a symbol of France and of his friendship with Crommelynck. Since 1981 Dine has made paintings, drawings, and prints of the gate and now, in 1984, a bronze sculpture using the *cire perdue* (lost wax) technique.

Monumental in scale, the *Gate* differs considerably from the original gate, being nearly twice as large, and many of the lyrical, curving arabesques have been replaced with jagged edges, straighter support bars, and an assortment of tools, many of which are bent and twisted. Dine's drawings of tools have always been some of his most arresting works of art. Here, too, each prosaic tool has been rescued from its ordinary role and endowed with its own history.

The Crommelynck Gate with Tools is both expressive and romantic. A tension exists between the form of the gate and its embellishment. The tools seem at first so out of place and inappropriate, but the uniform golden brown patina joins the elements together and the *Gate* seems to swell with authority.

D.E.S.

FRANK STELLA

American, 1936-

Birkirkara, 1984

Metal collage: honeycomb aluminum, etched honeycomb magnesium, molded fiberglass, sheet steel and paint, 382.2 x 388.6 x 198.1 cm.

Acquired through the generosity of The Friends of Art. F84-77.

Frank Stella was born in Malden, Massachusetts in 1936. After graduating from Princeton University with a bachelor's degree in history he moved to New York City in 1950 where he continues to live and work. From the time he took up painting in the late 1950s, Stella has been firmly committed to abstraction. His austere, non-representational black paintings of the 1960s set the ground for minimal art, and his extravagantly painted abstract work from the late 1970s helped inspire the neo-expressionists. His current work shows a continued concern with abstraction, while exploring new materials.

Birkirkara is number seven from Stella's Malta series; it is named for the town of Birkirkara on Malta. Stella always works in series, exploring each pictorial idea through several permutations. First he makes maquettes of the entire series and then he executes the final pieces, often working on more than one at a time. *Birkirkara* is made of honeycomb aluminum, etched honeycomb magnesium, molded fiberglass, sheet steel, and paint.

The three-dimensional relief is an exciting collage of brightly colored curves, half-circles, organically shaped forms and cutouts. The various parts are commercially produced to his specifications, and then Stella individually embellishes them with lavishly applied paint and ink. There is a strong contrast between the hard, cold industrial materials and the lush and extravagant surface embellishment.

Birkirkara, like Stella's other work, is, of course, totally abstract. The parts are so united that no one element assumes dominance over another. The artist has concentrated on its painterly elements such as form, color, and shape, and highlighted and accentuated them. Although the result may seem loud and aggressive, Stella's intention here—like so much of his art—is essentially reductive.

D.E.S.

89

LYNDA BENGLIS
American, 1941-
Aldebaran, 1983

Bronze wire mesh sprayed with
zinc, copper, and aluminum,
162.5 x 119.4 x 55.9 cm.

Gift of Norman and Elaine Polsky,
Fixtures Furniture, Kansas City.
F85-37.

Born in Louisiana, Lynda Benglis received her Bachelor of Fine Arts degree from Newcomb College in 1964. Among the many distinguished awards she has received are a Guggenheim Fellowship (in 1975) and, in 1979, a National Endowment for the Arts Grant. Benglis has taught extensively and has shown her work in solo and group exhibitions around the world since 1969. Benglis currently lives and works in New York City and East Hampton.

Benglis developed as an artist during the late 1960s when many artists of her generation were moving away from the reductive and abstract aspects of Minimalism. Her sculpture from the early 1970s reflects this break. Although she uses industrial materials such as metal and foam, it is the expressive way she uses them that distinguishes her work from the Minimal art which preceded it. Benglis infuses each of her sculptures with meaning so that it refers to something beyond itself. She creates three-dimensional pieces that seem to contradict the cold, non-artistic nature of her materials.

Aldebaran is made of bronze wire mesh which Benglis folds like a fan, bends and twists, and then sprays with zinc. The zinc functions as a bonding agent for the subsequent layers of copper and aluminum that are then applied in liquid form, layer by layer, to create a matte finish, and a firm but sensuous form. Weighing about 100 pounds, the piece looks at once both substantive and delicate. It prompts a wide range of associations, for one is reminded of classical Greek drapery, a frilly or ruffled dress, a bow, or a two-colored flower. But the title explains the stellar shape of the object, for Aldebaran is a red star of the first magnitude that appears as the eye in the head of the constellation Taurus. Though her materials may be unconventional, with them the artist achieves a deeply satisfying union of form and content in a sculpture that seems to emit a continuous flow of warmth and energy.

D.E.S.

90

WAYNE THIEBAUD
American, 1920-
Apartment Hill
Oil on linen, 152.5 x 122 cm.
Acquired through the generosity of The Friends of Art and The Nelson Gallery Foundation. F86-4.

Wayne Thiebaud worked briefly in the animation department of Walt Disney Studios, and later studied commercial art. In the late 1940s, he decided to become a painter. He attended college and received bachelor's and master's degrees in art. During the 1950s he taught art on the college level with a one-year hiatus while he lived in New York City. It was there that he met the artists Elaine and Willem de Kooning, Franz Kline, Barnett Newmann, and the art critic Harold Rosenberg. Serious critical recognition first came to Thiebaud during the 1960s, when writers, critics, and curators linked his paintings and drawings of familiar objects to the work of Pop artists such as Andy Warhol and Roy Lichtenstein. Although Thiebaud did not vigorously protest the association, he never considered himself a Pop artist. As he stated in 1974: "I see myself as a traditional painter. I'm very much interested in the concept of realism and the notion of inquiry into what the tradition of realism is all about."

Thiebaud's concept of himself as a traditional painter dedicated to representational art is evident in *Apartment Hill*. By pushing and stretching the limits of realism, he has created a stunning image: one that is essentially realistic, but filled with abstract passages. The apartment building and other dwellings are perched precariously high above the dizzying traffic of the freeway. The hillside was painted with broad, expressionistic strokes using a deep, intense palette. Then working with the same purple, blue, and green colors, the homes were described in greater detail, creating a strong visual bond between the natural and man-made structures. The apartment building was painted using higher-valued, less intense hues. Like the hillside, the building is handled rather expressionistically within its rectangular form, revealing Thiebaud's ability to express a strong image firmly based in reality in a spare, abstract style. The freeway is populated by brightly colored automobiles and trucks, blurred to suggest motion. A tension exists between the passage of time indicated here and the motionless, monumental quality of the hill and buildings. Thiebaud surrounds both sections with a warm golden glow that makes the picture appear like an icon in an unreal, other-worldly setting.

D.E.S.

91

FAIRFIELD PORTER
American, 1907-1975
The Mirror, 1966
Oil on canvas, 184.5 x 154 cm.
Gift of the Enid and Crosby
Kemper Foundation. F86-25.

Born in Winnetka, Illinois, Fairfield Porter grew up in a financially comfortable environment which allowed him to study, travel widely, and later on to pursue his art without having to work for a living. Porter's home during his youth was filled with photographs of Italian paintings and architecture and plaster casts of Greek sculpture. He studied art history at Harvard and received his degree in 1928. That year he moved to New York City and enrolled in the Art Students League, where among his teachers was Thomas Hart Benton. While in New York Porter befriended some of the most important artists, writers, and critics of the time, among them Willem de Kooning. It was not until 1951, though, that Porter had his first one-man show. In that year he became an associate editor at *Art News*, where he wrote reviews and articles about contemporary art. He was a frequent contributor to *The Nation, Art in America, Evergreen Review*, and wrote a monograph on Thomas Eakins. Porter entered the New York art world as the Abstract Expressionists were gaining worldwide recognition. Of these, he admired only de Kooning, the one member of this movement to maintain a commitment to the figure and the European art tradition.

In his own work Porter was greatly influenced by Edouard Vuillard. Like him, Porter chose traditional subjects such as landscapes, interiors, still lifes, and portraiture. Also like Vuillard, he painted those things that were familiar and close to him. His landscapes are usually scenes from his homes in Southampton, New York, and Great Spruce Head in Maine. His portraits are of friends or family. Above all, the scenes are natural; nothing ever looks too contrived or formal.

This sense of familiarity and informality is expressed well in the portrait and self-portrait known as *The Mirror*. The artist's daughter, Katie, sits informally for her portrait, while Porter stands reflected in a mirror propped behind her stool. Despite the contrivance of full-length mirror, a casual spirit prevails. Katie, dressed in a bright orange sweater, lemon yellow blouse, and brilliantly clashing red stockings, stares blankly at the viewer. We sense very little about her thoughts and emotions, and are consequently drawn into the painting to search for other clues to its meaning. In the mirror behind Katie, we encounter the artist, a full-length figure almost devoid of facial features. His pose and costume are both revealing and puzzling at the same time. Katie is looking toward a large window which provides us with a glimpse of the outdoors painted in Porter's typical landscape style. A white light enters the room from the window, casting an enchanting, quiet spell over the scene. It should be noted that Porter's favorite artist was the Spanish painter Velázquez; *The Mirror* apparently pays homage to the artist who brilliantly used the device of a reflection in a mirror in his masterpiece, *Las Meninas*.

D.E.S.

92

SUSAN ROTHENBERG

American, 1945-

Endless, 1982

Oil on canvas, 223.5 x 144.8 cm.

Gift of Norman and Elaine Polsky,
Fixtures Furniture, Kansas City.
F86-50/2.

Born in Buffalo, New York, in 1945, Susan Rothenberg studied at Cornell and George Washington Universities and the Corcoran Museum School. Since 1976 she has received numerous awards, including a Guggenheim Fellowship in 1980. During the early 1970s she gained prominence for her large paintings of roughly outlined horses. In these paintings she explored the expressive qualities of drawing, paint application, and gesture with a limited palette and limited subject. She has created some of the most important expressionist painting of the last fifteen years.

In *Endless*, which was painted in 1982, Rothenberg continued to use the roughly outlined form (in this case a falling torso) as a vehicle for exploiting the emotive qualities of her medium and technique. *Endless* at first appears to be a very simply constructed work, but upon closer viewing one sees the vitality of the paint application, the ambiguous placement of the torso in relation to the picture plane, and the subtle variations in hue throughout seemingly monochromatic passages.

D.E.S.

Department of Prints, Drawings, and Photographs

Donors to the Department 1977-1987

AFL-CIO
Jane Abrams
Anonymous
Anonymous Fund
Howard Aronson
The Baker Gallery
Mrs. Thomas King Baker
David T. Beals III Fund
Edward C. Bernstein
Mr. and Mrs. Robert L. Bloch
Mr. and Mrs. Thomas M. Bloch
Mrs. Peter T. Bohan
Mrs. Peter T. Bohan Bequest
Steven and Diane Boody
Helen Cronin Bourke Fund
Helen King Boyer (in memory of Louise M. Boyer)
W. J. Brace Charitable Trust
Martha Jane Bradford
Marjorie Tarbell Brentari
Myron Brody
Maurice L. and Virginia Brown
Mrs. George H. Bunting, Jr.
Elisabeth C. Burchard
Robert W. Carlson
Robert W. Carlson (in memory of Milruth Carlson)
Cecil C. Carstenson
Cecil C. and Blanche Carstenson
Kurt A. Caven
Pierre Chahine
Mr. and Mrs. David Claycomb
Mr. and Mrs. Jack N. Clevenger
Ralph T. Coe
Jordon S. Cohen
Michael Collier
Cranbrook Academy of Art (Printmaking Department)
Sarah Simpson Dean
Mrs. William N. Deramus, Jr.
Mr. and Mrs. Frank M. Dimaio
John Donnelly
Gertrude B. Drake
Cynthia J. Draney
John F. Duncan
Donald Eiler, M.D.
Dale Eldred
Joseph M. Erdelac
Dr. and Mrs. Arland K. Faust
Dr. Joseph Fischoff
Peter J. Florzak
Fred C. Frick
The Friends of Art
The Friends of Art Sales and Rental Gallery
Clinton H. Gates (in memory of Medill Smith Gates)
Dr. and Mrs. Leo R. Goertz

Mr. and Mrs. Richard Alan Gray
I. Groupp
The Guild of the Friends of Art
Ladislav R. Hanka
S. S. Harrison
Jane Haslem Gallery
Walt Hasler
Nicholas Hill
Richard M. Hollander
Peter Horn
John Ittmann
Dr. and Mrs. Joseph F. Jacobs
Christo Javacheff
The Jedel Family Fund
Harrison Jedel (in honor of Sylvan and Mary Cohen Jedel)
Mr. and Mrs. Scott Jones
Lee Judge
Mrs. Arthur Kase
Mr. and Mrs. Arthur J. Kase
Ivo Kirschen
Mrs. Leonard Charles Kline
David Evans Kling
David Knaus
Elatia Harris Koepfli (in honor of Ruth Harris Bohan)
Mr. and Mrs. John Kwiecinski
Annacarol Lampe
Leawood Women's Club
Jean S. Lighton
Frances M. Logan Bequest
R. L. McCowan
Mr. and Mrs. Richard McDermott
Milton McGreevy Bequest
Mrs. Milton McGreevy
Mr. and Mrs. George L. McKenna
Carl W. Melcher, M.D.
Hugh Merrill
Bonnie Micheletti
Missouri Arts Council
Ray and Grace Morgan
William Morley
Frederick J. Myerson
NBC Fund
Kenji Nakahashi
National Academy of Design (Mrs. William Troost Brewster Bequest)
Mr. and Mrs. Geoffrey A. Oelsner
Don, Joyce, and Josh Omer
Cruise Palmer
Mr. and Mrs. Tom H. Parrish
Jim L. and Sue A. Peterson
Pratt Graphics Center
The Print Collectors of the Friends of Art
The Print Society of the Friends of Art
Bernie and Sue Pucker (in honor of Mr. and Mrs. J. W. Pucker)
Philip F. Rahm

Robert and Elizabeth Raymond
Allene Reese
Mrs. George Reuland
Dr. and Mrs. Gordon C. Sauer
Kate Schaeffer
Charles M. Schulz
Richard Shields Fund
Laurence Sickman
Laurence Sickman (as Artistic Executor of Thomas Handforth)
John M. Simpson
Miriam Babbitt Simpson Bequest
Mrs. Louis Sosland
Helen F. Spencer Bequest
Felice Stampfle (in memory of Arthur J. Suiter)
Felice Stampfle (in memory of Harry J. and Grace Suiter Stampfle)
Marius Lane Starkey
Mr. and Mrs. John W. Starr
David L. Stewart
Strahl and Pitsch, Inc.
Connie Sullivan
Gary Sutton
John L. Swarts
Mr. and Mrs. Stephen Tabb
Mr. and Mrs. Ross E. Taggart
Shirley Tarbell
Mr. and Mrs. Blake K. Thomas
Dean E. Thompson
Mr. and Mrs. W. Douglas van Loan
James N. Wallace Bequest
Margaret Tarbell Wehmeyer
Robert and Iris Wheeler
Mrs. John F. Wilber
Robert L. Wilson
Mrs. Oliver Wolcott
The Woodcut Society
Blanche Young
Dan Younger

JACQUES VILLON
French, 1875-1963
L'Ombrelle Rouge, 1901

Etching and color aquatint,
49.6 x 39.3 cm.

Acquired through the generosity
of an Anonymous Donor.
F78-3/1.

Villon was an etcher from the age of sixteen and produced his finest color prints in etching and aquatint by 1910, when he turned to Cubism. His subjects were the fashionable and bohemian ladies of the day, drawn in elegant arabesques and vibrant coloring in flat planes. Often his trial proofs, as in this instance, are far more striking than the completed, more conventional versions. Here the gracefulness of the forms and the dramatic intensity of the color scheme result in a picture of great charm. The light shining through the trees in the background forms a mottled, abstract setting, rather like a tapestry.

G.L.McK.

94

ABRAHAM BLOEMAERT
Dutch, 1564-1651

Diana

Pen and brown ink with red and brown washes, 13.9 x 10.8 cm. (reproduced actual size)

Bequest of Milton McGreevy. 81-30/5.

Bloemaert trained with his father Cornelis by copying drawings by the Renaissance master Frans Floris. In 1591 Abraham moved to Amsterdam. Two years later he settled in Utrecht where he remained for the rest of his long and successful career. Essentially a Mannerist artist, in later years Bloemaert also was influenced by the revolutionary style imported to the Netherlands by his students, Honthorst, Terbrugghen and Jan van Bijlert — collectively known as the Utrecht *Caravaggisti.*

The careful outlines and shading of the Museum's drawing suggest that it was preparatory for a print, as was the case with a similar drawing by Bloemaert, his *Saint Veronica* at Christ Church, Oxford. Possibly the *Diana* was part of a series depicting the Goddesses of Mount Olympus; a related series, in three-quarter length format, was engraved by Jan Saenredam after drawings by Hendrick Goltzius. Here the Goddess of the hunt and the moon is self-consciously posed in the "stylish style" known as Mannerism. Typical are the contorted forms of Diana's hands.

E.R.

JAN VAN HUYSUM
Dutch, 1682-1749

Flower Piece

Signed lower right: *Jan Van Huysum fecit*

Pen and black ink over black chalk with washes in black and brown ink, heightened with opaque white, 41.3 x 32.4 cm.

Bequest of Milton McGreevy. 81-30/35.

This is one of the finest flower drawings by Van Huysum, considered the greatest of the Dutch flower painters. The presence of a signature suggests that, like several of the artist's flower drawings, this work was a collector's item and considered not just a compositional study but a work of art in itself.

The flowers — mainly tulips, roses, poppies and carnations — splay out from the center, formed by three light-hued roses, in a clockwise, pinwheel pattern. The passage of time is suggested by the tulips at lower right which, past their prime, fall to the ground. It was a time-honored tradition among Dutch still life painters to include such suggestions of decay as allegories of the vanity of earthly existence. At upper left a *pentimento* is clearly visible.

Jan van Huysum studied as a young man with his father, himself a flower painter. His work was widely appreciated in his day. Contemporaries, however, speak of Jan's mania for secrecy; because of his fear that his special colors and technique would be appropriated by others, he refused, with one short-lived exception, to take on any pupils. The Museum owns a beautifully preserved oil on panel flower painting by this master (Inv. no. 32-168).

E.R.

96

JOHN MARTIN
English, 1789-1854
Ruins in Moonlight
Signed lower left: *J Martin*
Brown ink wash on white paper,
17.7 x 23.3 cm.
Bequest of Milton McGreevy.
81-30/51.

In his lifetime John Martin as a painter was compared to Turner. Though lacking the latter's genius, his paintings do take as their subjects the historical and moralizing themes set in vast panoramic landscapes that characterize Turner's early production. As the contemporary essayist Charles Lamb remarked: "His towered structures are of the highest order of the material sublime. Whether they were dreams, or transcripts of some elder workmanship, Assyrian ruins old, restored by this mighty artist, they satisfy our most stretched and craving conceptions of the glories of the antique world." In his devotion to depicting the sublimity of nature and the insignificance of man before it, Martin was a true Romantic artist.

Largely self-taught, Martin took lessons with an Italian drawing master whose collection of engravings after Salvator Rosa and Claude Lorraine had a lasting effect on the young artist. He himself engraved, and his designs for a printed edition of Milton's *Paradise Lost* brought him great renown.

The subject of the present drawing has not been identified, but its theme may be a general elegiac one of the decay of some ancient civilization. A sole human figure is represented by a white statue, silhouetted against the background ruins.

E.R.

97

ROY F. LICHTENSTEIN
American, 1923-
Modern Head No. 6, 1970
Solid brass relief, 59.9 x 45.1 cm.
Gift of Mr. and Mrs. Tom H. Parrish. F82-10/6.

Published by Gemini G.E.L. in Los Angeles, this relief sculpture is the last in a series of six multiples executed in various media. All of the representations of human heads in the group are rendered in sleek, geometrical forms, their abstracted lineaments recalling synthetic Cubism and its later relation, the Art Deco mode of the 1920s. The artist's immediate inspiration was a group of constructivist paintings of heads by the Russian master Alexei Jawlensky which he had seen at the Pasadena Art Museum. The enlarged dots of half-tone photo-mechanical reproduction that are a hallmark of Lichtenstein's style serve as grid-like mathematical surfaces defined into heavily bounded planes. Cutout sections, embossing, and brilliant contrasts of figures and ground, which appear in the relatively flatter linocuts or serigraphs of the rest of the series, are here surpassed by the lustrous three-dimensional surfaces crafted with mechanical precision into a high relief.

G.L.McK.

98

HORACE CLIFFORD
WESTERMAN

American, 1921-1981

The Lost Planet, 1972

Color lithograph, 56 x 76.3 cm.

Gift of Mr. Robert W. Carlson.
F82-59.

A self-avowed anti-intellectual, addicted to satirical, semi-malicious visual comments on the world as-is and to-be, Westerman is perhaps most celebrated for his imaginative constructions, often in beautifully crafted wood, which are as enigmatic as the famous surreal boxes of Joseph Cornell. *The Lost Planet* depicts a world recently wasted by cataclysm, a bleak environment of insect and beast amid spiny pinnacles and smoking volcanoes. Whether seen as a forbidding forecast or a throwback to an ancient world, Westerman's lithograph is fluently drawn and freely washed, a brightly hued image for all its apparent doom.

G.L.McK.

THE LOST PLANET

JACQUES BELLANGE

French, active c. 1580-1638

The Martyrdom of Saint Lucy,
c. 1615-16

Etching with engraving,
46.5 x 35.3 cm.

Purchase, The Nelson Gallery
Foundation. F83-2.

The prints of Jacques Bellange, a native of the Duchy of Lorraine in France, are exceedingly scarce. A portraitist, scenery designer, and decorator, Bellange was first painter to the elegant court of Charles III at Nancy but only a handful of his paintings survive, most of them having been destroyed by fire in the ducal palace. Some eighty of his drawings exist, but Bellange is best known for the few fine impressions that remain of his forty-seven etchings, dating from 1606 to 1620.

Bellange adapted figures and compositions from the Italian art which he apparently knew only through prints. These and the paintings by provincial artists which he saw at Fontainebleau during a visit in 1608 served as sources for his highly individualistic compositions. Like the thirty some figures in this, his first large scale print, Bellange's forms are attenuated in proportion, twisted in posture, and arrayed in garments that are arranged in eccentric curves to accent or obscure the contours of the bodies beneath. These Mannerist alterations are matched by the no less eloquent disposition of light. Protuberant surfaces are bleached to white, making brilliant planes that contrast with the stippled modeling. These emphasize the intricate play of shadow and illumination and give the forms a *sfumato* appearance, reminiscent of the works of Correggio. A sense of volume is subordinated to the overall turbulence of design. Thus, while the agony of Lucy is spotlighted and approached by an elevated, empty pathway, revealed beyond the backs of the foreground soldiers, the attention of the figures in the restless human wreath around her is focused elsewhere. Some gesture towards the pagan deity Diana, whom Lucy refused to worship. Others face the viewer. Even the executioner, bent to his task of stabbing with a dagger, looks aside.

Within a deliberately constricted space, all is in the service of a rhythmic composition in which undulant curves contrast with straight lines, dark with light, and smooth with irregular. Costumes are either high-waisted and extravagantly draped or, in the case of the soldiers, consist of highly ornate armor. In the lower left corner, a fantastic version of a Roman sandal and Bellange's scrolly signature echo the prevailing liveliness of design. Through this wealth of visual detail the eye may wander at will, alighting here on a graceful gesture, there on a striking, or erotic expression, before returning to the comparative calm of the center. Bellange's approach to a religious subject may be defined as more spirited than spiritual.

Of the Museum's collections of early and late Mannerist prints—which include examples by Parmigianino, Jacopo Caraglio, and Jacques Callot—none of them so fully exemplifies the extravagance of Mannerist art as this etching by Bellange, literally and figuratively an ornament to the collection.

G.L.McK.

100

CHARLES KIFFER

French, 1902-

Maurice Chevalier, c. 1948

Color lithograph, 160 x 119.4 cm.

Acquired through the generosity of Richard Shields. F83-3.

This is a striking, color lithographed poster of one of the more popular singers of our era, Maurice Chevalier. Kiffer first became known in the 1920s as a poster designer for theater, music hall, and circus entertainers. Among his later subjects were Marcel Marceau, Edith Piaf, and Brigitte Bardot.

He made his first poster of Chevalier in 1925, and has composed several others since. The summary construction of Cubism and the Art Deco style is evident in this appealing work of around 1948. It is a rare example, in that it lacks lettering which identifies the singer and the theater (probably the Alhambra) where Chevalier was performing. Kiffer took particular pride in personally lithographing his own posters. In later years he has authenticated them, in this case by a 1974 handwritten inscription below the printed signature.

This unmistakable, jaunty likeness of Chevalier joins Toulouse-Lautrec's *Jane Avril* and Mucha's *Sarah Bernhardt* in the Museum's choice collection of posters depicting modern-day celebrities of the stage.

G.L.McK.

IMP. BEDOS & Cⁱᵉ PARIS

101

JASPER JOHNS
American, 1930-
Souvenir, 1970
Color lithograph, 60 x 43.8 cm.
Gift of Mr. and Mrs. Tom H. Parrish. F83-18.

One of the most technically complex of the artist's works in lithography, *Souvenir* was printed in eleven colors from nine stones for the Philadelphia Museum of Art at the time of a ten year retrospective there of his prints. Like much of Johns's graphic production, this lithograph is based on images derived from his prior accomplishments in other media, in this instance, the second of two paintings of the same title of 1946, and a number of drawings dating from 1966.

The view of the blank back of a stretched canvas (marked "2/souvenir") may refer to this painting, providing a submerged recollection of a picture whose reverse is now delineated with as much precision as its front. In the lower left of the print is the simulacrum of a ceramic, souvenir dinner plate of the type Johns had seen in Tokyo, in 1964, decorated here with the face of the artist, who appears to scrutinize the observer. The flange, or shoulder, of the dish bears Johns's familiar stencil letters in the primary colors that symbolize the spectrum of light, without which there is no vision. The artist's oft-repeated flashlight, seen at the right, casts a beam upward onto the bicycle mirror ("something for looking backward while moving forward") which then illuminates the canvas and plate. *Souvenir* is thus a commemoration of memory (that of Johns and the spectator, both) of elements recollecting the artist's previous work and recast into this present, resonating composition.

G.L.McK.

102

FRANCOIS BOUCHER

French, 1703-1770

Three Putti in Clouds, c. 1759

Black, white, and red chalks on buff paper, 19.7 x 28.7 cm.

Purchase, The Nelson Gallery Foundation with the assistance of Helen Cronin Bourke. F83-27.

This sheet is the only known surviving drawing associable with one of Boucher's most beautiful smaller mythological canvases, the *Jupiter, in the guise of Diana, seducing Callisto* (signed and dated 1759) which for more than five decades has been one of the most popular paintings in the Nelson-Atkins Museum. The drawing was made in the technique described as *trois crayons*, meaning three different colored chalks, never used more brilliantly than by the 18th-century French painters Antoine Watteau and Boucher himself. The figures first were outlined, worked up, and shaded in black, then highlights were added with white, and finally many of the contours and details were reinforced or accented with red. The sheet is in mint condition and provides an opportunity to enjoy both the spontaneity and subtlety of Boucher's draftsmanship.

The exact nature of the relationship between the Museum's drawing and painting is not perfectly clear. It is obvious, in the first place, that the sheet is not a rough working design wherein tentative ideas were first expressed: there are no *pentimenti* in this carefully balanced group of three units that overlap and interlock, and the drawing is highly finished. The alternative assumption that it is a fully realized *modello* for the related section of the painting seems to be contradicted by the fact that neither the under-painting nor the finished picture includes the third *putto*, on the right in the drawing. Furthermore, a comparison of the drawn and painted *putti* reveals that they are not of the same size, for those in the design are actually larger than their painted counterparts. Therefore this exquisite sheet would seem to be an example of Boucher's practice of the redeployment of individual figures and motifs that originally had been created for other purposes. Apparently it was made by borrowing the two *putti* on the left from the Kansas City painting, and combining them with the one on the right who is derived from a completely different, earlier source.

R.W.

103

JOSE DE RIBERA, called
LO SPAGNOLETTO

Spanish, 1591-1652

The Martyrdom of Saint Bartholomew

Signed and dated: *1624*

Etching, first of two states,
32.3 x 23.6 cm.

Purchase, The Nelson Gallery
Foundation. F83-34.

A favorite subject of the artist, the etching is printed on the grey paper which Ribera favored for the finest early impressions of his plates. In this, his first multi-figured work, the artist's late manner is evident, characterized by cross-hatching for shadows, thin parallel lines for grey middle tones, and hundreds of small dots and flicks to define form and volume. The effect is to lighten and refine Ribera's earlier high-contrast style which he had learned from Caravaggio in Naples, one which was later adopted by Rembrandt.

The artist considered etching an independent art form, not a repetition of a painted prototype. In each of his sixteen known prints, he used this medium for working out his visual ideas as freely as he would have drawn in pencil, or sketched in oils.

Sharpening the knife which will be used to flay the saint, the malevolently grinning assistant at the left reappears in many of Ribera's pictures, in alternating postures and guises.

G.L.McK.

MASTER S., identified as
SANDERS ALEXANDER VAN
BRUGSAL

Flemish, active c. 1505-died 1554

Madonna and Child on a Crescent,
early 16th century

Hand-colored engraving,
10.9 x 7.6 cm.
(reproduced actual size)

Purchase, The Nelson Gallery
Foundation. F83-35.

This print is a unique impression of a hitherto unrecorded plate by an artist who made nearly a dozen versions of this same theme, the Virgin in Glory or Queen of Heaven, enclosed in this instance by a flame-like mandorla. Beautifully tinted by hand in red, yellow, and green, this rare work is the first colored engraving to enter the collection.

A prized supplement to the Museum's renowned group of hand-colored German woodcuts of approximately the same period, the *Madonna* by Master S also adds distinction to the Netherlandish portion of the collection. The latter contains examples by Lucas van Leyden and Dirck Vellert, artists who influenced the Master S in his use of a late medieval sculptural style, slender proportions, and the technique of crosshatching and closely drawn lines to render form and shadow.

G.L.McK.

CAMILLE PISSARRO

French, 1830-1903

Wooded Landscape (Paysage sous bois à L'Hermitage), 1879

Soft-ground etching, aquatint, and drypoint, 21.8 x 26.7 cm.

Purchase, The Nelson Gallery Foundation. F83-60.

The foremost printmaker among the French Impressionists, Pissarro derived this intaglio print from his painting of the same title (the present cat. 64). The etching is less abstract and evenly textured than the picture and was produced by a technique—direct application of acid strokes to the mottled aquatint ground, with very few, linear drypoint accents in the sixth and final state—that makes the graphic version as painterly, in its way, as the slightly earlier painting.

The subject is one of Pissarro's favorite motifs: a screen of dappled trees with a scattering of cubist-like buildings beyond in the shimmering sunlight. The richly textured print fully evokes the artist's preoccupation with the effects of natural light.

Until the Museum purchased this sparkling impression, it had never been out of the hands of the Pissarro family. Four earlier, preliminary states of the print, mounted on yellow paper and housed in a single purple frame, were shown by the artist at the Fifth Impressionist Exhibition, of 1880. On the occasion, an edition of fifty (from which the Museum's example came) was printed for the only issue of *Le Jour et la nuit,* an album published by Degas. Pissarro worked closely with Degas at that time. He had no press and Degas often proofed his plates for him.

G.L.McK.

106

JOHAN THORN PRIKKER

Dutch, 1868-1932

Holländische Kunstausstellung in Krefeld, 1903

Color lithograph, 85.4 x 120.7 cm.

Purchase, The Nelson Gallery Foundation. F84-2.

One of the most famous Dutch Art Nouveau posters ever printed, this work advertises a Dutch art exhibition in Krefeld, Germany, where the artist lived after migrating from Holland. Unlike the more sinuous and convoluted designs familiar to us from Continental Art Nouveau practice, Thorn Prikker's approach is typically Dutch in its symmetry and comparative restraint. There are stylistic devices derived from batiks imported from Java, a Dutch possession at the time, and from medieval manuscripts of the Celtic tradition that the Dutch never entirely forsook.

A designer of furniture, murals, textiles, and wallpaper, Thorn Prikker also created stained glass windows, the black lead framing and primary colors of which seem to be adapted to the poster. The basically floral interlacing of positive and negative forms, both Javanese and Celtic in origin, appear to be based on the tulip, appropriate for a Dutch theme. In the simplification of his forms and rigor of contour, Thorn Prikker—who was associated with the artists' colonies in Germany that evolved into the Weimar Bauhaus—anticipated the International Style of building and household products.

G.L.McK.

107

HENDRICK GOLTZIUS
Dutch, 1538-1617
Nox, Goddess of Night, designed
c. 1588/89, printed c. 1594
Chiaroscuro woodcut,
34.5 x 25.5 cm.

Purchase, The Nelson Gallery
Foundation. F84-56

Nox is part of a set, in oval format, which is entitled the *Six Deities*, sometimes associated with the myth of Persephone, but usually considered to be grouped in pairs. Thus "Helios," or the Sun, emblematic of Day, was the pendant of Night. The imagery is thoroughly nocturnal, and includes: Persephone coursing across the sky in a wagon (derived from the carnival processions Goltzius had seen during his stay in Florence), drawn by bats; the wicker cab bearing clambering rats (the gnawing devourers of time); the crowing rooster anticipating the dawn; the owl sitting beside Persephone, whose mantle has star designs and who lights her progress with the torch. Within the cab, the concealed sun lights the orb of the earth, the signs of the zodiac signify the passage of time, and the passenger in the wagon personifies Sleep (or possibly Persephone returning to earth from her sojourn in Hades). Partaking little of the Mannerist postures, elongated proportions, and formularized, swelling-line technique usually seen in Goltzius's engravings, *Nox* has a fluid, harmonious appearance, more suggestive of painting, the art to which Goltzius devoted himself exclusively from 1600 onwards.

The Museum has in its collections eight of the 364 engravings made by Goltzius, six of them regarded as his masterworks, the *Life of the Virgin* series, after painted prototypes by Italian masters. These were published about the same time as *Nox*, in around 1594. Goltzius, however, was most original in his twenty-five known woodcuts, the majority of the "chiaroscuro" prints, which, with their color tone blocks and sparkling white highlights (from the unprinted paper), were intended to emulate polychrome pen and wash drawings.

G.L.McK.

CHRISTOFFEL JEGHER, after
P. P. Rubens

Flemish, 1596-1652/3

Silenus Accompanied by a Satyr and a Faun, c. 1635

Woodcut (I/II), 46.3 x 35.3 cm.

Purchase, The Nelson Gallery Foundation. F84-57.

This monumental woodcut was modeled after a drawing by Rubens (1577-1640) now in the Musée du Louvre. Like Raphael and Titian before him, Rubens disseminated his compositions with the aid of a staff of studio assistants, mostly a dozen engravers trained in the workshop of Goltzius. They prepared prints from fully realized drawings in which Rubens recorded his painted compositions. Rubens himself etched two or three plates, one of the *Allegory of Youth and Old Age*, completed in engraving by his assistant Paulus Pontius (of which the Museum owns an impression), and he closely supervised and corrected such printmakers' work. While the engravings are successful transcriptions of Rubens's heroic, Baroque style, few of them have the grand sweep and dramatic impact which Jegher—the only woodcut artist among the assistants—managed to impart to this strikingly impressive print.

Ultimately derived from Roman stone reliefs, the image is the definitive version of Silenus, the mentor of Bacchus, as envisioned by Rubens. It is a subject depicted by Rubens on some ten other occasions.

G. L. McK.

CVM PRIVILEGIIS.

109

WILL H. BRADLEY
American, 1868-1962
Narcoticure, 1895
Color lithograph, 50.2 x 34.5 cm.
Purchase, The Nelson Gallery Foundation. F84-78.

One of the first prominent poster designers in the United States after about 1890, Will Bradley was influenced by both the English Arts and Crafts movement, headed by William Morris, and by the international Art Nouveau style, exemplified in Great Britain chiefly by Aubrey Beardsley. Direct American contact with Continental poster production was limited to the two *affiches* made by Toulouse-Lautrec for companies in the United States and to Grasset's two posters for *Century* magazine.

In his earlier work, and particularly in his covers and posters for the periodicals *The Inland Printer, The Chap-Book*, and his own publication *Bradley: His Book*, the artist showed the obvious influence of the swirling linearism and contrasting planes of Beardsley. He was also inspired by the elaborate borders and figured patterns of pre-Raphaelite publications (directed by William Morris), which are based on medieval Celtic precedents such as the Book of Kells. With his awareness of pertinent antecedents, and the artist's real knowledge of typography (derived from his training as a printer), Bradley's posters present a distinctively integrated appearance.

Impressed by the financial success of artistic posters, promotion books, and magazines, modern manufacturers exploited the merits of such advanced pictorial design to promote their own commercial output. *Narcoticure* revolutionized the advertising of patent medicines, replacing the extended blocks of letterpress and simple black and white illustrations—often of the trademarked visages of pharmaceutical founders such as the Smith brothers—with full-color presentations of a more visually striking sort.

Narcoticure apparently derives from the ancient theme of Saint George killing the dragon, the latter here a prickly-leaved demon, like some evil artichoke, being impaled by the lance of the knight riding to the attack through a cloud of swirling smoke. The dynamic black lines forming the horseman and his mount are highlighted against the plain buff ground, accentuating this thrusting movement.

G.L.McK.

110

GIOVANNI DOMENICO
TIEPOLO

Italian, 1727-1804

*Mary, Helped by an Angel, and Joseph
Carrying the Basket, Passing a Flock,*
Plate 24 from the series of 27 in
The Flight into Egypt, c. 1753

Etching, 18.5 x 24.1 cm.

Purchase, The Nelson Gallery
Foundation. F84-80.

In the 18th century, Venice was the center of etching production by Canaletto and the Tiepolo family, who brought to prints the brilliance of lighting and clarity of atmosphere that animated their canvases and frescoes. The style of Domenico, the eldest son of Giovanni Battista Tiepolo, became the most imitated in Europe, especially in France.

The *Flight* scene is one of Domenico's more unusual compositions; it centers on the figure of Joseph, high in the foreground and silhouetted against the sky, with the forms of Mary and the Angel relegated to one corner. The scene is one of movement into and across the picture plane; all four human figures are united by the horizontal motif of a strand of passing sheep. The stage-like device of the over-arching palm tree derives from prints by Rosa and Castiglione, as do the lively, scribbled strokes. Domenico's wiry, energetic lines have a greater variety, range of tonality, and wider spacing, though, all of which contribute to the extraordinary vivacity of this scene.

G.L.McK.

111

LEON BAKST
Russian, 1866-1924

The Martyrdom of Saint Sebastian, 1911

Color lithograph in 2 parts, 130.2 x 201.8 cm.; 133.8 x 205.9 cm.

Acquired through the generosity of the Leawood Women's Club, Richard Shields, and Felice Stampfle in memory of her uncle Arthur J. Suiter. F85-9/a,b.

A painter, decorator, graphic artist, and scenery and costume designer, Bakst trained at the St. Petersburg Academy of Fine Arts. He was a prominent member of the Mir Iskustva (World of Art) group, which was dominated by Serge Diaghilev, the future impressario. This organization sponsored art exhibitions in Russia and France, introduced contemporary western European painting (mostly Post-Impressionism) to Russia, and produced a progressive periodical designed by Bakst. After working at the Imperial theaters, Bakst achieved worldwide fame with his designs for Diaghilev's Ballets Russes, which performed in Paris from 1909. In 1911 Bakst dissolved his exclusive association with the dictatorial and mercurial Diaghilev and collaborated with Ida Rubinstein, a dancer, actress, and fellow defector from the Ballets Russes, who formed her own company and produced a series of dance spectacles in Paris.

The Martyrdom of Saint Sebastian was her first presentation. On May 22, 1911, this five-act play in the form of a sacred medieval "mystery" was produced at the Théâtre Châtelet, with music by Claude Debussy, libretto in archaic French by Gabriele d'Annunzio, choreography by Fokine, and settings and costumes by Bakst. Its plot involved the persecution of Christians by the Roman emperor Diocletian and the defiance by Sebastian of the emperor's demand for pagan idolatry. This refusal led to the dissident saint's being shot with the arrows of his own company of Imperial bodyguards. In Bakst's poster, Saint Sebastian, played by Ida Rubinstein, is the first figure on the left, and Diocletian, the fourth.

This rare and spectacular poster has the horizontal format and strip typography typical of 17th- and 18th-century Russian *lubki*, or bright, hand-colored, primitive printed cartoons. It is the culmination of the representational yet decorative spirit in early 20th-century poster design, that was soon to be overshadowed by Cubist and Constructivist modes of abstract simplification. In its monumental, frieze-like form, brilliant color, and medieval costumery—so reminiscent of Russia's Byzantine heritage—the *Saint Sebastian* poster is an imposing manifestation of its time and type.

G.L.McK.

LE MARTYRE DE

SAINT SEBASTIEN

112

WINSLOW HOMER
American, 1836-1910
Perils of the Sea, 1888
Etching, 42 x 56 cm.
Purchase, The Nelson Gallery
Foundation. F85-10.

Besides the expatriate Whistler, Homer was the first American printmaker of major importance. As an illustrator for *Harper's Weekly* and other periodicals, Homer was a prolific designer of wood engravings, of which he produced 220. Between 1886 and 1889 Homer turned to etching. In this medium he executed only eight prints, all of them serious, dramatic studies that were far removed (except for his Civil War wood engraved scenes) from the comparatively lighthearted views of children at play, summer resort frequenters, adults dancing, sports and pastimes, and the activities of farmers and backwoodsmen that, in magazine illustration, had made his early reputation.

The turning point for Homer came during his stay in England in 1881-82. At the port of Tynemouth, on the North Sea, the artist responded to the subject matter of the hardworking, ocean-going fishermen and their families who were forever at the mercy of dangerous storms. Upon his return to America, Homer adapted from the studies made at Tynemouth the sea scenes most commonly associated with the artist. *Perils of the Sea*, like other prints made from his own paintings, is based on a drawn precedent, in this instance a watercolor now in the Clark Art Institute, Williamstown, Massachusetts. From the composition Homer removed distracting elements such as a pointing figure at center, a group of people on the porch of the coast guard station, and a railing along the quay, in order to heighten the sense of emotional tension of those who wait on the shore for the return of the beleaguered fishing boats. On the bottom margin is depicted an anchor. This is a *remarque*: analogous to a musical grace note, it is an auxiliary visual comment of the sort often used by 19th-century artists on the borders of their works to complement the subject. In the second printing, not made until 1941, another *remarque*, the head of a bearded fisherman in sou'wester hat has been added.

The present etching is an excellent impression, printed meticulously without over-inking, which shows Homer's ability to exploit all possible tonal nuances of the turmoil of water and sky by sheer massing of line. Of special effectiveness is the sculptural solidity of the figures who form a veritable frieze of anxious quietude in the hostile face of nature.

G.L.McK.

113

GIOVANNI ANTONIO
CANALE, called CANALETTO

Italian, 1697-1768

Ale [sic] *Porte del Dolo,* c. 1741

Etching, 30.2 x 43.1 cm.

Acquired through the generosity
of Richard Shields and David T.
Beals, III. F85-18.

Only eleven of Canaletto's thirty-four prints, including this one, depict actual, rather than arranged, scenes of locations in the Veneto region. The print shows a view of Dolo, a town some fifteen miles west of Venice on the Brenta canal, in which a passenger barge, or *burchiello*, is seen leaving the locks. It is an expansive landscape, in the artist's mature style, exhibiting the spontaneity Canaletto was able to bring to an accurate rendition. Parallel lines, tremulous in the sky and water, are varied with curves and squiggles to define pools of light, and with crosshatchings of shadows on figures and buildings to define form. The result is a shimmering quality that captures for the observer the full, brilliant reality of a sunstruck day.

G.L.McK.

114

JAMES ABBOTT McNEILL
WHISTLER

American, 1834-1903

San Giorgio, 1879/80

Etching, 21 x 30.5 cm.

Purchase, The Nelson Gallery
Foundation. F86-11.

Celebrated for his dynamic views of harbors and shoresides in England and on the Continent, Whistler has brought to this etching a freshness and vitality seldom seen except in such early proofs as the present rare impression. From the artist's second set of Venetian scenes, *Twenty-six Etchings*, this is a calm, wide expanse looking over the Giudecca canal from San Marco toward the distant architecture on the far shore. Instead of this distant view, however, it is the sprightly composition of ships that is paramount. Unlike his other Venetian etchings, whose plates were bitten with nitric acid, Whistler's *San Giorgio* was done with so-called "Dutch mordant" (a solution of hydrochloric acid and potassium chlorate, devised by Whistler's brother-in-law, supposedly to duplicate Rembrandt's formula). This acid gives a wiry, prickly character to the lines in this print, imparting a distinct textural vibration differing from the smoother, wider depths of contour in the others of the series.

G.L.McK.

115

LUCAS VAN LEYDEN

Dutch, 1494-1533

Esther before Ahasuerus, 1518

Engraving, first state,
27 x 22.1 cm.

Purchase, The Nelson Gallery
Foundation. F86-24.

This subject is taken from the Old Testament Book of Esther. King Ahasuerus (Xerxes) took as his second wife the "fair and beautiful" Esther, who unbeknownst to him was Jewish. It happened that at this very time the King's chief minister Haman was campaigning for the massacre of all Jews in the Persian Empire. With great courage, Esther took up the cause of her people and went to her husband, the King. Court etiquette decreed that to enter the King's presence without being summoned was punishable by death. Upon seeing her, though, Ahasuerus held out his scepter, signifying that an audience had been granted, and Esther swooned with relief. Her objective succeeded, the Jews were spared and Haman himself was put to death.

In Christian art, the subject was interpreted as a prefiguration of the Virgin in her role as intercessor for the sake of mankind.

Within a convincing architectural setting, Lucas has placed forms enveloped in a web of strokes and stipplings, shot through with light, imparting to this rare, first of three states a mellow, silvery tone typical of the best impressions of the engraving. The scene is suffused with tenderness and deliberation, appropriate to the subject, in which the idealized beauty of the queen wins over the absolute power of her monarch spouse.

G.L.McK.

116

HENRI DE TOULOUSE-
LAUTREC

French, 1864-1901

La modiste, Renée Vert, 1893

Lithograph, 47.6 x 30 cm.

Gift of Mrs. Leonard Charles Kline. F86-33.

One of only twenty-five impressions on Japanese paper, signed and numbered by the French master, the print originally served as a menu for the dinner, June 23, 1893, of the Société des Indépendants, a Paris organization which sponsored annual salons of the work of non-academic artists. In this second-state impression, the menu was removed, leaving only the "l" of the word "hotel" still visible.

The subject is the milliner Renée Vert shown trimming a hat for the dancer Jane Avril, a theme of the sort favored by many of the Post-Impressionist artists, among them Lautrec's idol Degas. According to their friend Misia Natanson, "Hats delighted Lautrec as much as they did Renoir . . . he couldn't stop himself from stroking muffs and dresses as though they were human beings." One of Lautrec's earliest and most charming prints, *La modiste* comes from one of the great private collections of the artist's work, that of Ludwig Charell, part of which — including this lithograph — was sold at auction in London in 1966. The print is a valued addition to the Museum's group of ten other graphics by Lautrec, ranging from 1893 to 1898.

G.L.McK.

Index of Artists

Concordance by Accession Number